Painter

THE WORLD'S FINEST PAINTER ART

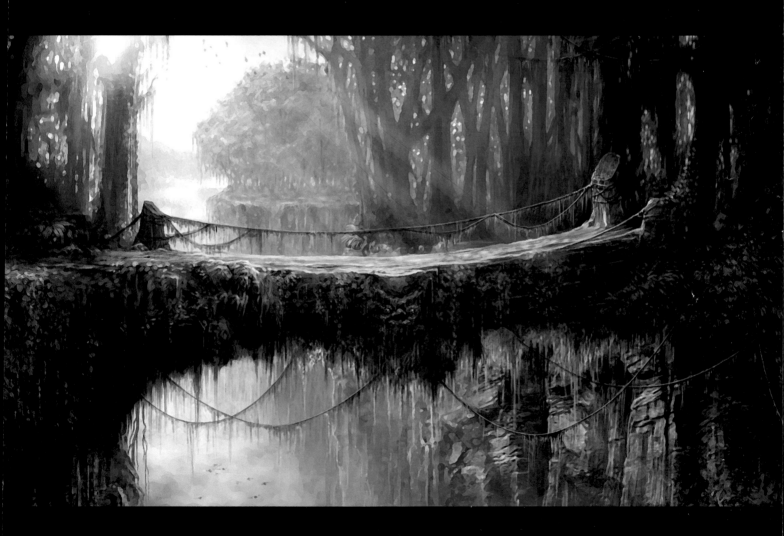

Edited by

Daniel Wade & Paul Hellard

Publishers

Mark Snoswell & Leonard Teo

Painter

Published
by

Ballistic Publishing

Publishers of digital works for the digital world

Aldgate Valley Rd
Mylor SA 5153
Australia

www.BallisticPublishing.com

Correspondence:
info@BallisticPublishing.com

First Edition published in Australia 2006 by Ballistic Publishing

Softcover Edition ISBN 1-921002-18-2
Special Edition ISBN 1-921002-20-4

Managing Editor
Daniel Wade

Assistant Editor
Paul Hellard

Art Director
Mark Snoswell

Design
Lauren Stevens

Image Processing
Stuart Colafella

Printing and binding
Everbest Printing
www.everbest.com

Partners
The CG Society (Computer Graphics Society)
www.CGSociety.org

Also available from Ballistic Publishing
d'artiste Digital Painting Slipcased ISBN 0-9750965-5-9
d'artiste Matte Painting Slipcased ISBN 1-921002-16-6
EXPOSÉ 3 Softcover/Hardcover ISBN 1-921002-14-X/1-921002-13-1
EXOTIQUE Softcover ISBN 1-921002-26-3

Visit www.BallisticPublishing.com
for our complete range of titles.

Cover image credits

Knight Shift
Painter
Anry Nemo, RUSSIA
[Front cover: PAINTER Softcover edition]

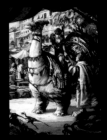

Market
Painter
Torsten Wolber, GERMANY
[Back cover: PAINTER Softcover edition]

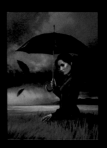

Waiting
Painter, Photoshop
Joerg Warda, GERMANY
[Front cover: PAINTER Special Edition]

EDITORIAL

Daniel Wade | Managing Editor & Mark Snoswell | Publisher

There is one dominant factor that determines an artist's success: their ability to express their vision. Whether it's done in traditional mediums or with digital tools, a painter's skill remains the same. To this end, Painter is a unique tool. It amplifies the traditional artists ability rather then restricting it. Combined with pressure (tilt and direction) sensitive drawing pens, Painter accurately reproduces all of the natural media a painter could ever dream of... and it does much more!

Painting has a history that stretches back tens of thousands of years. The oldest paintings can be found on cave walls all over the world. The techniques that painters use today have been honed by countless artists over millennia. Techniques and styles have been guarded and passed down over time. Perhaps because of this rich history, the craft of digital painting has met with resistance from the wider art community. However, as this book shows, digital painting expands the tools and forms of the artist's craft. Digital painting preserves traditional techniques while adding new ones.

With this book, PAINTER, digital art has reached a milestone where the tools need not leave a signature that says "computer-generated". Corel Painter is the most advanced "natural media" painting software. Over nine revisions, it has closed the gap with several hundred years of traditional painting techniques and added many new techniques. In partnership with Corel, Ballistic Publishing has created PAINTER to showcase the world's best digital paintings created using Corel Painter.

PAINTER is a completely independent production of Ballistic Publishing, with images selected solely on their artistic merit. An independent advisory board of high profile artists and authors was appointed including: John Derry, Jeremy Sutton, Don Seegmiller, Philip Straub, Ryan Church, Cher Threinen-Pendarvis, Howard Lyon and Andrew Jones. With their help, we sorted through close to 2,600 entries to select 209 images from 128 artists in 29 countries.

Images were allocated to one of twelve categories: Character in Repose, Character in Action, Portraits, Transport, Wildlife, Environment, Still Life, Abstract & Surreal, Humorous, Editorial Illustration, Fantasy and Concept Art. By category, the best-judged images were awarded Master Awards and depending on merit, 1-3 images received Excellence Awards.

As with our EXPOSÉ and ELEMENTAL series, the hardest part of the process was agonizing over all of the fantastic images entered. We only have room to print a small fraction of them. The number and quality of entries for this first edition was fantastic. Less than one in twelve images made it into print. We encourage you to visit our web site to see all of the images entered for this and other books from Ballistic Publishing.

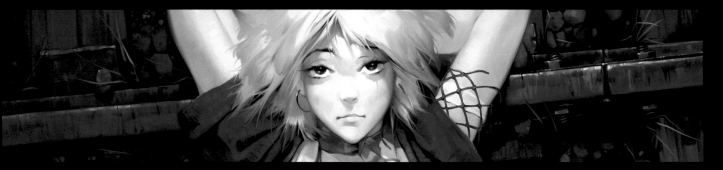

CHARACTER IN REPOSE (page 18)

Falling Sky, Painter
Anry Nemo, RUSSIA

One in eight entries for PAINTER fell into the Character in Repose category. The category recognized the greatest talent in bringing a character to life. The judging criteria for entries encompassed technical skill, believability, composition and, most of all, emotion. The overall challenge was to test the artist's ability to breathe life into their character whether human, creature or robot. Several genres were represented in the category including fantasy, anime, realism and comic illustration. The level of artistry in this category was great with Cyril Van Der Haegen's 'Circu, Dimir lobotomist' created with Painter taking out the Master Award.

Other notable entries in the category came from the hugely talented Russian artist Anry Nemo with his 'Beatrice' and 'Falling Sky' pieces, created with Painter, taking Excellence Awards. Joerg Warda also took an Excellence award for the slightly surreal 'Waiting' created using Painter and Photoshop.

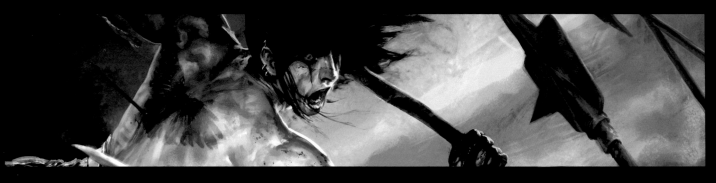

CHARACTER IN ACTION (page 34)

Medieval crow, Photoshop, Painter, Artrage
Aleksi Briclot, FRANCE

The Character in Action category honored the highest achievement in capturing the sheer power, energy and elegance of a character in motion. Although many artists aspire to create animations that come to life, it is a rare talent to capture expressive motion frozen in a moment in time. One in sixteen entries for PAINTER fell into the category with several using conflict as the subject matter. The Master Award went to Christian Alzmann for his 'Rage upon him' piece capturing a warrior in a pitched struggle with a fearsome monster. An Excellence Award went to Simon Bull for 'News flash: Giant Panda destroys Tokyo' capturing a rampaging Panda towering over Tokyo and threatening it with its laser vision. Notable entries which also received Excellence Awards included Cyril Van Der Haegen's 'Taaaxi!' featuring a vampire in a hurry in New York, and Anry Nemo's remarkable 'Knight Shift', the cover art for the softcover edition of PAINTER.

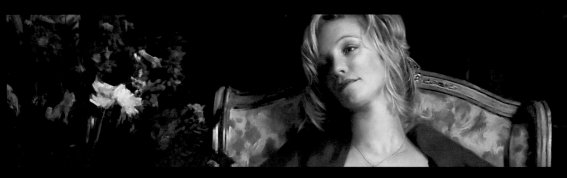

PORTRAITS (page 46)

Laura, Painter
Roger Barcilon, USA

The Portraits category was a new one for a Ballistic Publishing book and many entries for PAINTER fell into this category. The judging criterion for the category was to create a portrait that conveyed the personality of the subject while encompassing technical skill, believability, and composition. Painter offers a great deal of options for painting over photographs, so images were not automatically excluded if they took advantage of these features. In some cases, it was difficult to tell if photo reference was used due to the skill of the artist. There was an even mix of entries where photo reference was used. Bruce Hamilton Dorn's 'Dancers in Repose' took out the Master Award with a wonderful composition created in Painter. Excellence Awards went to Vanessa Lemen for her 'Autumn' portrait created with Painter and Photoshop, and to Sequoia C. Versillee for her stylistic 'Gloria In Red' portrait created with Painter.

CONCEPT ART (page 62)

The Concept Art category recognized the highest achievement in bringing a concept into being, whether for a movie, TV or game environment. The defining criterion for this category was to convey a sense of place and drama. Technical skill, composition, color palette and mood all contributed to the success of a concept piece. One in thirteen PAINTER entries fell into the Concept Art category. The subject matter for the category was quite varied with several game concept art entries featured including weapon designs for Sony Online Entertainment's 'EverQuest: Omens of War'. The Master Award went to Justin Kunz for his game concept for 'Ghost Detective 2' created in Painter and Photoshop. The Excellence Awards went to Kevin Dart for 'Abby and the Monster' created using Painter and Photoshop, Eduardo Schaal for 'Turbo Iesma' created using Painter and Photoshop, and Evan Shipard for 'Charge' created using Painter.

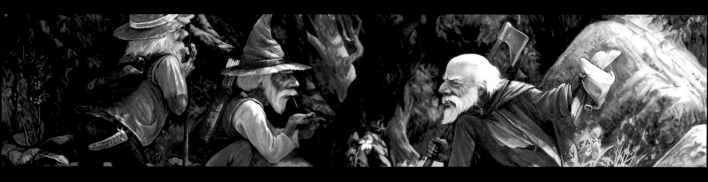

FANTASY (page 78)

The Fantasy category in PAINTER honored the highest achievement in the mythic fantasy style. The artist's talent in evoking an emotional response or attachment with the image was paramount. This category focused on the mythic or fairytale aspects of the work. Excellence in all technical aspects was a must so as to create the evocation of atmosphere required. One in nine entries for PAINTER featured a fantasy theme. A large proportion of the entries focused on traditional fantasy subjects such as dragons and elves. The Master Award went to Torsten Wolber for his beautifully painted 'Market' piece created with Painter. The Excellence Awards went to Chris Beatrice for his highly detailed fairytale illustrations of 'Giant Killer' and 'Old Scratch Returns for his Coat' created using Painter and Photoshop, and Aleksi Briclot for his atmospheric 'Legend of the Round Table' created using Painter, Photoshop and Artrage.

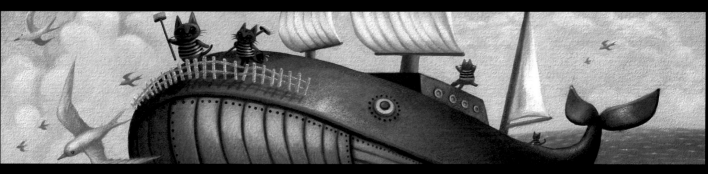

EDITORIAL ILLUSTRATION (page 94)

The Editorial Illustration category honored entries which told a visual story in the context of a publication whether it be a book, magazine or newspaper. Successful entries combined artistic interpretation with styles which were sympathetic to their medium. This included technical skills, and also the skill of telling a story. The Editorial Illustration category was the most diverse featuring work from several different mediums including magazine editorial, childrens' books, and newspaper cartoons. The Master Award for Editorial Illustration went to Jeff Wong for 'Sistine Chapel of Sports' published in Sports Illustrated magazine created using Painter and Photoshop. The scope of the illustration was remarkable and was a worthy award winner. The Excellence Awards went to Mark Bannerman for his 'Mrs McMurdo's perspective correctional School for Wayward Gals', Ture Ekroos for 'The Godfather', and Kevin Dart for 'The North'.

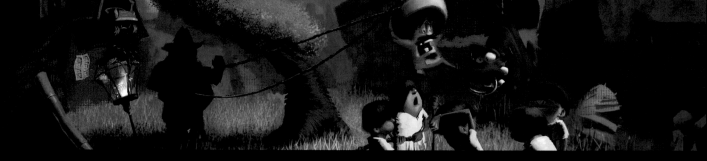

HUMOROUS (page 112)

Pinata, Painter, Photoshop
Bryan Beus, USA

The Humorous category recognized the most amusing image whether cartoon, humorous, satirical or just plain ridiculous. The category was all about making the viewer smile or even laugh out loud. One in twenty-six images entered for PAINTER fell into the Humorous category. The high quality of entries in the category made the judging challenging with several entries vying for Excellence Awards. The Master Award went to Jian Guo for the wonderful 'Training to Slay the Dragon' created using Painter and Photoshop. Excellence Awards went to Chris Beatrice for 'The Lute Player' created using Painter and Photoshop, Eduardo Schaal for 'Servant of Creation' created using Painter and Photoshop, and Bryan Beus for 'Pinata' created using Painter and Photoshop. Other notable entries in the category included Denis Fokin's 'Basic instinct', and Chet Phillips for 'Steam Roller Coaster' and 'I love Sushi'.

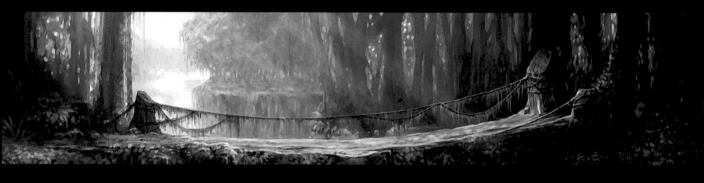

ENVIRONMENT (page 128)

Bridge, Painter
Weiye Yin, CHINA

The Environment category honored the best set or location whether indoors, outdoors, underwater, or in space. The artist's ability to evoke a sense of wonder and a wish to see more was paramount. This category demanded a combination of artistic interpretation, detail and lighting to create a believable and enticing environment. One in thirteen images entered for PAINTER fell into the Environment category with subject matter varying between real environments such as carnivals, piers and cityscapes to fantastic environments like castles, floating monoliths and organic superstructures. The Master Award for Environment went to Marek Olejarz for 'The City' created using Photoshop and Painter. The Excellence Awards went to Weiye Yin for 'Bridge' created using Painter, Emrah Elmasli for 'In the jungle' created using Painter, and Zhimin Wang for 'Carlendour' created using Painter.

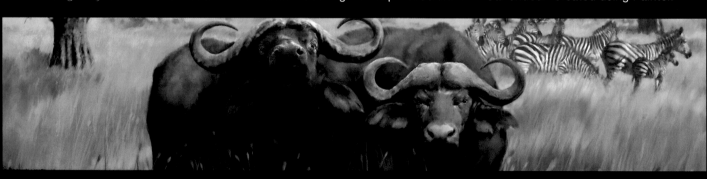

WILDLIFE (page 146)

Two bad duga boys, Painter. Client: Beman
Robert Corsetti, USA

The Wildlife category recognized the greatest talent in breathing life into a wild animal or pet. The defining criterion was the artist's ability to give their animal presence. This encompassed technical skill, believability, composition and emotion. Most entries opted for photo-realistic scenes with Robert Corsetti setting a very high standard with his wild animals in their natural settings. The sheer artistry in some of the Wildlife entries were incredible with some pieces featuring hand-painted fur such as Tina Harkin's amazing 'Cat napping'. The Master Award deservedly went to Robert Corsetti for 'BBad boys' created for his client Beman using Painter. The Excellence Awards went to Chet Phillips for 'The Lion and the Mouse' created using Painter, Weiye Yin for 'Helpless' created using Painter, and Robert Corsetti for 'Two bad duga boys' created for his client Beman using Painter.

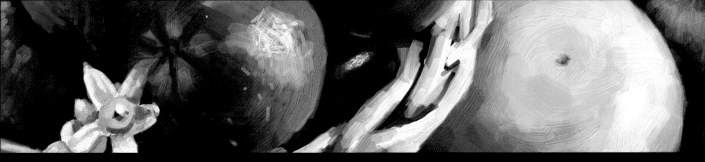

STILL LIFE (page 158)

Oranges, Painter
Maria Khurram, PAKISTAN

The Still Life category honored the best rendition of a still life scene. The category stretched the artist's technical and artistic talents. The artist's ability to select the subject, set design, light, texture and artfully render the scene was paramount in this category. Though there were only a small number of entries that fell into the Still Life category (in all one in eighty-six entries), the majority of these were of flowers. Notably, Maura Dutra's flowers stood out among the crowd with two of her pieces featured. Dennis Orlando was also well represented in the category.

The Master Award went to Maura Dutra for 'White Tulips' created in Painter. The Excellence Awards went to Maura Dutra for 'Flame red Tulip' created using Painter, Dennis Orlando for 'Flowers in light and shadow' created using Painter, and Maria Khurram for 'Oranges' created using Painter.

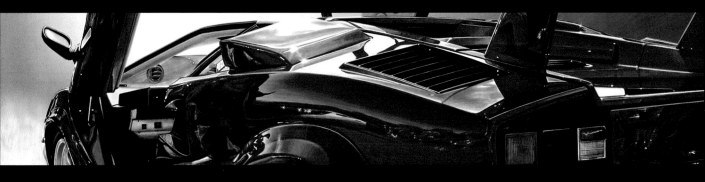

TRANSPORT (page 164)

Countach, Painter
Wu-Huang Chin, USA

The Transport Category recognized the best device for moving about in. The defining quality sought after here was the artist's ability to capture and evoke the desire to travel to a place, or by a mode of transport or to travel in a particular way. The real challenge for this category was for artists to faithfully render mechanical detail in a two-dimensional medium. Only one in forty-three entries fell into the Transport category, however, the level of quality of these entries was very high with Wu-Huang Chin standing out with several amazing renditions of well-known cars including detailed reflections and part details.

The Master Award went to Wu-Huang Chin for 'Race time' created using Painter. The Excellence Awards went to Wu-Huang Chin for 'Dreaming' created using Painter, Erik Holmen for 'ROBRADY Design Rmoto Concept 03' created using Painter, and Emrah Elmasli for 'Vulva fields' created using Painter and Photoshop.

ABSTRACT & SURREAL (page 176)

Thought Process, Painter
Chet Phillips, USA

The Abstract & Surreal category honored the highest achievement in bringing a surreal character or abstract scene into being. The defining criterion was the artist's ability to create a dreamlike or nightmarish scene which invoked an emotional response ranging from wonder to disturbing. This encompassed technical skill, composition and, perhaps more than any other category, emotion. The Master Award for Abstract & Surreal went to Hernán Cañellas for 'Brazo' created using Painter. The Excellence Awards went to Chet Phillips for 'Thought Process' created using Painter, Mike Reed for 'Self Portrait' created using Painter, and Rafal Wojtunik for 'Lamp' created using Painter and Photoshop. Another notable entry for the category was 'Waters of Styx' created by Richard Wazejewski and Claire Waterhouse using Photoshop and Painter. Huge amounts of detail can be found throughout the painting giving it great depth and interest.

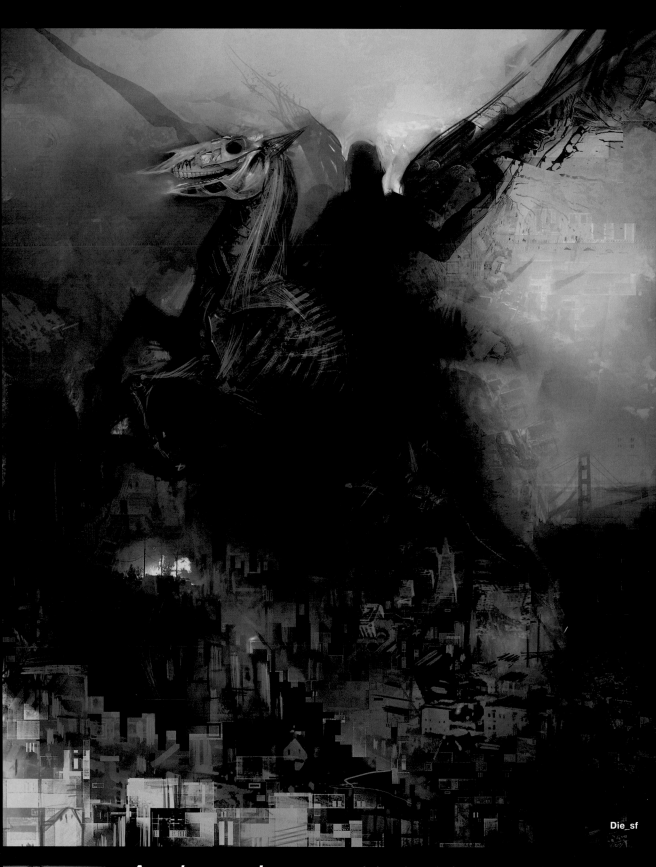

Die_sf

Andrew Jones
Advisory Board

Andrew Jones is Creative Director of www.massiveblack.com. Andrew's vision has guided the visual direction of Nintendo's AAA Metroid franchise, and he has also worked on PC, console and handheld games. Andrew began his career working at Industrial Light and Magic. He has since gained recognition as an industry leader in the digital art field, is one of the founders of www.conceptart.org, and teaches conceptual art workshops around the world.

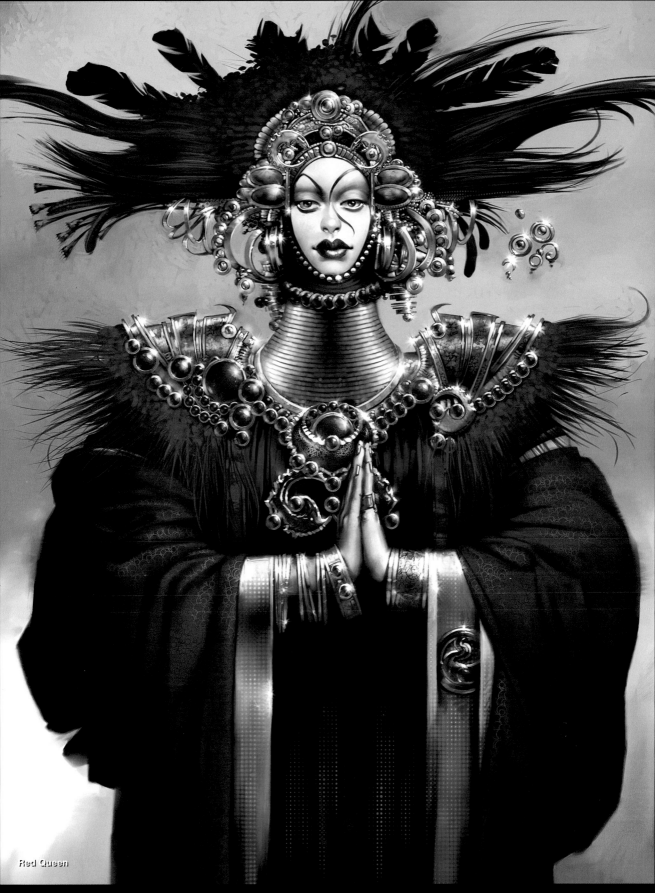

Red Queen

Don Seegmiller teaches in the Department of Visual Design at Brigham Young University. Over the last 20 years, Don has completed more than 700 paintings. For six years, he was the Art Director at Saffire Corporation, a local game developer. Don is a regular speaker at the Game Developers Conference, where he teaches full-day tutorials on character design and digital painting. In 2003, he wrote a book entitled 'Digital Character Design and Painting' for Charles River Media.

Don Seegmiller
Advisory Board

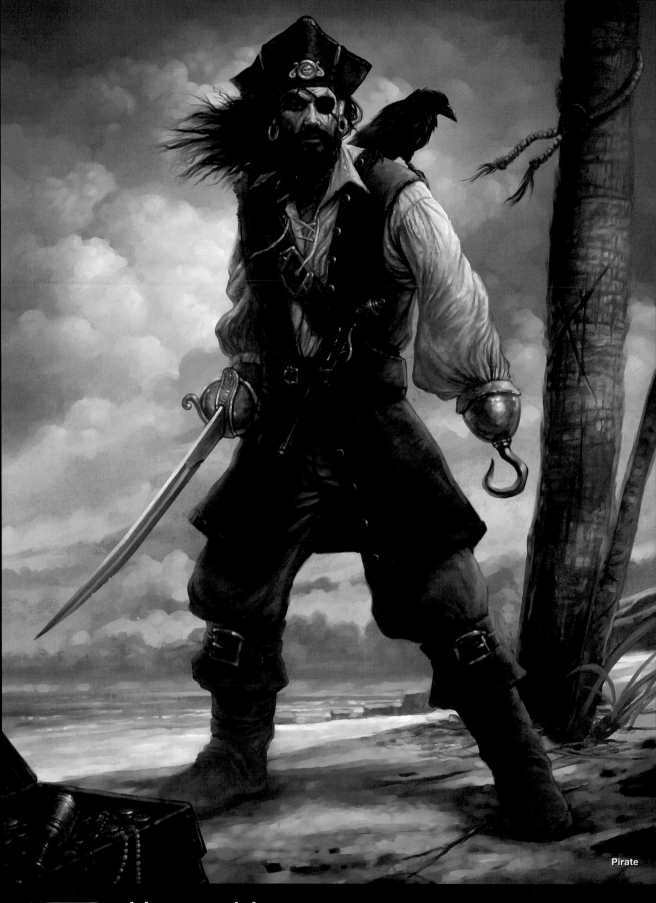

Pirate

Howard Lyon
Advisory Board

Howard Lyon studied Illustration at Brigham Young University. Over the last 10 years he has been working as an Art Director in the video game industry and as a freelance illustrator. Howard served on the advisory board for the Art Institute of Phoenix for three years and his work has been published internationally in various magazines. He has done work for a wide range of high-profile clients, from Nintendo and NCSoft to Wizards of the Coast.

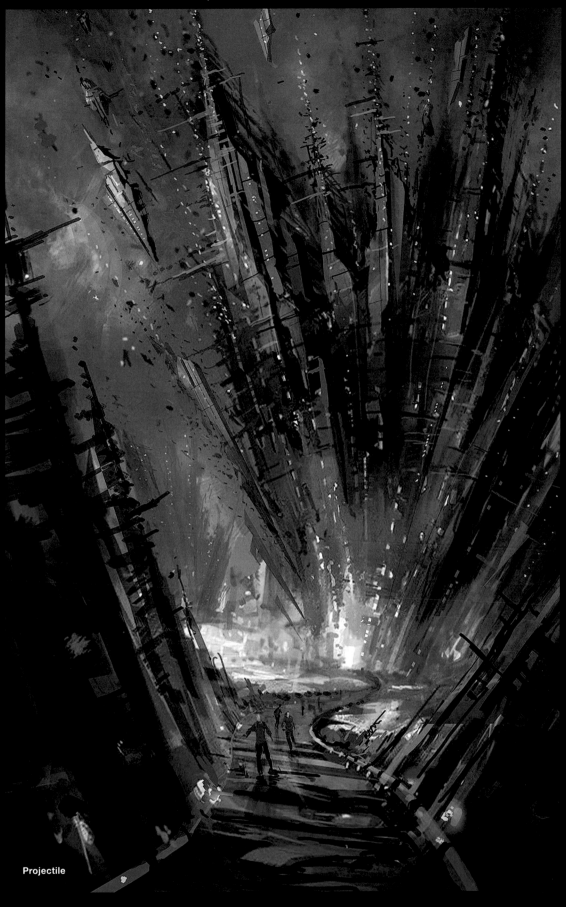

Projectile

Philip Straub is currently employed by Electronic Arts as Concept Art Director, and has been working as an illustrator/concept artist in the entertainment, advertising, and publishing industries for over 10 years. He has created illustrations for over 30 children's books and has been a featured artist in numerous publications. Philip was a co-author for d'artiste Digital Painting and recently completed the first CGWorkshop, Environment Concept Art.

Philip Straub
Advisory Board

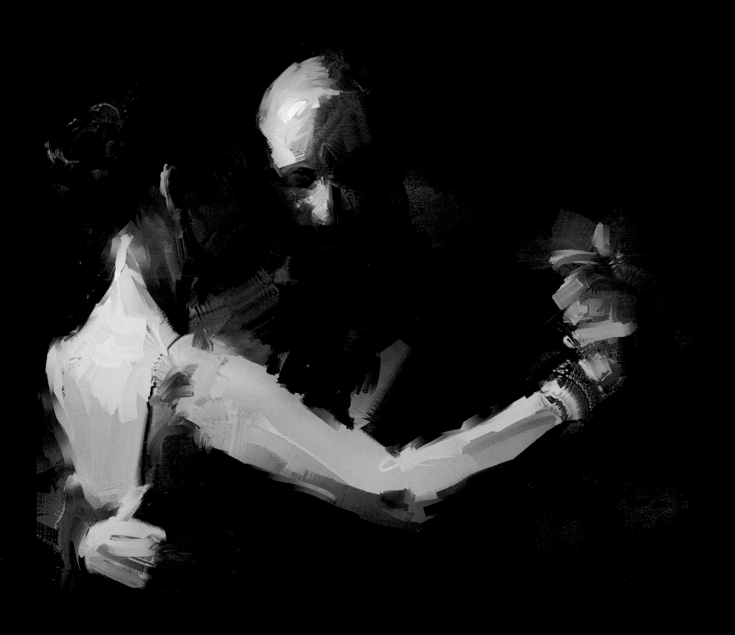

Moment in Time

Jeremy Sutton
Advisory Board

Jeremy Sutton is a San Francisco-based artist, author and educator, and has a Master of Arts degree in Physics from Oxford University. Jeremy has written several books, including 'Painter IX Creativity: Digital Artist's Handbook' and 'Fractal Design Painter Creative Techniques', and he has produced other Painter training material such as video/DVD tutorials, including a new Corel Painter IX tutorial set. Jeremy has also taught Painter and presented seminars worldwide since 1995.

Agaves on the Edge

Cher Threinen-Pendarvis is an award-winning artist, author and educator based in San Diego, California. Cher holds a B.F.A. with Highest Honors and Distinction in Art, specializing in painting and print making. She has lead Painter and Photoshop workshops around the world since 1992 and is the author of all seven editions of 'The Painter Wow! Book'. Her most recent books are 'The Photoshop and Painter Artist Tablet Book: Creative Techniques in Digital Painting' and 'The Corel Painter IX Wow! Book'.

Cher Threinen-Pendarvis

Advisory Board

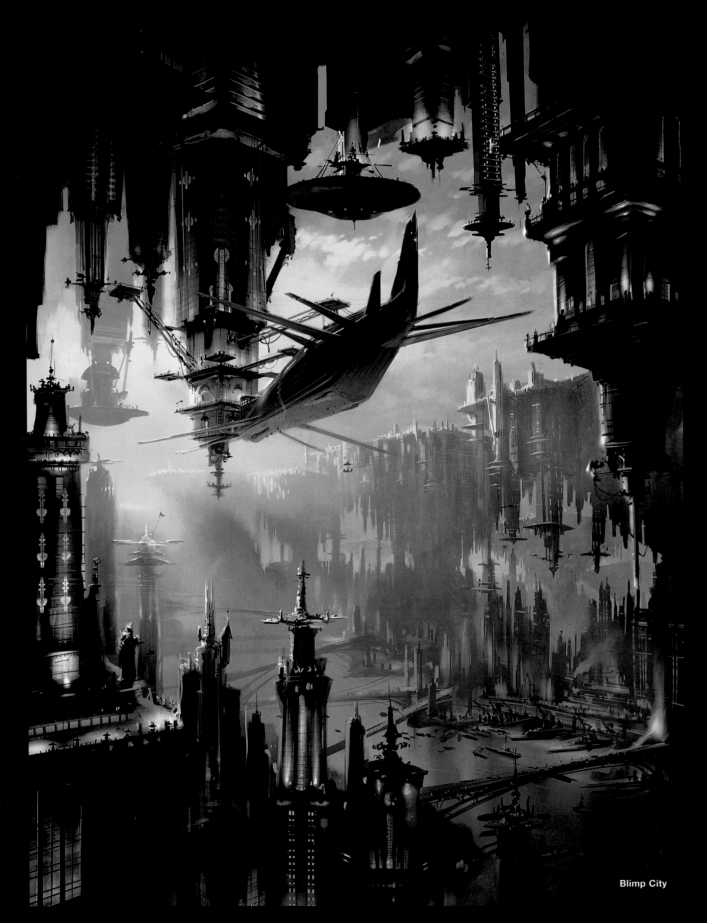

Blimp City

Ryan Church
Advisory Board

Ryan Church is one of the leading concept artists working today. He has taught Entertainment Design at Art Center College of Design in Pasadena, California, and worked with clients like Walt Disney Imagineering, Universal Studios, Industrial Light and Magic, and Lucasfilm. Ryan was a Concept Design Supervisor for Star Wars: Episode III and is a Senior Art Director at ILM.

COREL

Sean Young | Product Manager, Corel Painter

We are so proud to be part of the inaugural edition PAINTER, featuring a compilation of breathtaking art created by Corel Painter artists from around the world.

This book is a tribute to the talent, skill, and creativity exhibited by Corel Painter artists. We are amazed by their ability to capture their imaginations using this powerful digital medium.

At Corel, we challenge ourselves to create software that enables our customers to achieve their very best. This drive has ensured that Corel Painter is the software of choice for professional artists and photographers who are recognized as leaders in their field. We are extremely proud that Corel Painter IX sets the standard against which all other digital painting applications are compared.

On behalf of the entire Corel team, I would like to thank the passionate and talented Corel Painter artists who inspire us every day to keep pushing the limits of what's possible in the world of digital painting. We'll never stop dreaming of new ways to make Corel Painter the ultimate realistic digital painting experience.

I hope you enjoy the pages of this beautiful book as much as we have.

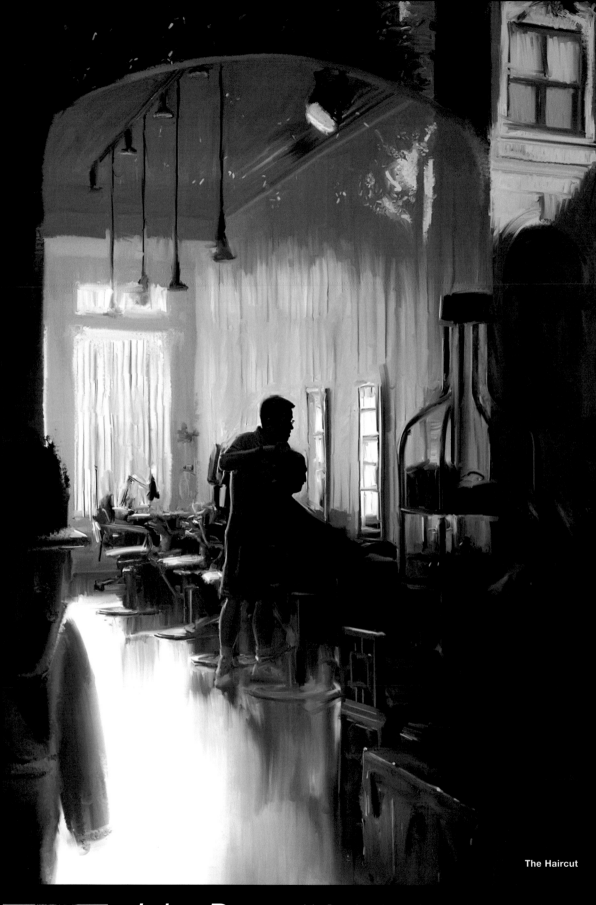

The Haircut

John Derry

Advisory Board

John Derry is a pioneer of digital painting and one of the original authors of Corel Painter. Since 1985, he has leveraged his background in drawing and painting to advance the look and experience of traditional art-making tools on the computer. John's illustration and design work have appeared in publications including Communication Arts, Print Magazine, Mac Art & Design, Computer Artist and The Painter WOW! Book series.

FOREWORD

John Derry | Original Painter Author

Today we take sophisticated applications like Corel Painter IX for granted, but it's been a short 17 years since this essential tool made its debut. Before there were layers, realistic oil painting brushes, and pressure-sensitive tablets, the landscape of hand-mediated digital art tools was pretty sparse. The mouse—which is like drawing with a bar of soap—was the primary input device in use. A 256 color palette—all available at once!—was considered leading edge. 256K of memory was an expensive luxury. The 40MHz Apple Macintosh IIfx was considered "wicked fast". Let's face it: this was the Digital Stone Age.

When Fractal Design Painter made its public debut on August 6, 1991 in the Wacom booth at Boston Macworld, many of the attendees couldn't believe their eyes. With Wacom pen in hand, Mark Zimmer was creating pencil sketches, crayon drawings, and oil paintings...all on a computer! I was across the aisle in the Truevision booth demonstrating Time Arts Oasis, another paint application with natural-media tendencies. Oasis had already been making a splash for a few months, but when I saw Mark showing off Painter, I immediately knew that Oasis was doomed.

Within a year, I had joined Mark and Tom Hedges to develop Painter. From the beginning, Painter was based on the primary directives of translating the artist's gesture for the purpose of personal creative expression. Coupled with a pressure-sensitive pen and tablet, Painter utilizes this device's data stream to faithfully reproduce the artist's expressive intent. This enables one to easily transfer existing art skills to the digital world of ones-and-zeros. Previously, many digital paint-and-draw tools imposed a signature upon artwork created by them. You could tell what application created a piece by the look of the work. Painter doesn't have a signature; rather, it enables the artist's style to remain intact.

When Corel acquired Painter, it quickly became clear that the product had found the home it needed. With the release of Corel Painter IX, the product has truly come of age—setting a standard for professional painting software that no other application can meet.

With the production of illustrative art now primarily digital in nature, Corel Painter IX has become the tool of choice for many professional artists. The response to Ballistic Publishing's Call for Entries for this publication was overwhelming in its breadth of style and polish. The emphasis is not on Corel Painter—rather, the focus is on the creative expression of the artists.

I am truly humbled by the masterpieces Corel Painter has played a part in creating. When Mark, Tom, and I worked on Painter back in that Digital Stone Age 17 years ago, we never in our wildest dreams imagined that the software would become so intertwined with such inspiring works of art. To the artists, I salute you.

Viva Corel Painter!

Master
Character in Repose

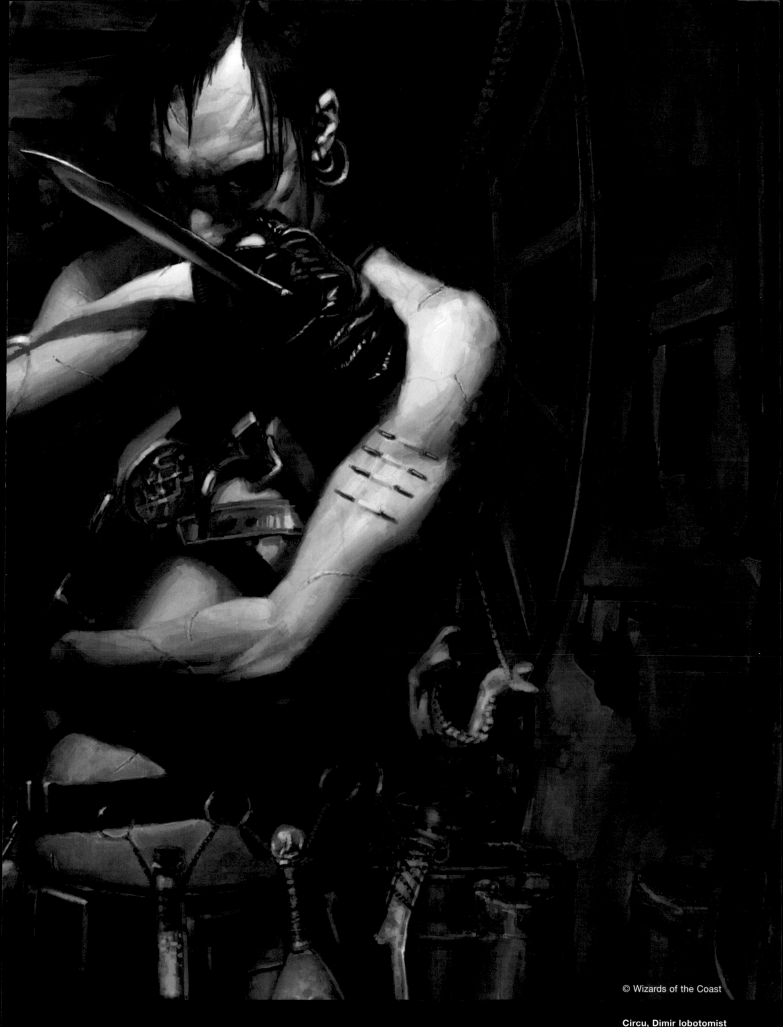

Circu, Dimir lobotomist

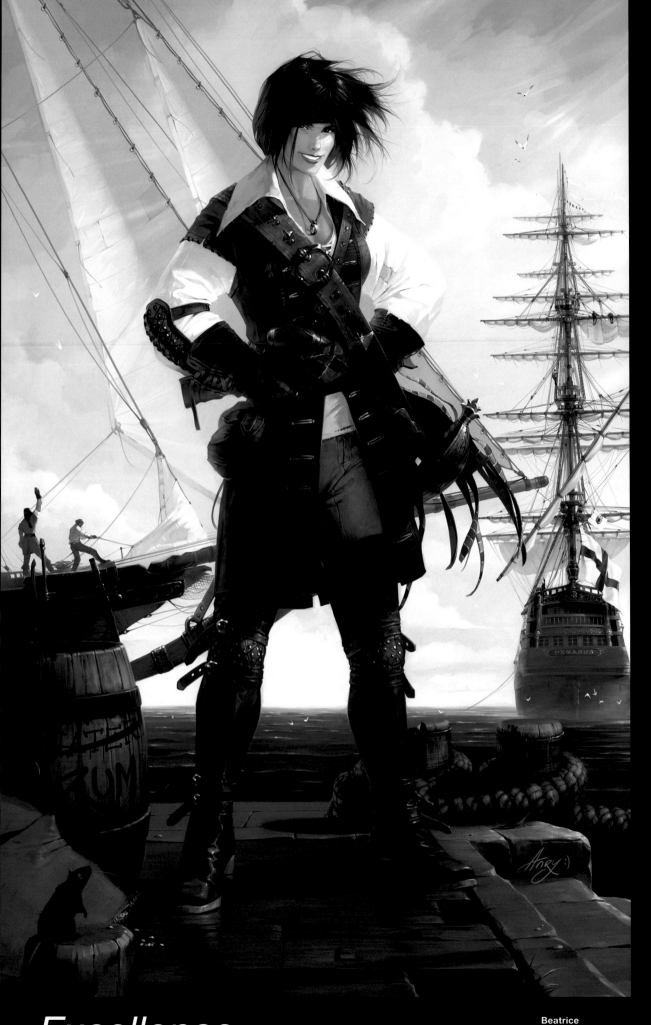

Excellence

Beatrice
Painter
Anry Nemo, RUSSIA

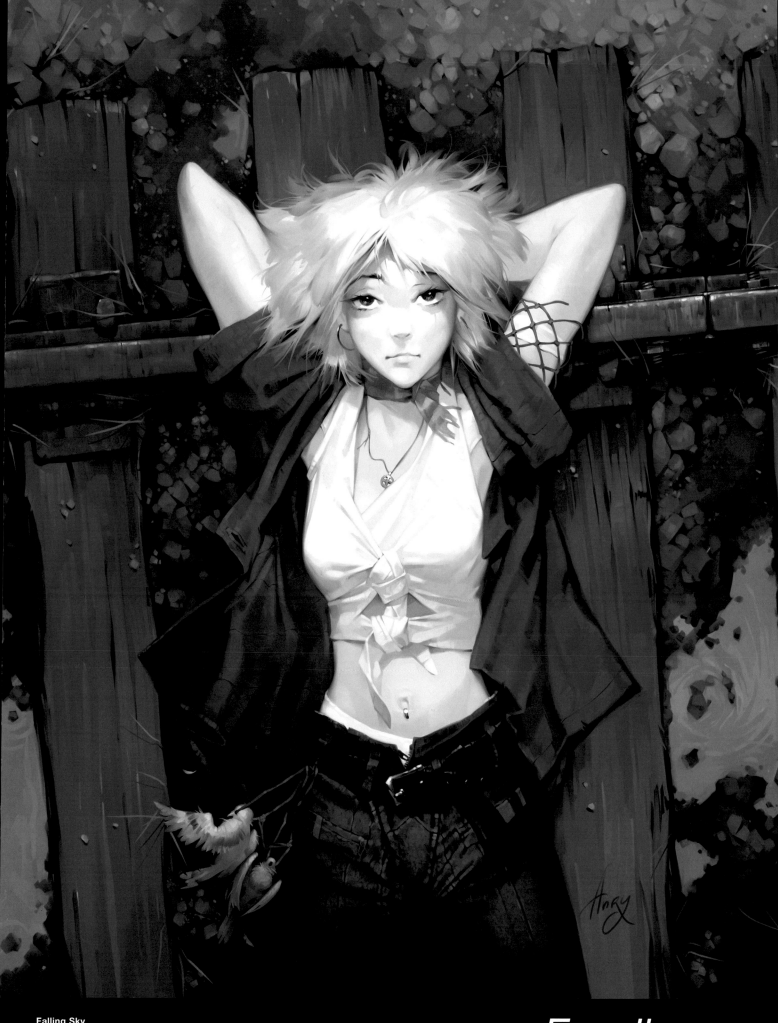

Excellence
Character in Repose

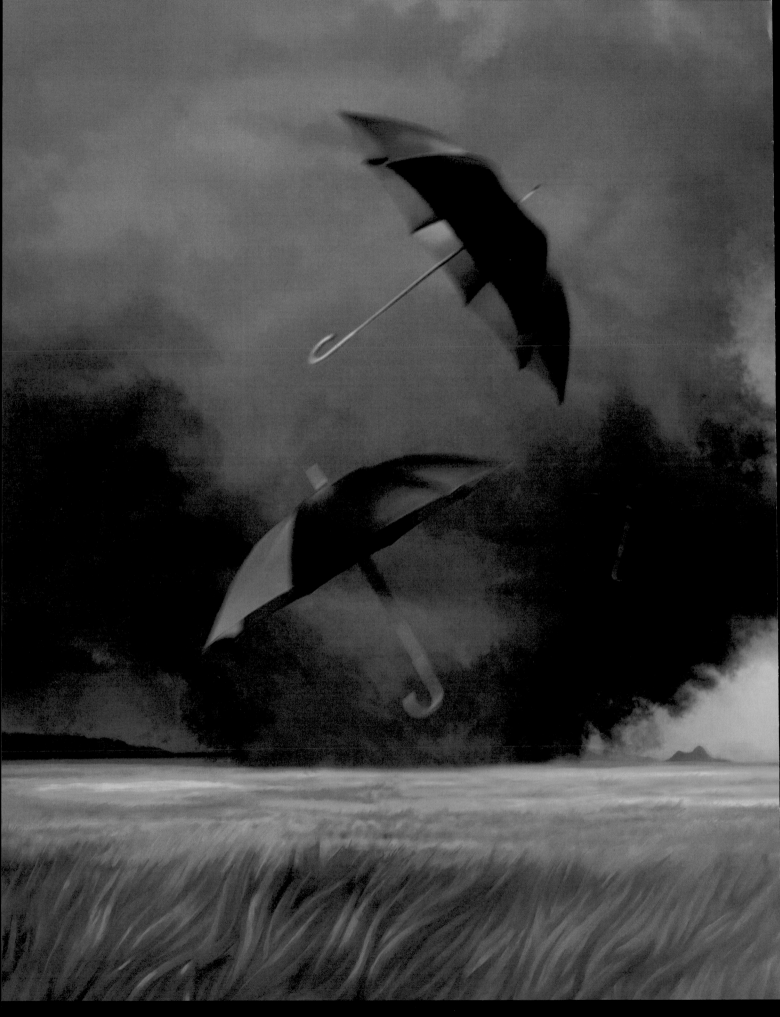

Excellence
Character in Repose

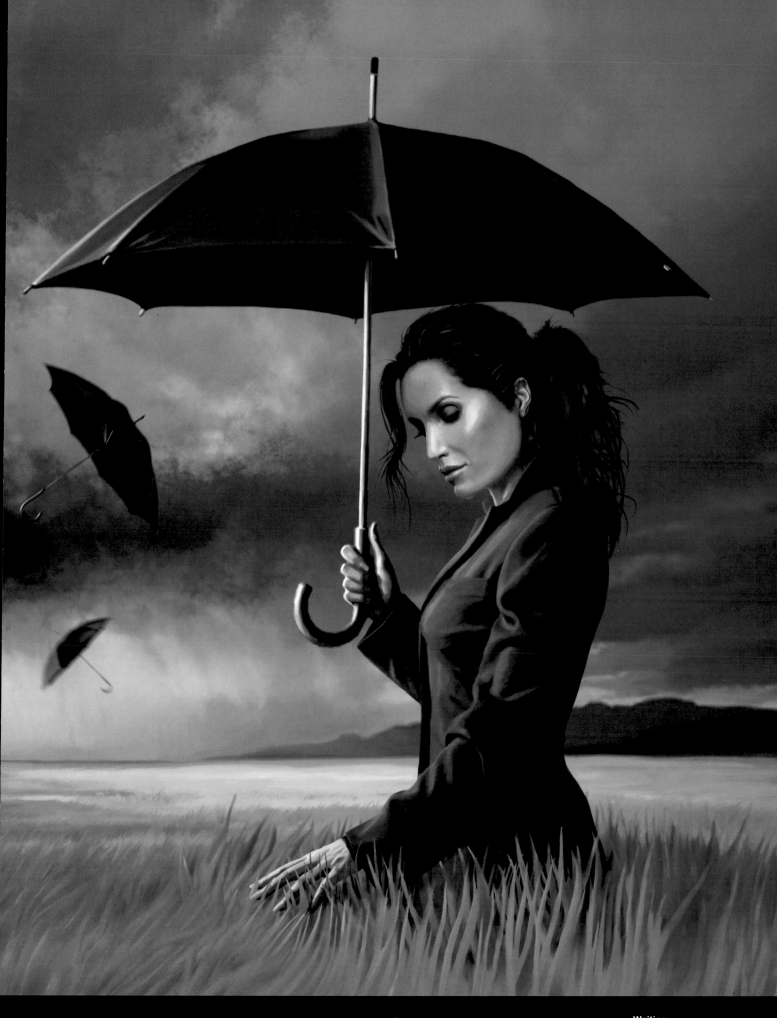

Waiting
Painter, Photoshop

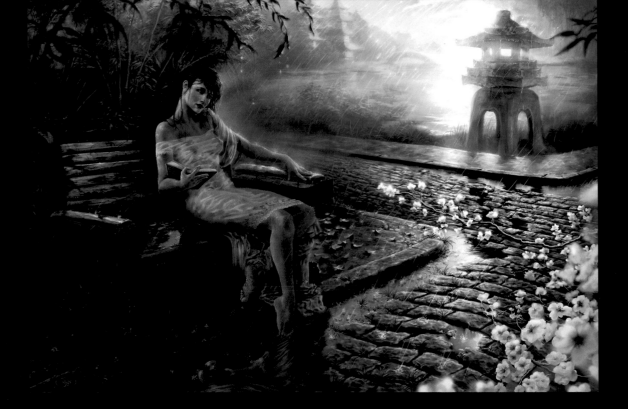

Love
Painter, Photoshop
Orly Wanders, BRAZIL
[top]

Ihor
Painter, Photoshop
Katarina Sokolova, UKRAINE
[above]

Caged cat coughing cashews
Painter, Bryce
Mark Bannerman, GREAT BRITAIN
[right]

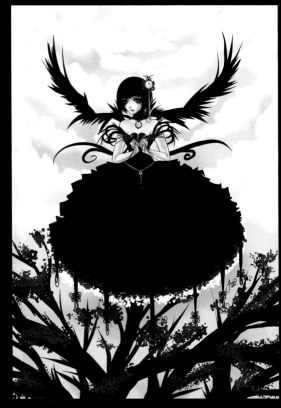

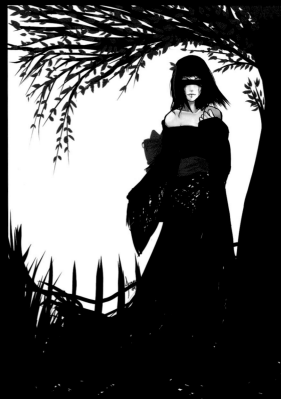

Clotha
Painter, Photoshop
Paul Pham, USA
[top]

Black flower
Painter
Jennifer Duong, CANADA
[above]

Black.White.Red
Painter
Jennifer Duong, CANADA
[above]

Min the patriarch
Painter, Photoshop
Pierre Droal, FRANCE
[right]

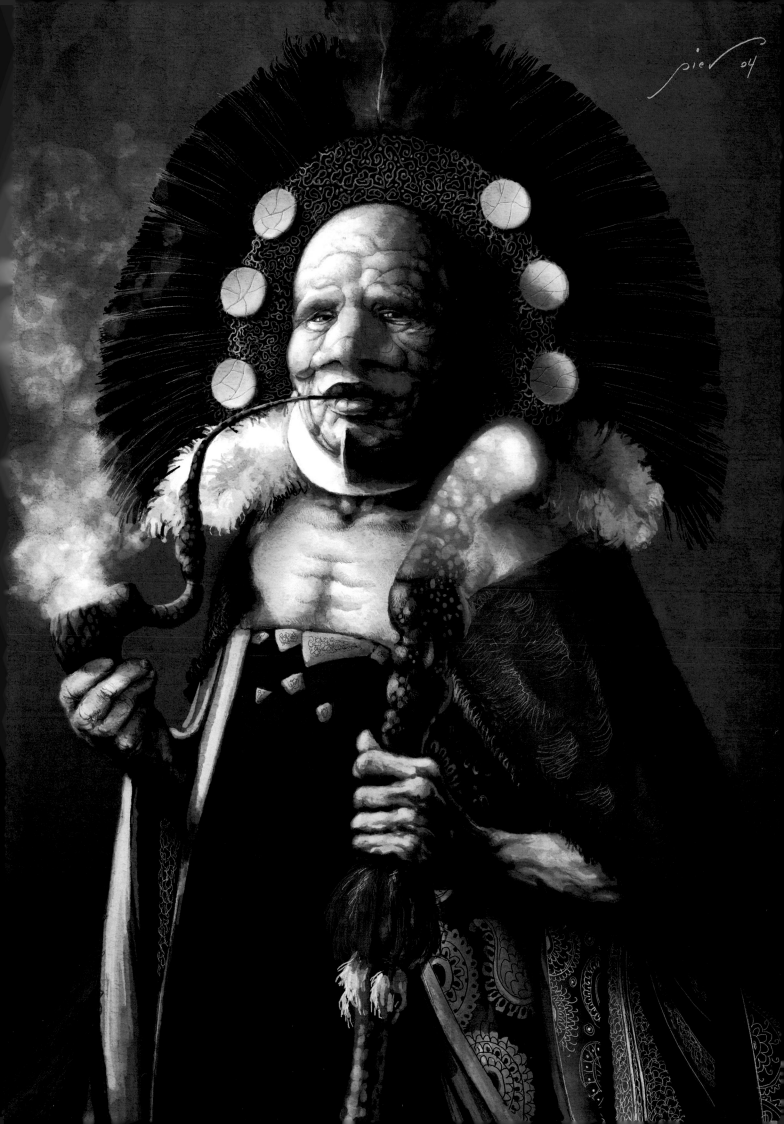

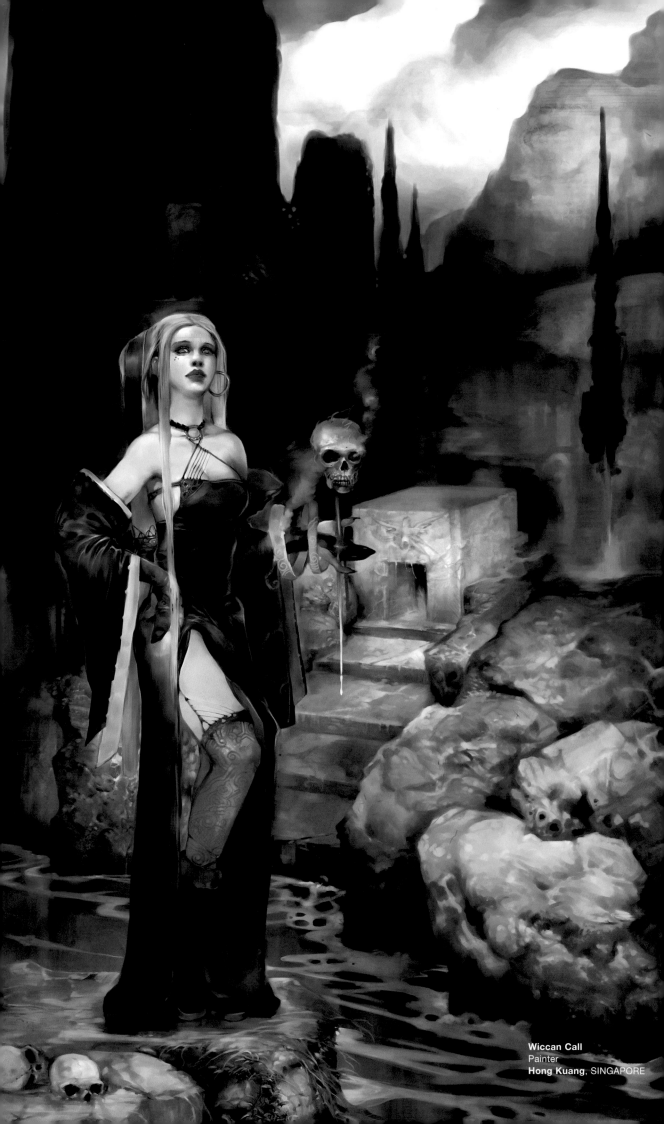

Wiccan Call
Painter
Hong Kuang, SINGAPORE

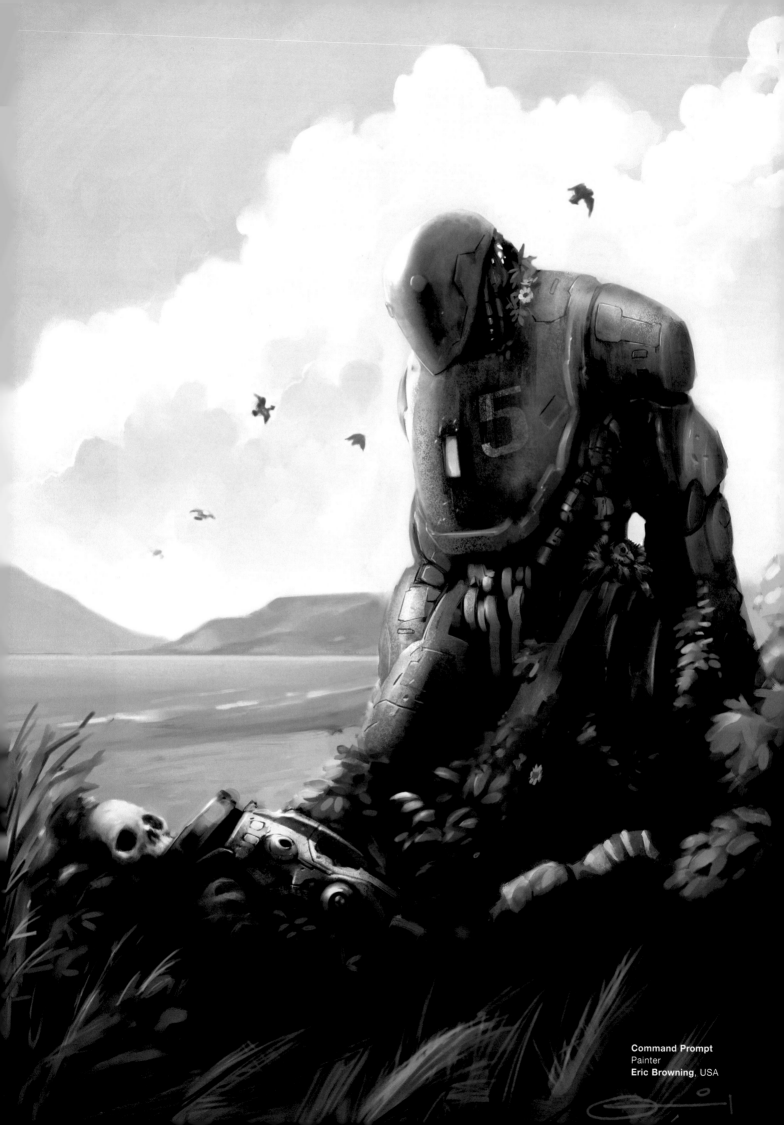

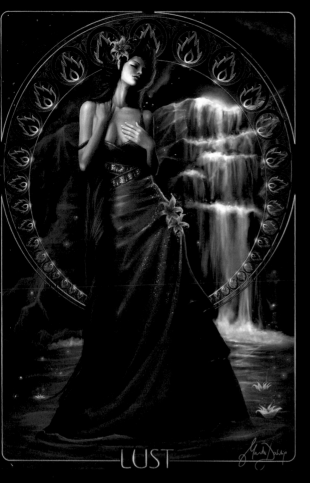

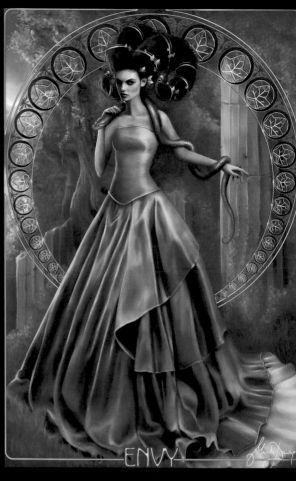

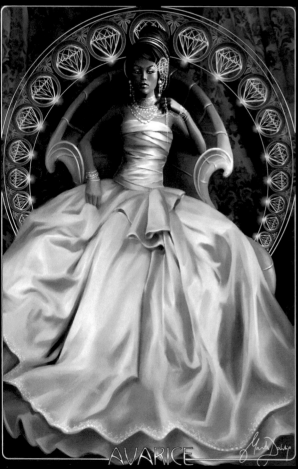

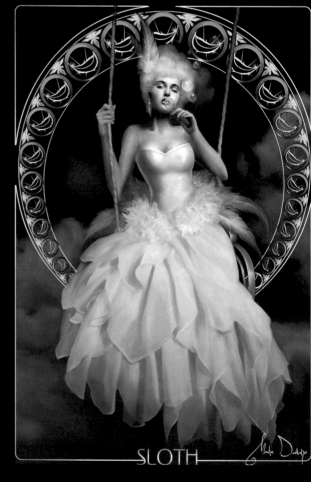

The seven deadly sins: Lust
Painter
Marta Dahlig, POLAND
[top]

The seven deadly sins: Avarice
Painter
Marta Dahlig, POLAND
[above]

The seven deadly sins: Envy
Painter
Marta Dahlig, POLAND
[top]

The seven deadly sins: Sloth
Painter
Marta Dahlig, POLAND
[above]

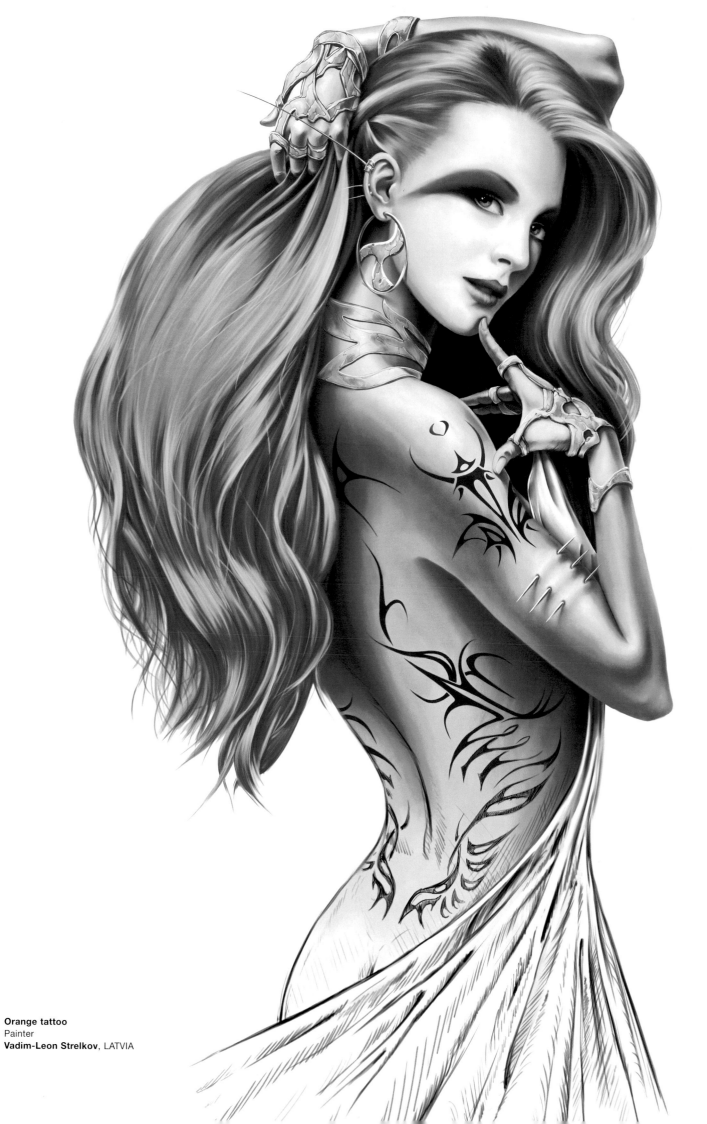

Orange tattoo
Painter
Vadim-Leon Strelkov, LATVIA

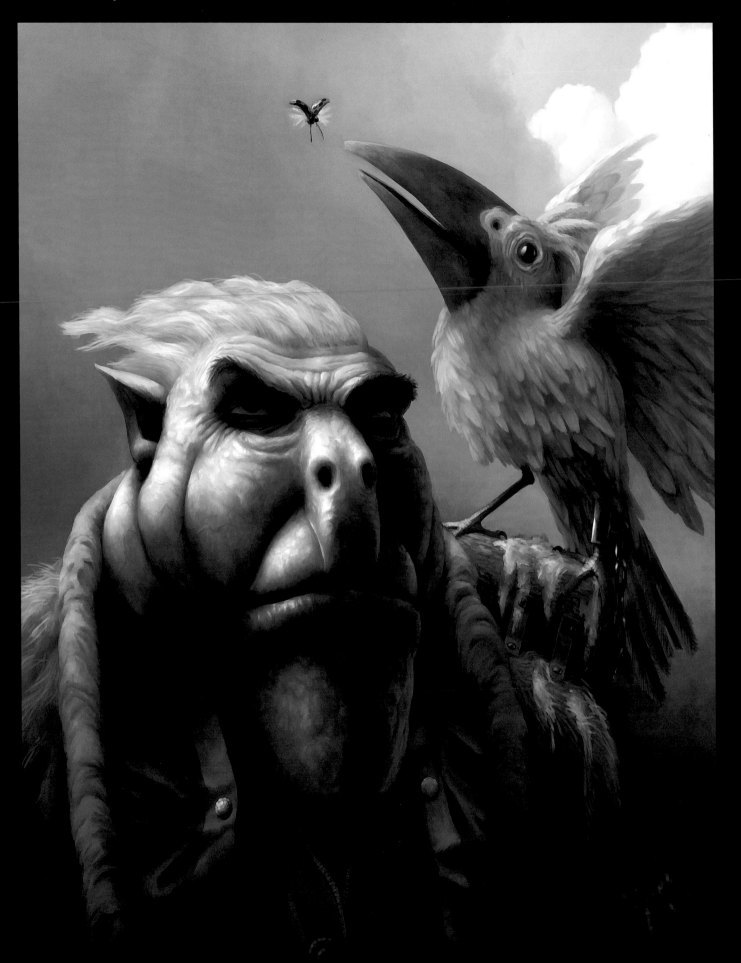

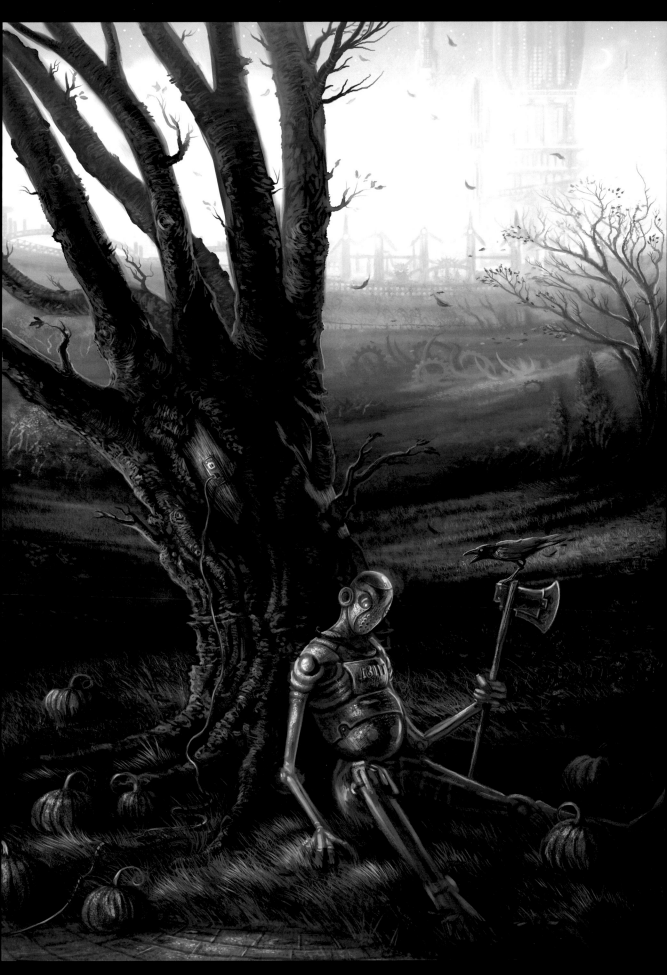

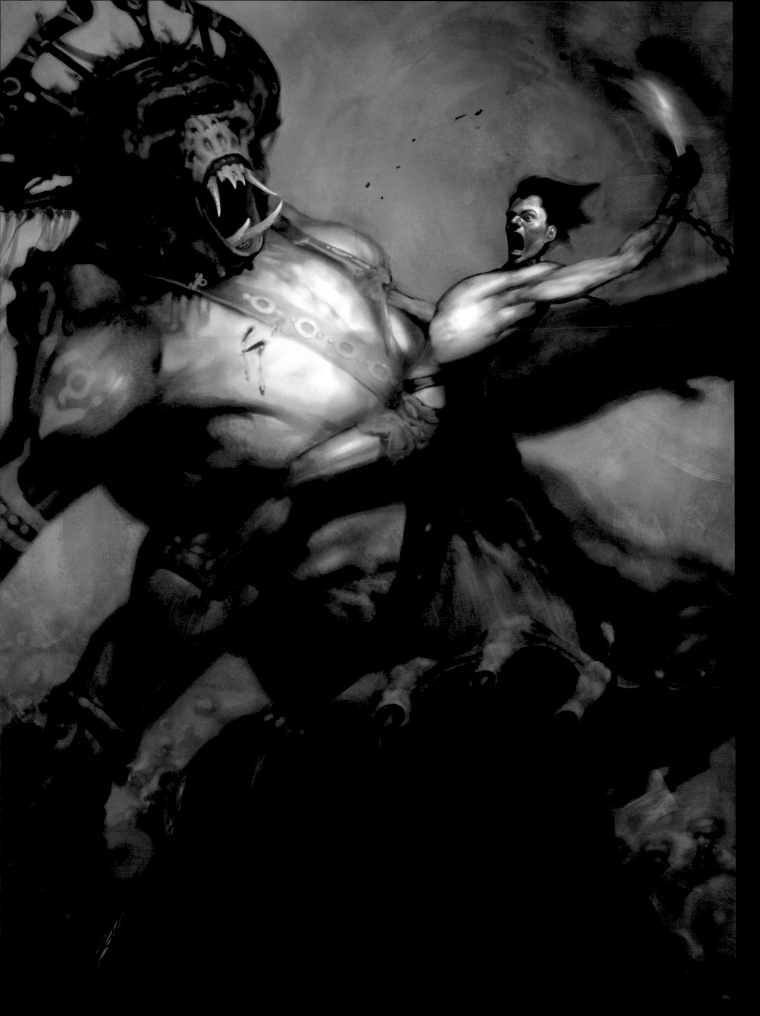

Master
Character in Action

Rage upon him
Painter, Photoshop
Christian Alzmann, USA

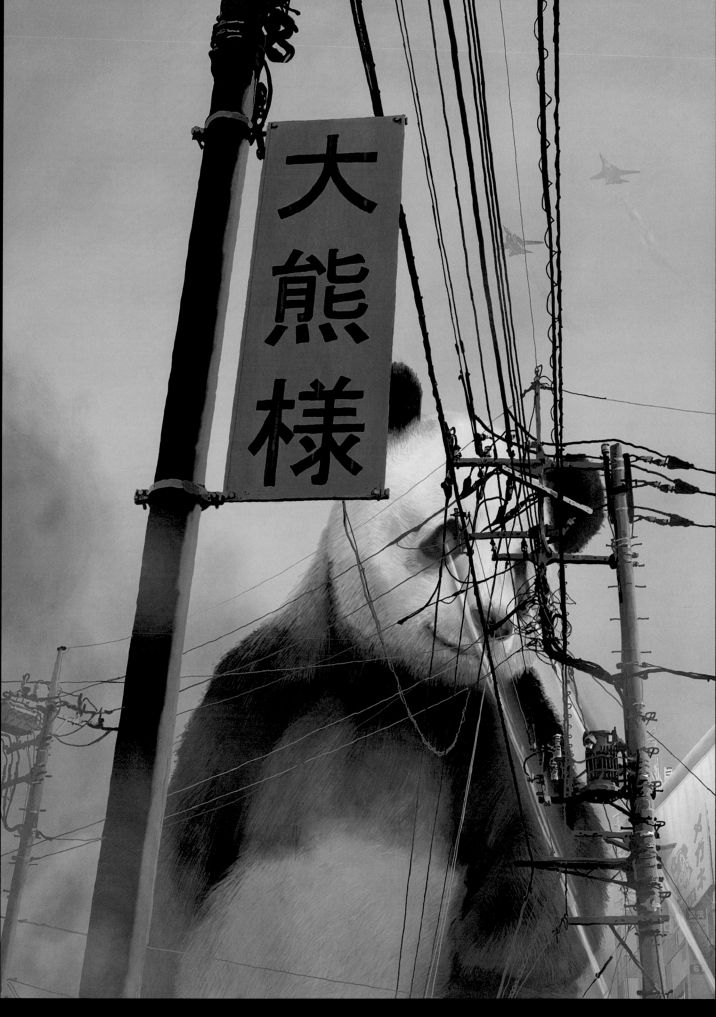

大熊様

News flash: Giant Panda destroys Tokyo
Painter
Simon Bull, JAPAN

Excellence

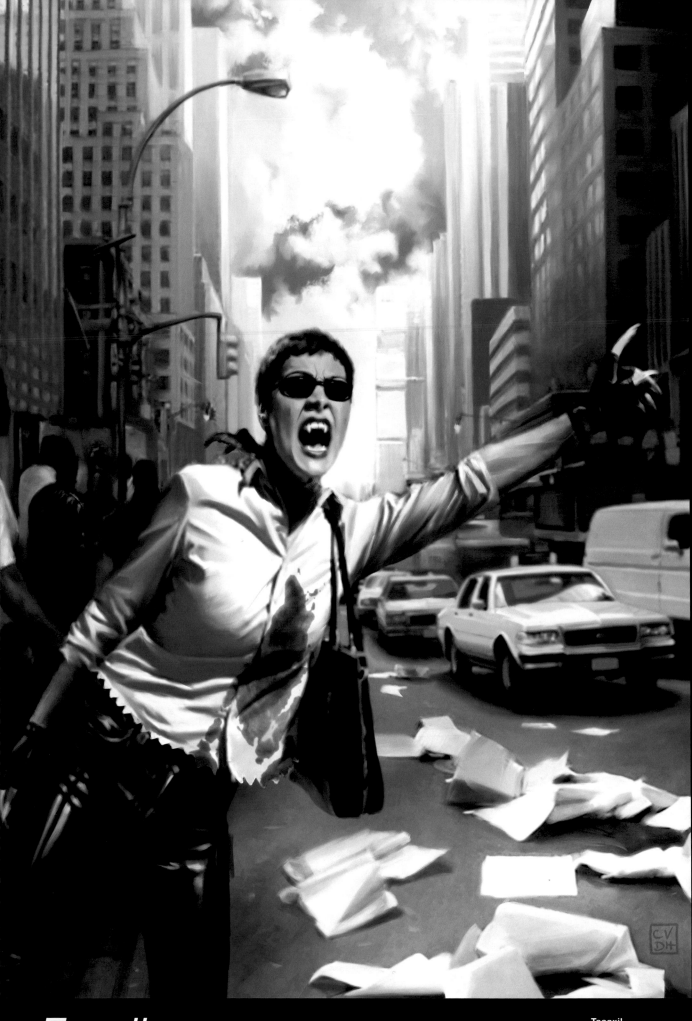

Excellence
Character in Action

Taaaxi!
Painter
Cyril Van Der Haegen,
USA

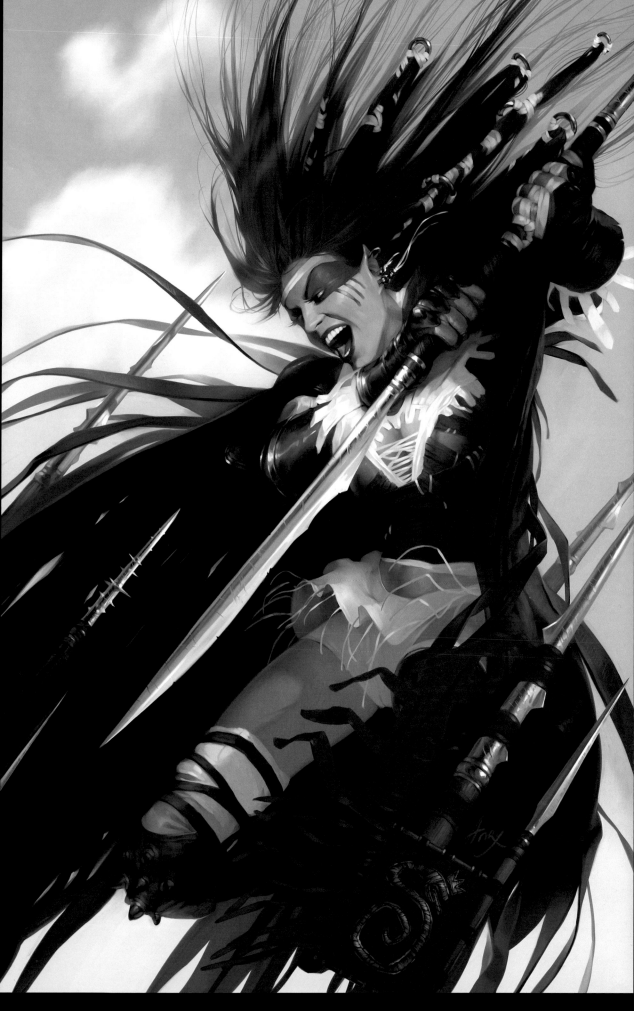

Knight Shift
Painter
Anry Nemo, RUSSIA

Excellence

Book of words
Painter, Photoshop
Client: Calmann Levy
Aleksi Briclot, FRANCE
[top]

Oliphant
Painter
Client: Triking
Matthew S. Armstrong, USA
[above]

Wish
Painter, Photoshop
Jason Chan,
USA
[right]

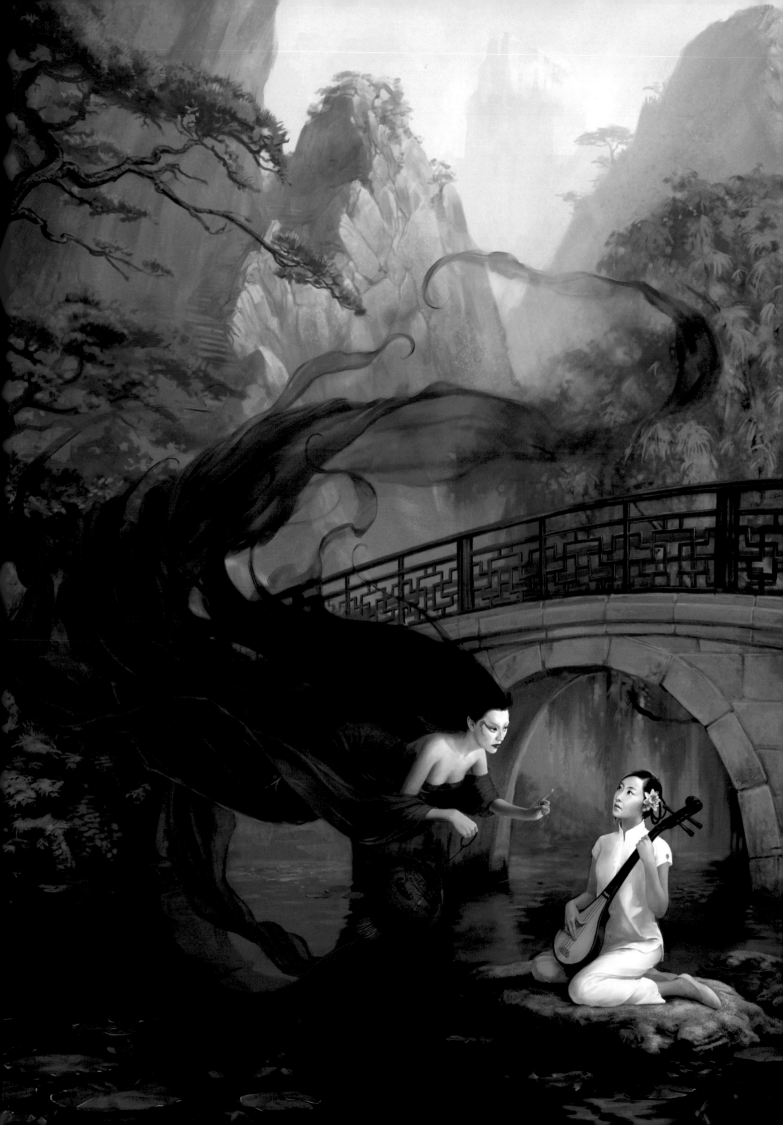

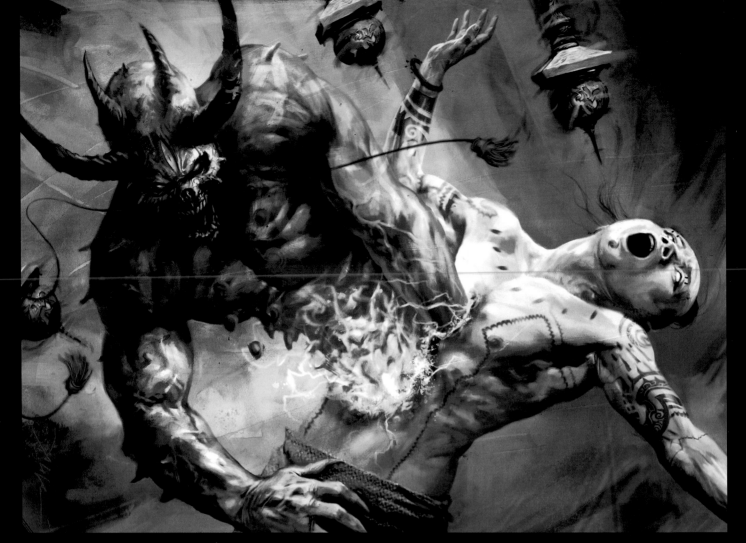

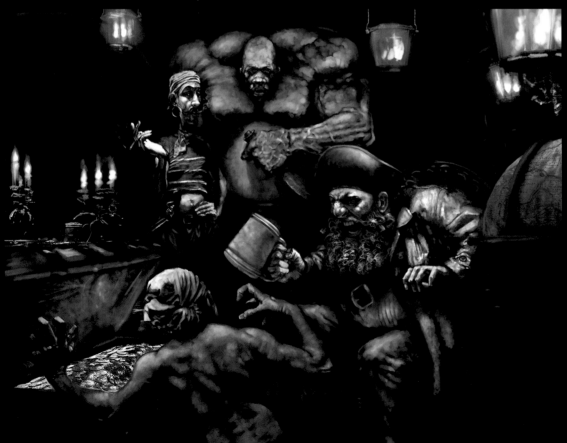

Oni possession
Painter, Photoshop
Aleksi Briclot, FRANCE
[above]

Pirate party
Painter
Michael Pavlovich, USA
[left]

Medieval crow
Painter, Photoshop, Artrage
Aleksi Briclot, FRANCE
[right]

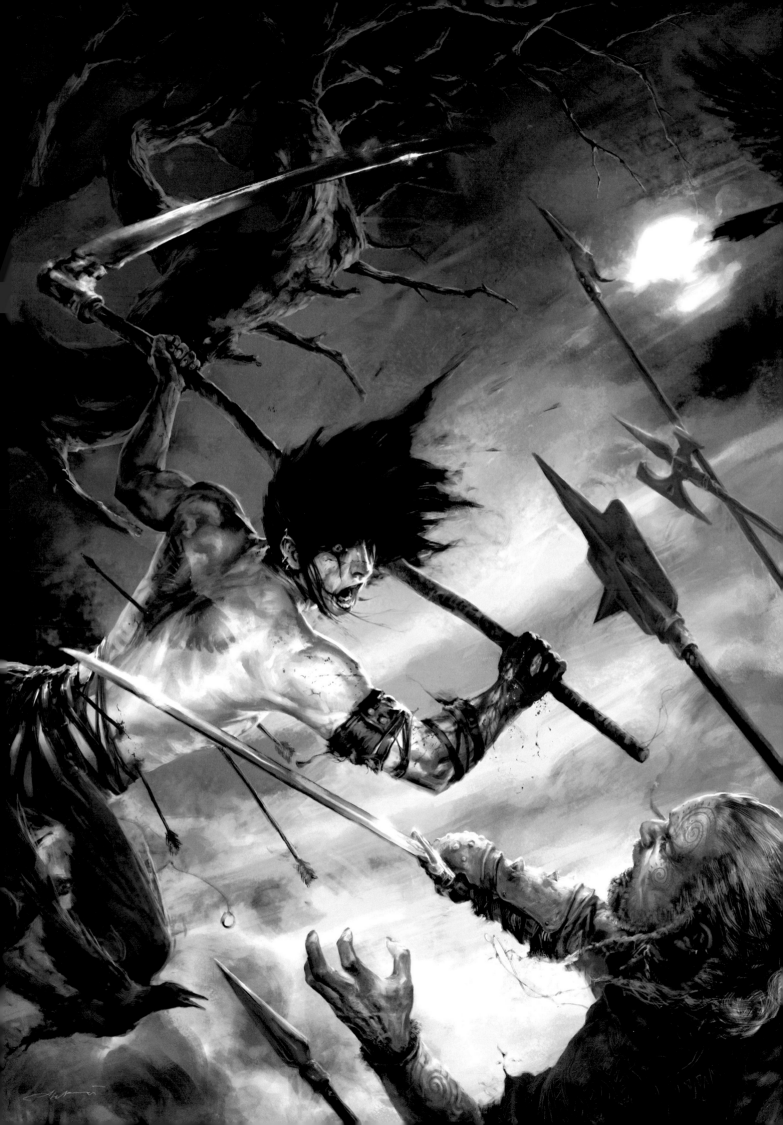

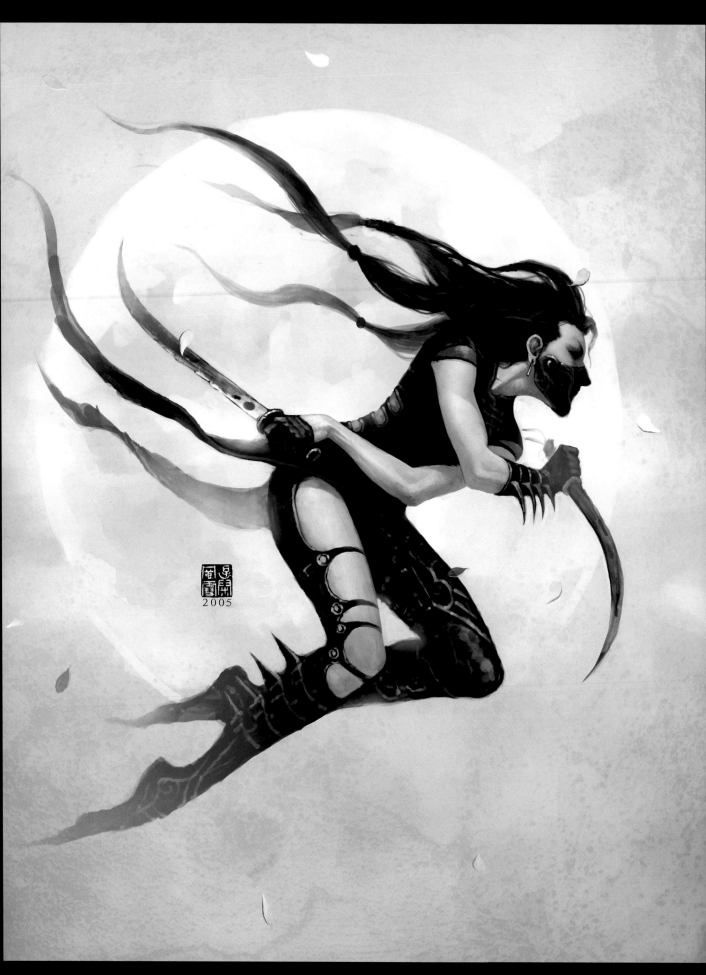

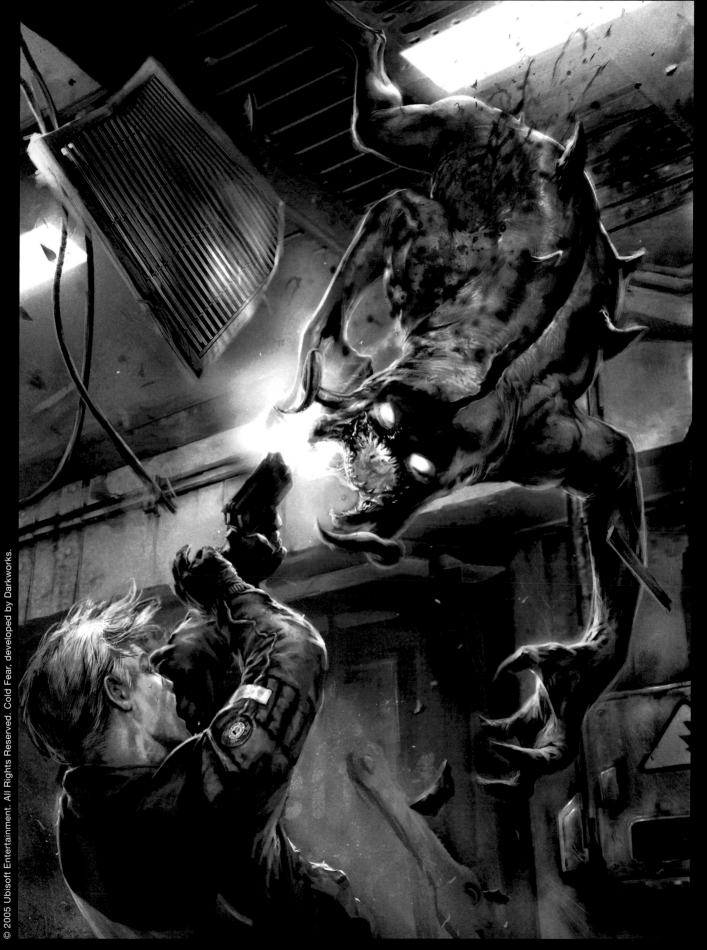

Exoshade's attack
Painter, Photoshop
Client: Darkworks for Ubisoft Entertainment
Aleksi Briclot, FRANCE

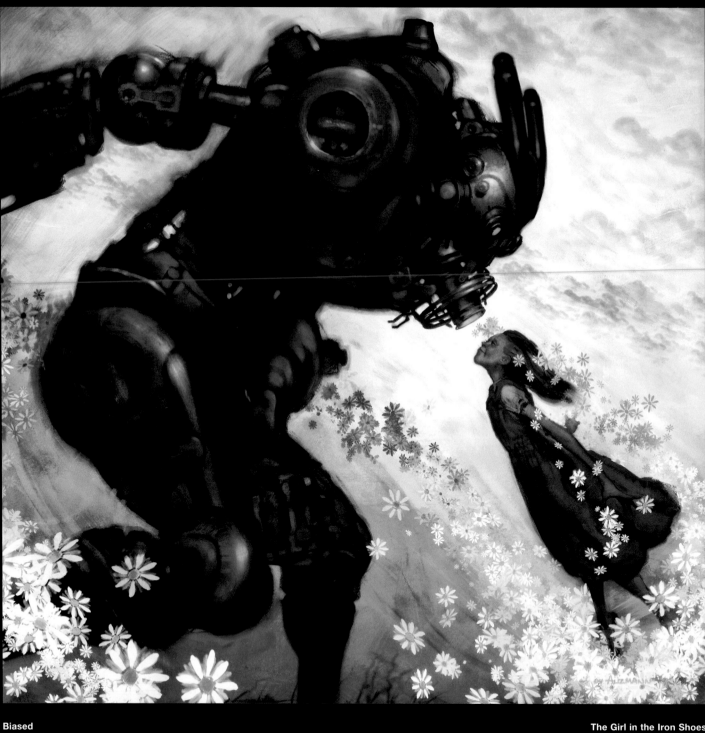

Biased
Painter, Photoshop
Christian Alzmann, USA
[above]

The Girl in the Iron Shoes
Painter
Chris Beatrice, USA
[right]

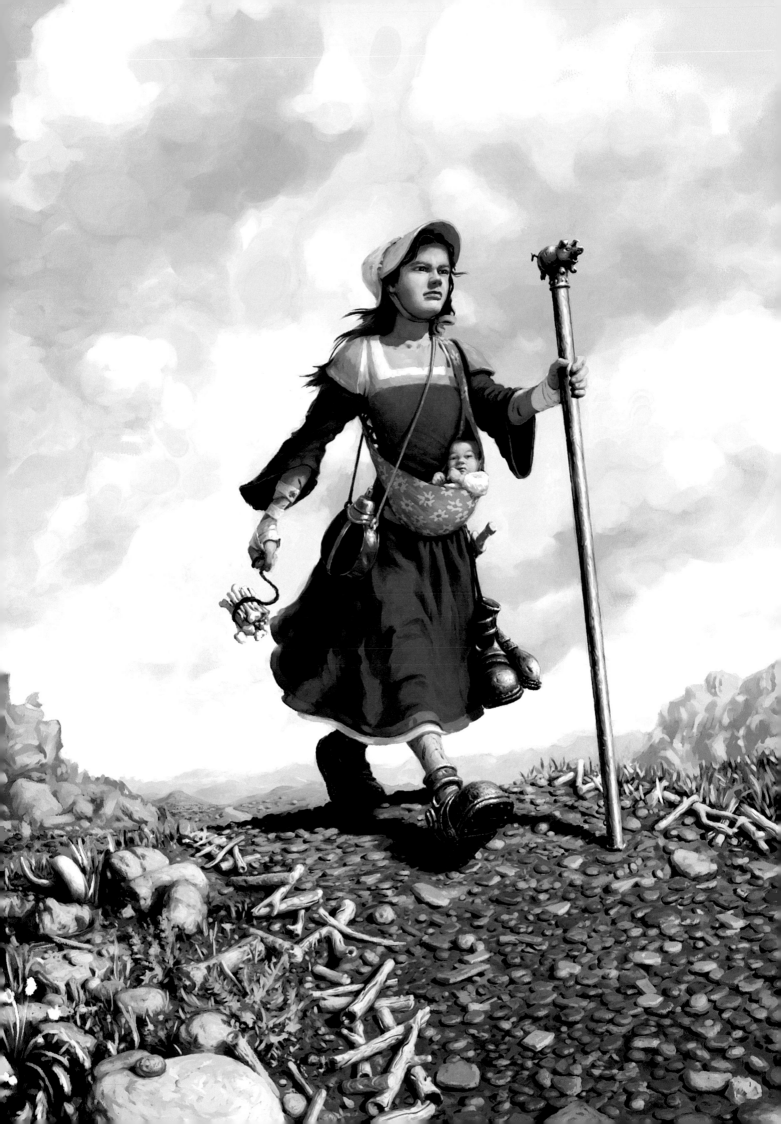

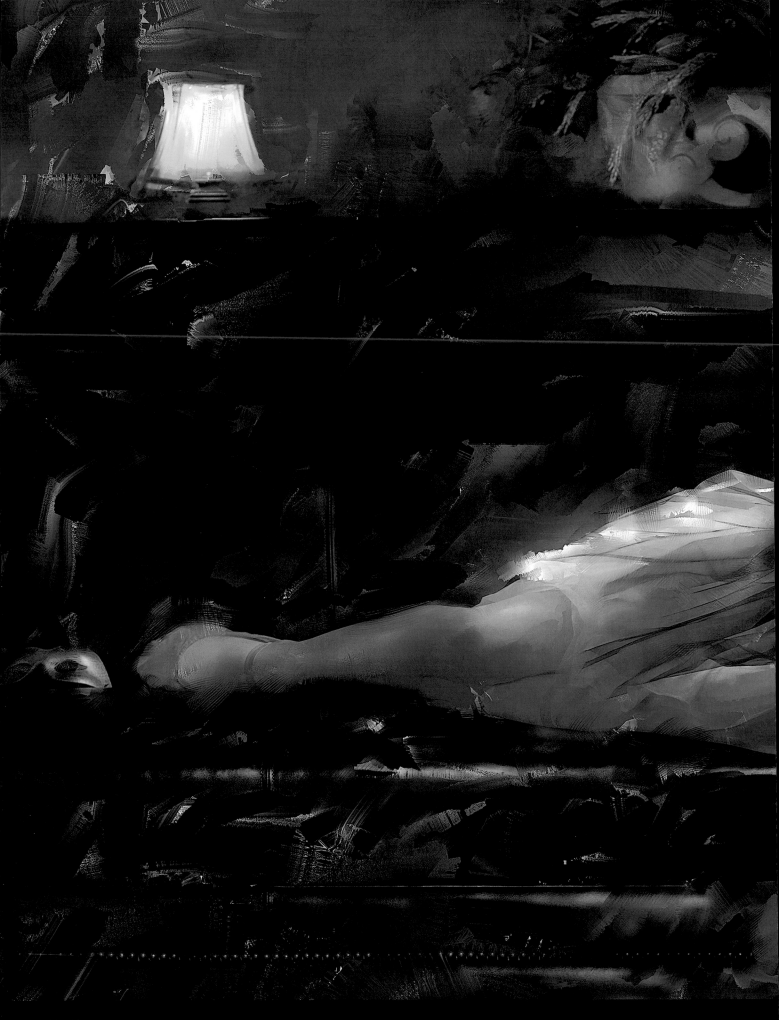

Master
Portraits

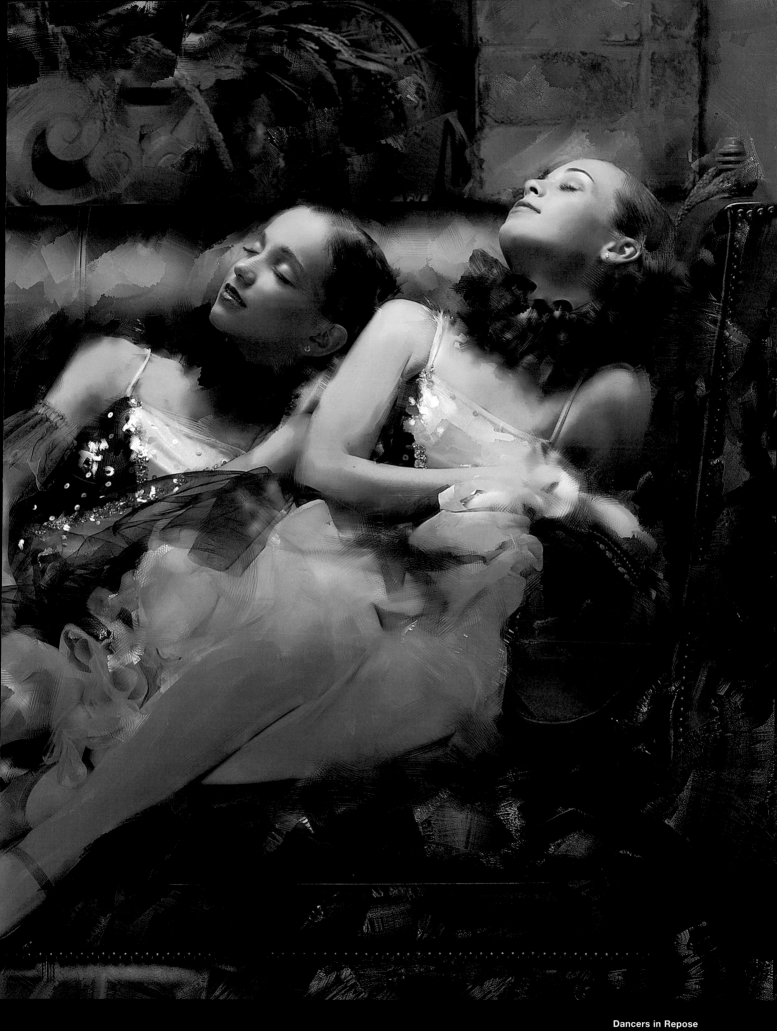

Dancers in Repose
Painter
Bruce Hamilton Dorn, USA

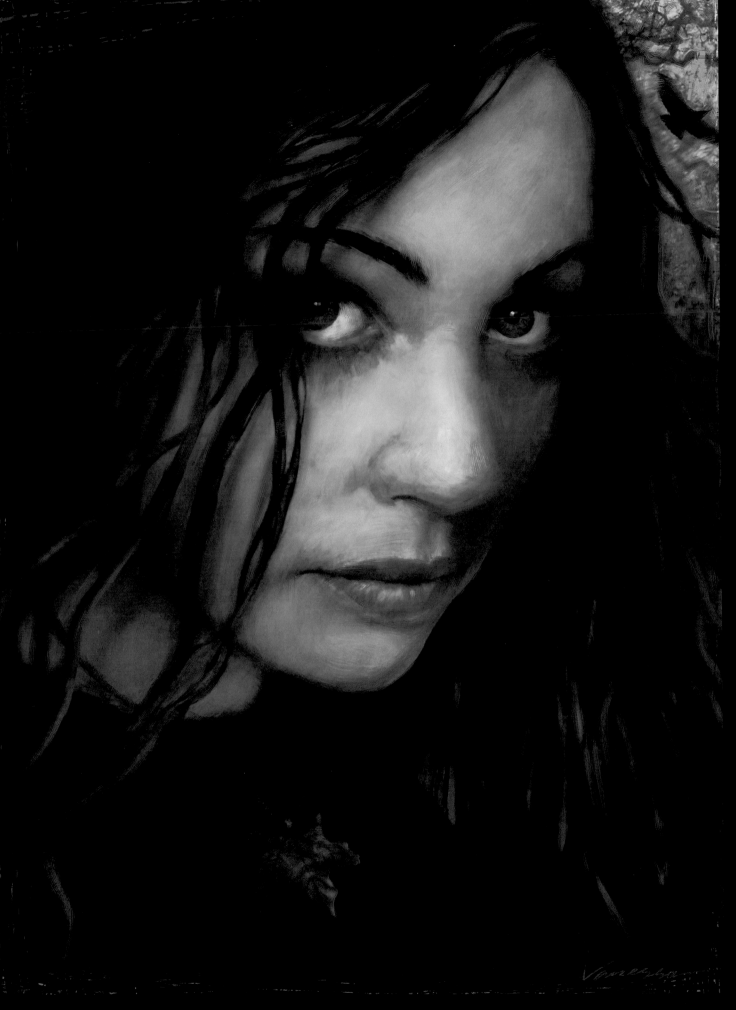

Excellence

Portraits

Autumn
Painter, Photoshop
Vanessa Lemen, USA

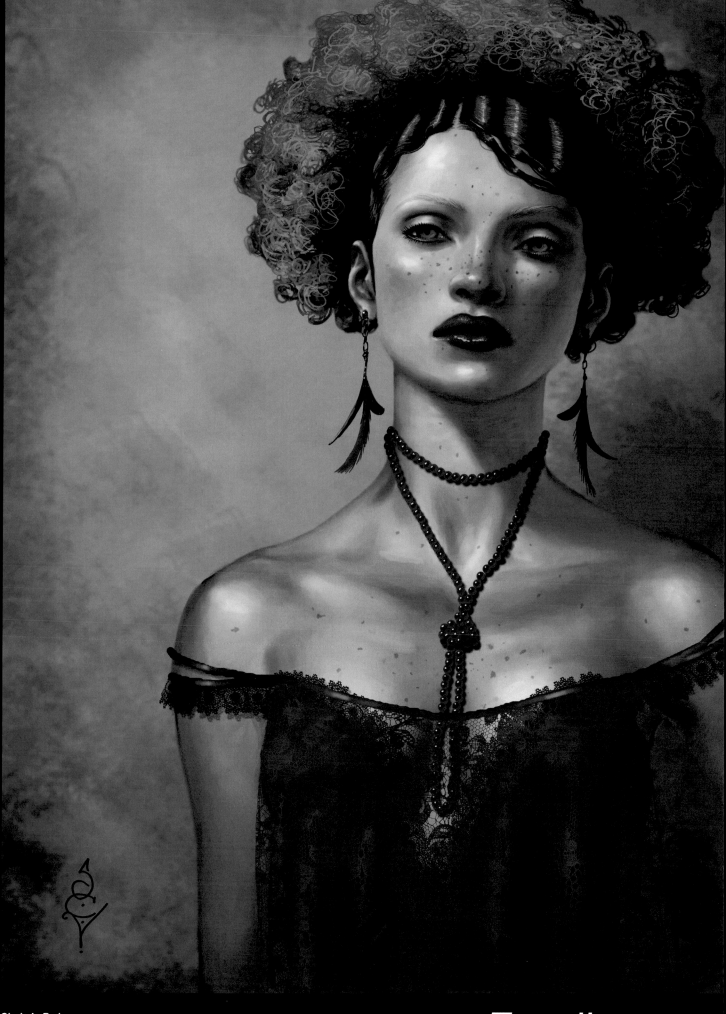

Gloria In Red
Painter
Sequoia C. Versillee, USA

Excellence

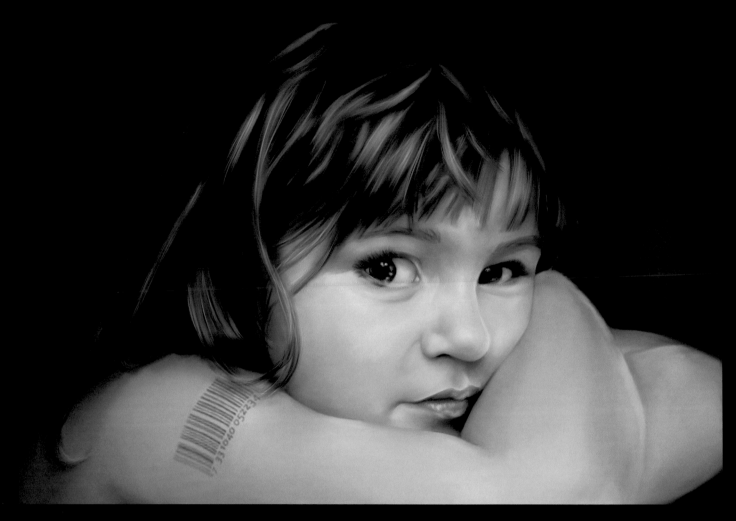

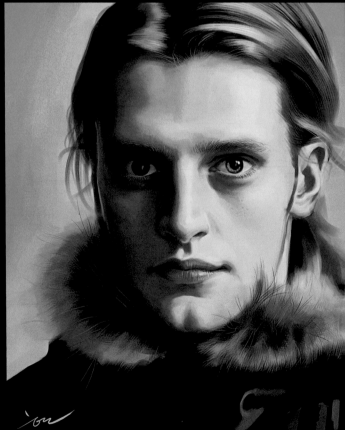

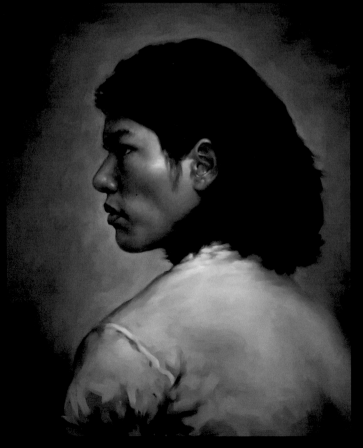

Tina
Painter, Photoshop
René Blom, SWEDEN
[top]

Study of an Unknown Model
Painter
Ji Hyun Kim, KOREA
[above]

Sp of Nov 16
Painter
Jason Asato, USA
[above]

Self Portrait
Painter
Roger Barcilon, USA

Excellence

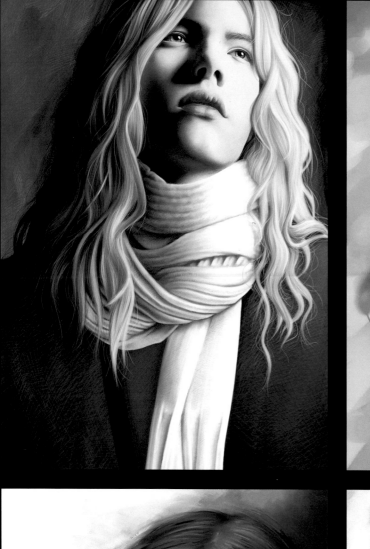

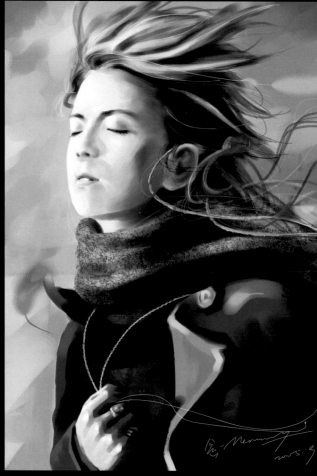

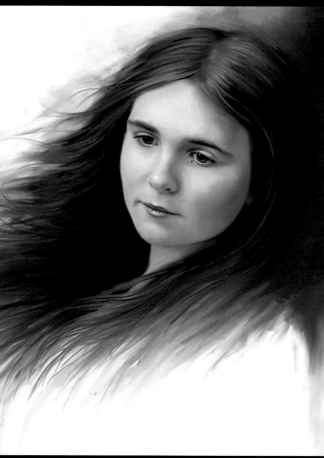

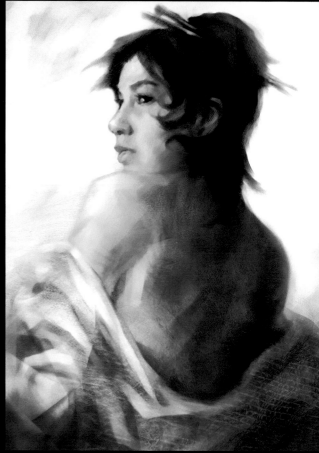

The Bishuonen **Not a girl, not yet a woman** **The Cape of Storms** **Butterfly**

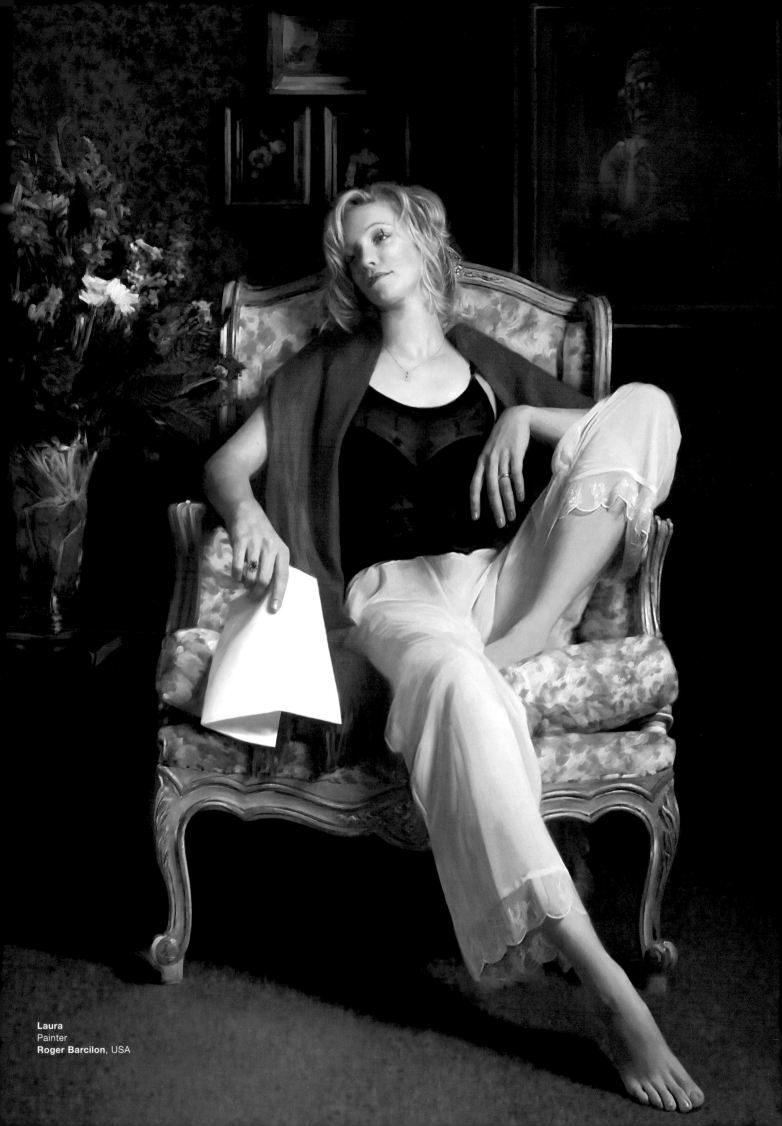

Laura
Painter
Roger Barcilon, USA

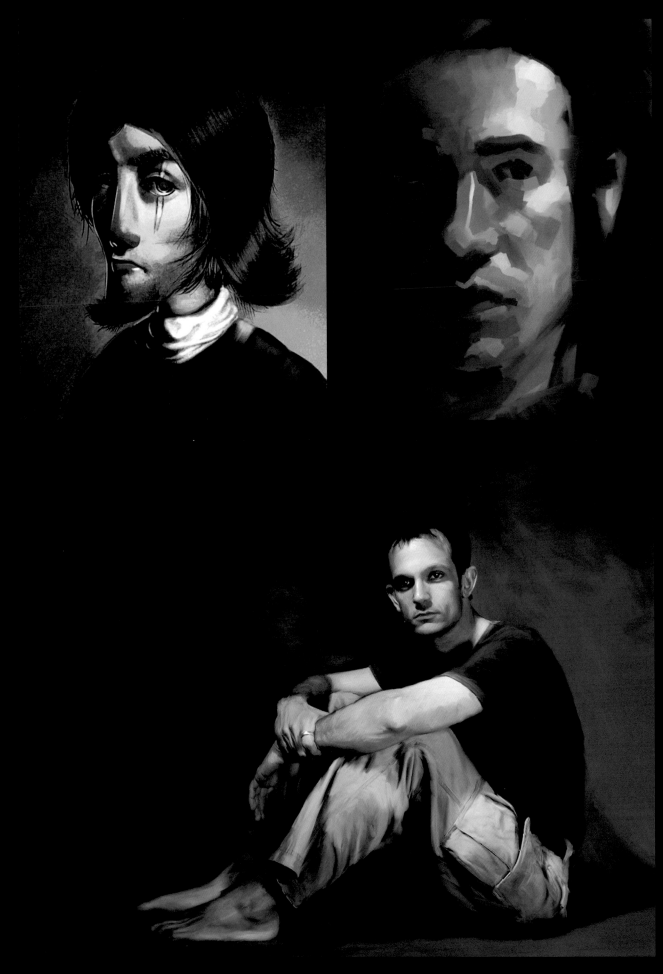

Rembrandt's pirate
Painter, Photoshop

Painted Artist
Painter, Photoshop

Self portrait
Painter

Self portrait
Painter
Christian Guldager, DENMARK

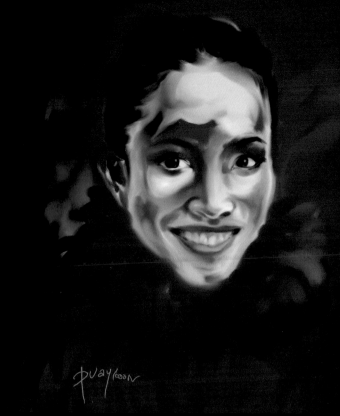

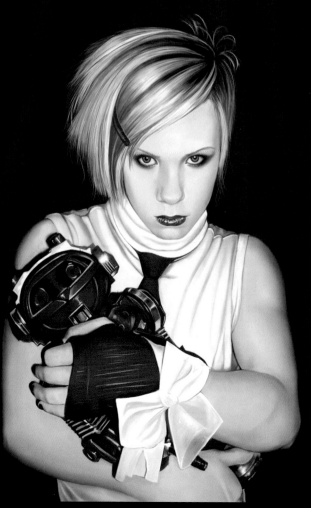

Goth girl
Painter, Photoshop

A Boy and his Droid
Painter, Photoshop

Fann
Painter, Photoshop

Butterflies queen
Painter

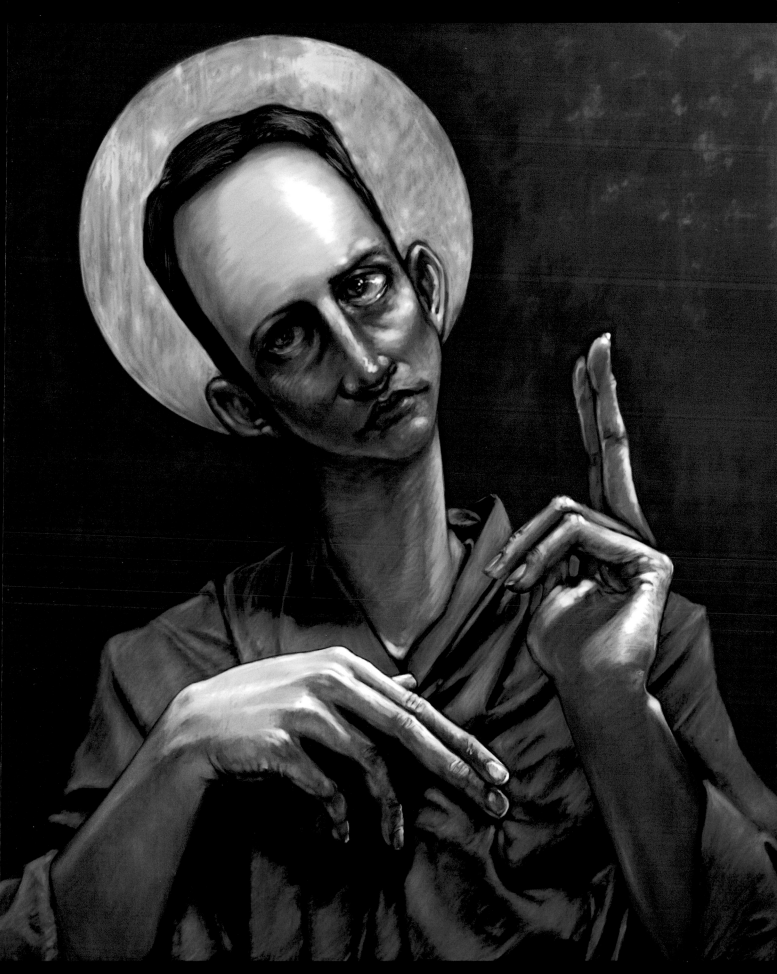

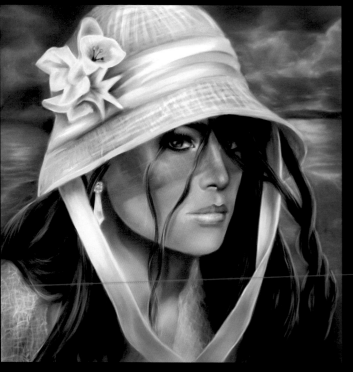

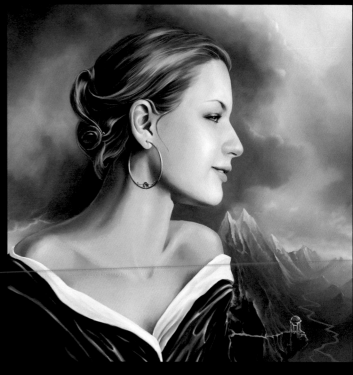

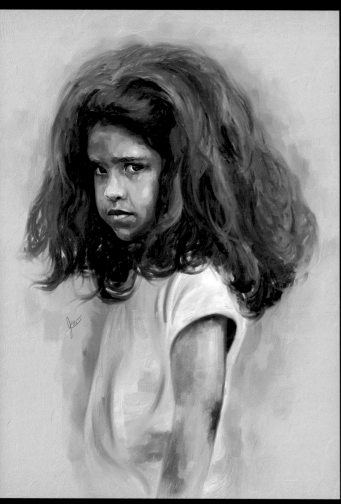

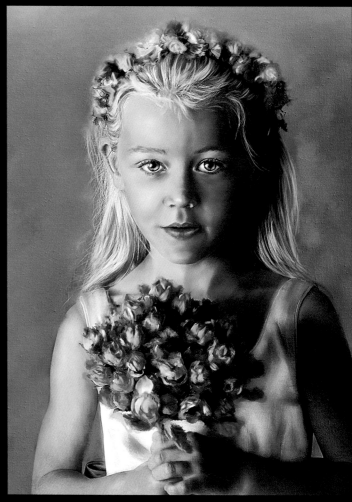

Lady of mystery
Painter
René Blom, SWEDEN
[top]

Hey there, lonely girl
Painter
Joel Cooper, USA
[above]

Anastasia
Painter
Client: Anastasia Guseva
Vadim-Leon Strelkov, LATVIA
[top]

Flower girl
Painter
Carrie Woeck, USA
[above]

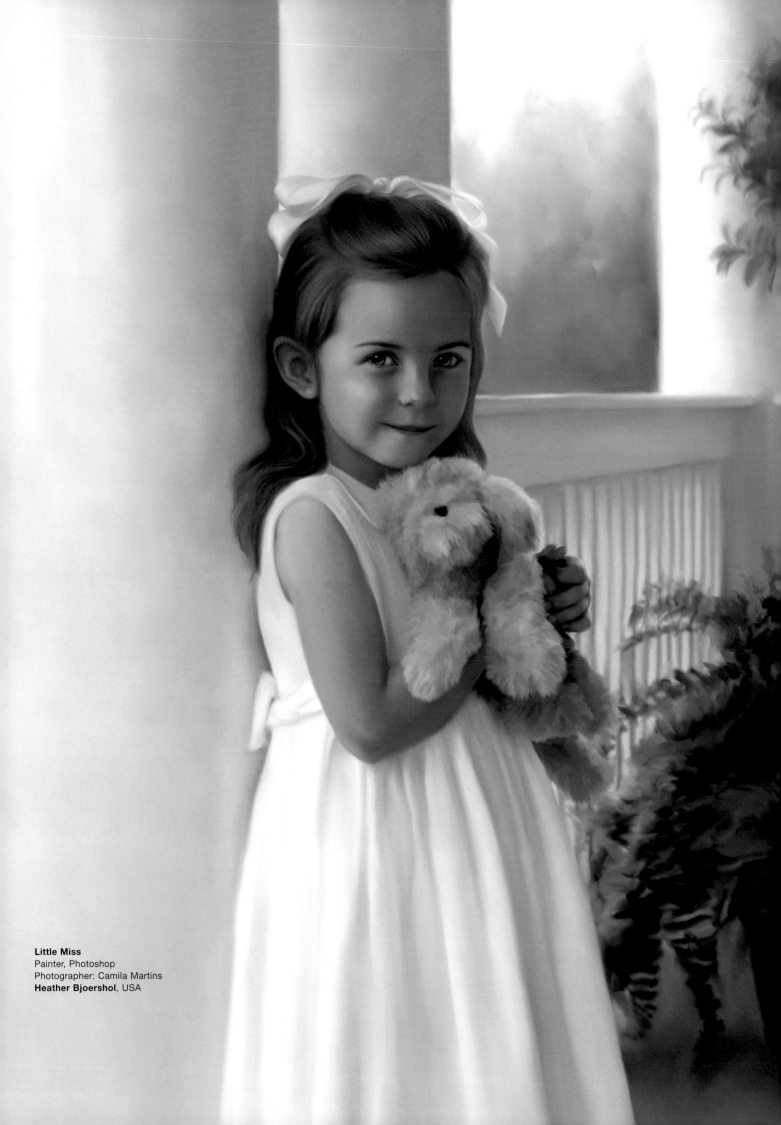

Little Miss
Painter, Photoshop
Photographer: Camila Martins
Heather Bjoershol, USA

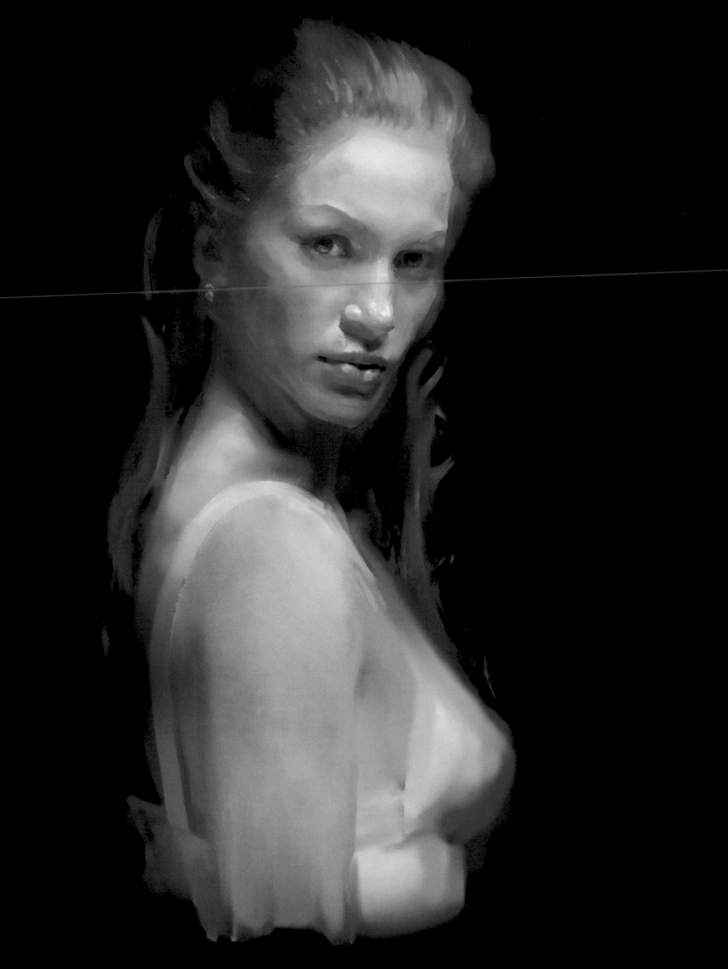

Miss J.
Painter
Benedict Campbell,
GREAT BRITAIN

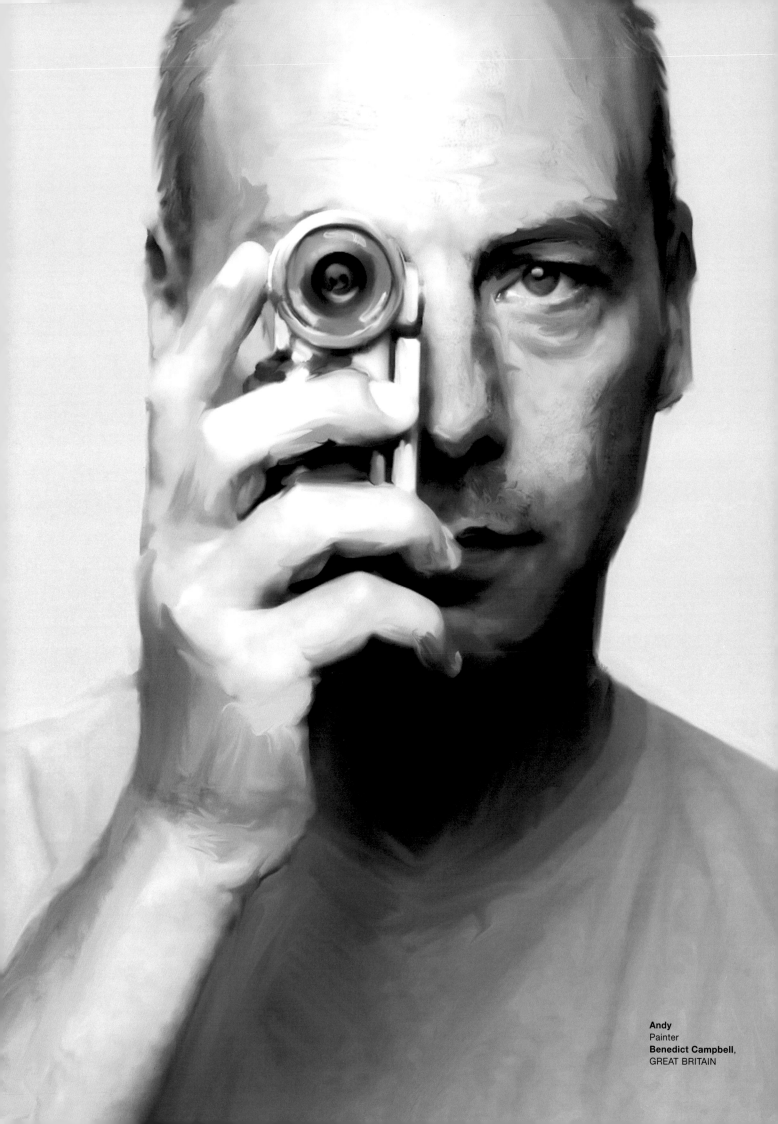

Andy
Painter
Benedict Campbell,
GREAT BRITAIN

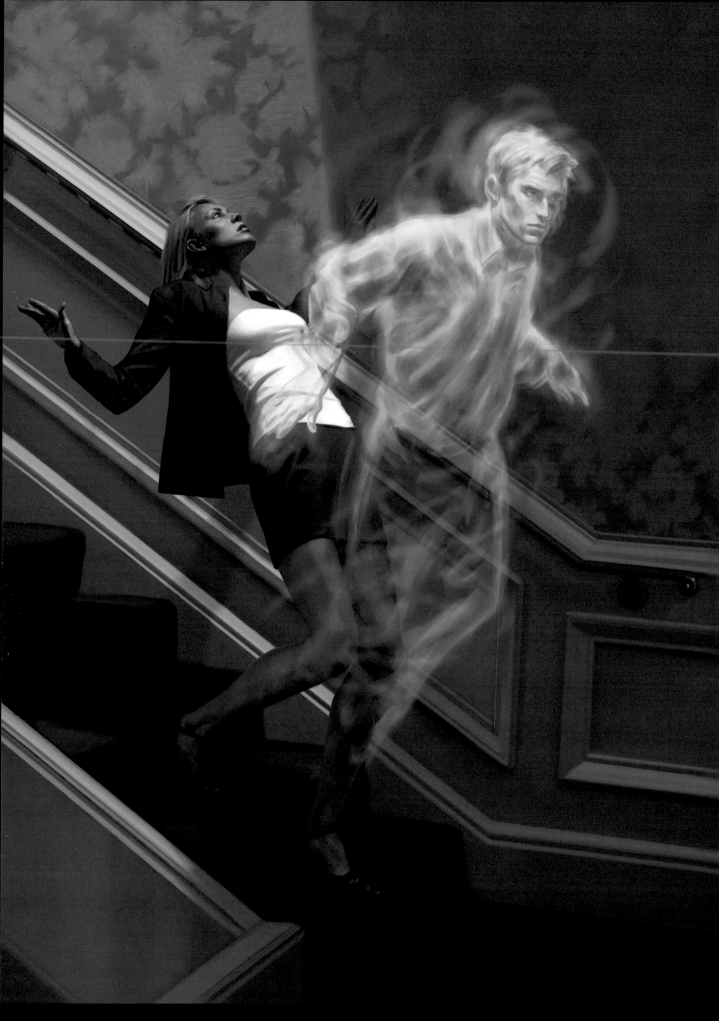

Master
Concept Art

Ghost Detective 2
Painter, Photoshop
Justin Kunz, USA

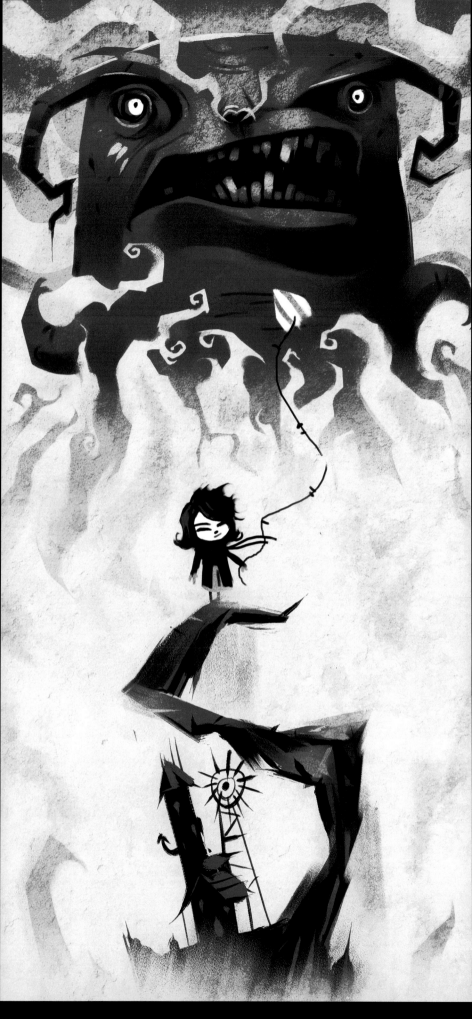

Abby and the Monster
Painter, Photoshop
Kevin Dart, USA

Excellence

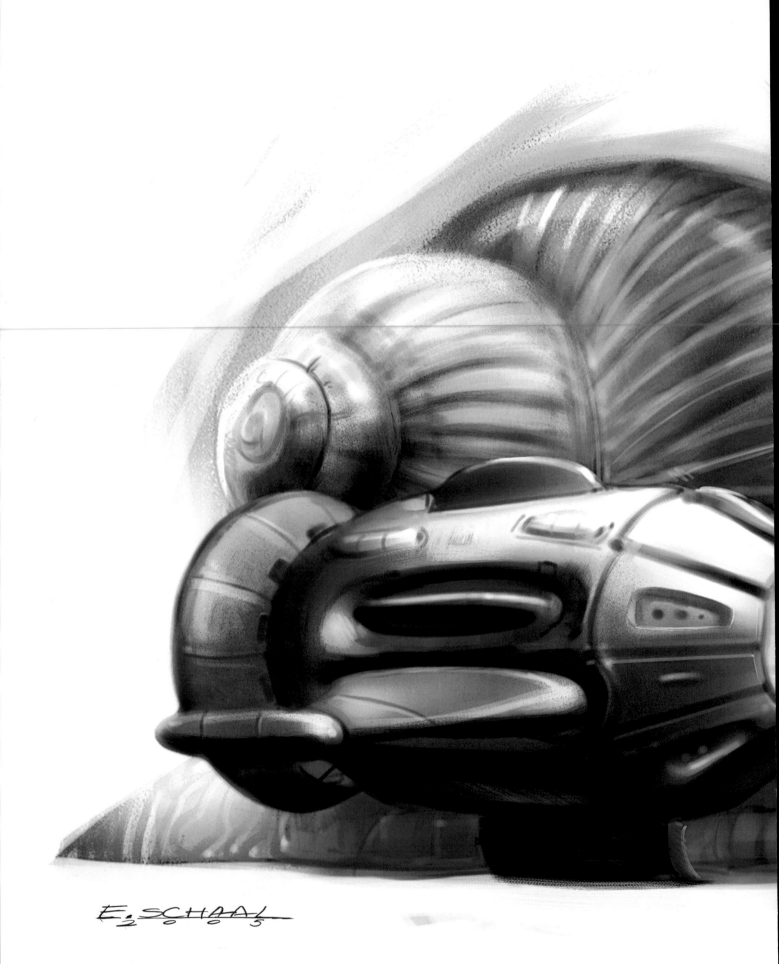

Excellence

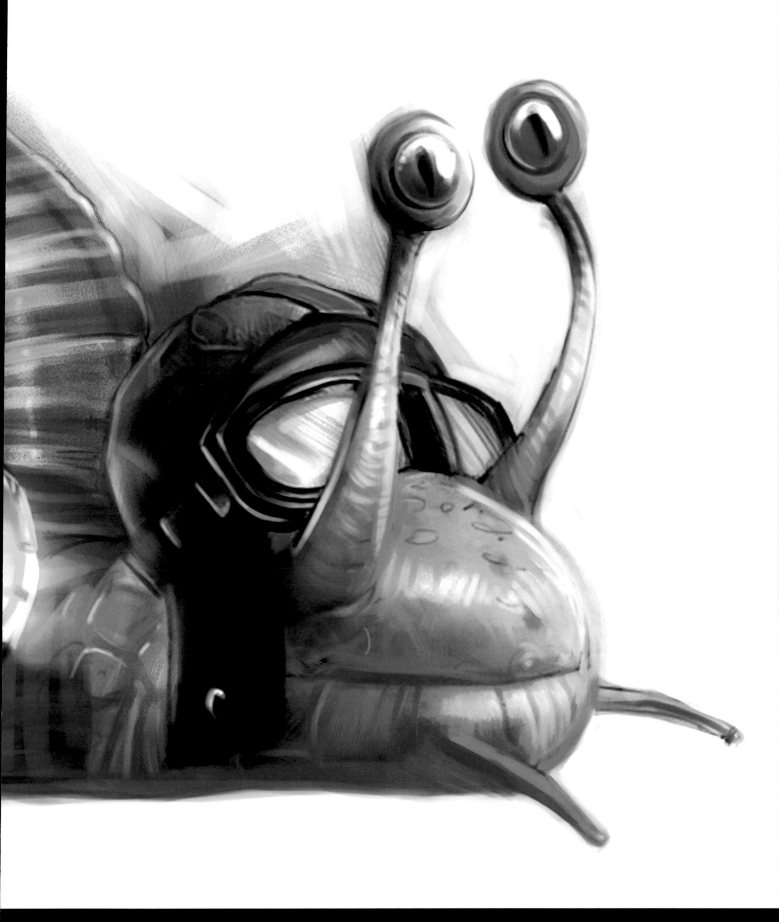

Turbo lesma
Painter, Photoshop
Eduardo Schaal, BRAZIL

Breeder's village
Painter
Jeff Nentrup,
USA
[top]

Orange world
Painter
Client: Wizkids, Inc.
Kian Chai Ng, USA
[above]

Vigilante
Painter
Tim Warnock,
CANADA
[right]

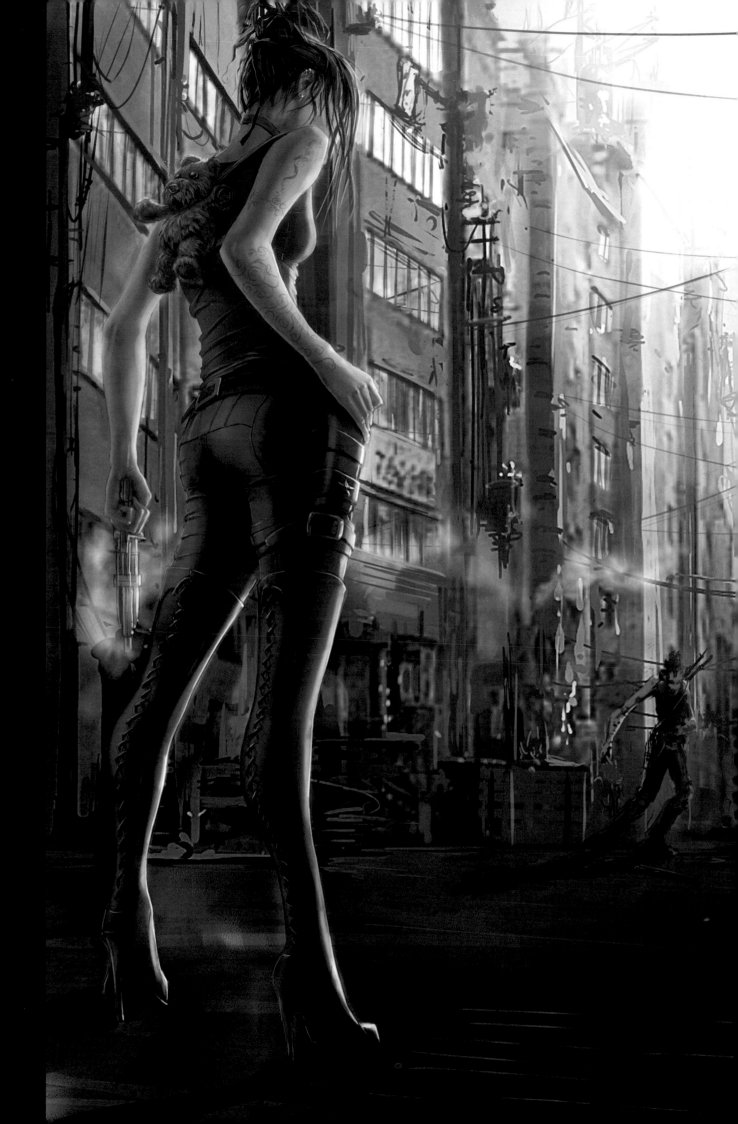

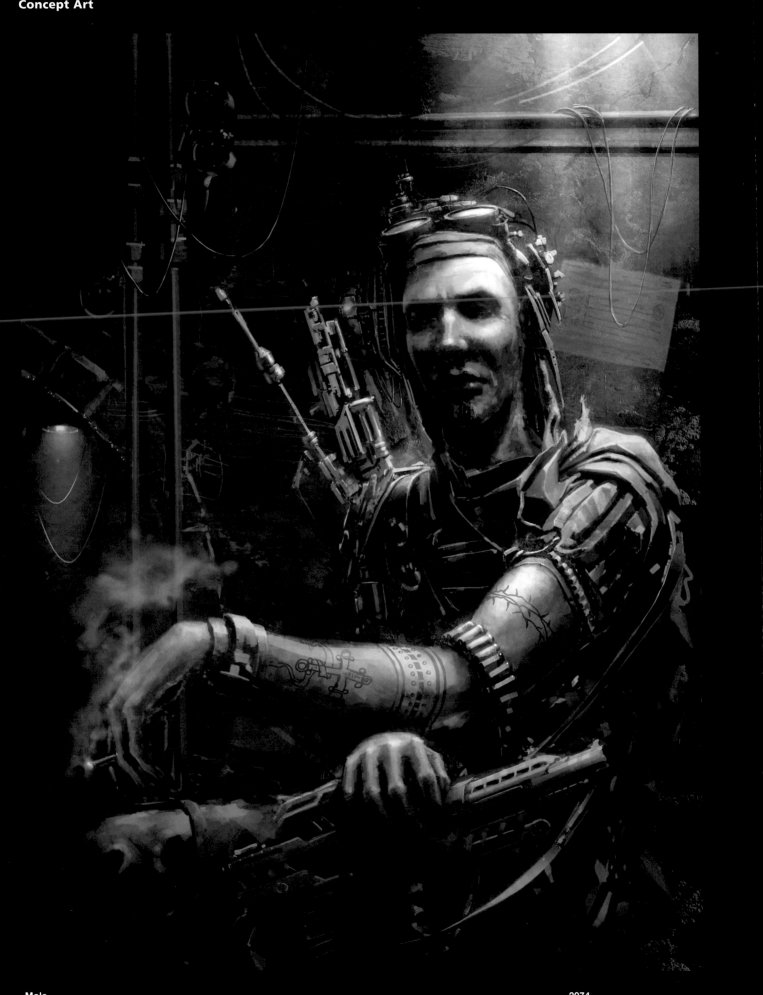

Mole
Painter

2074
Painter

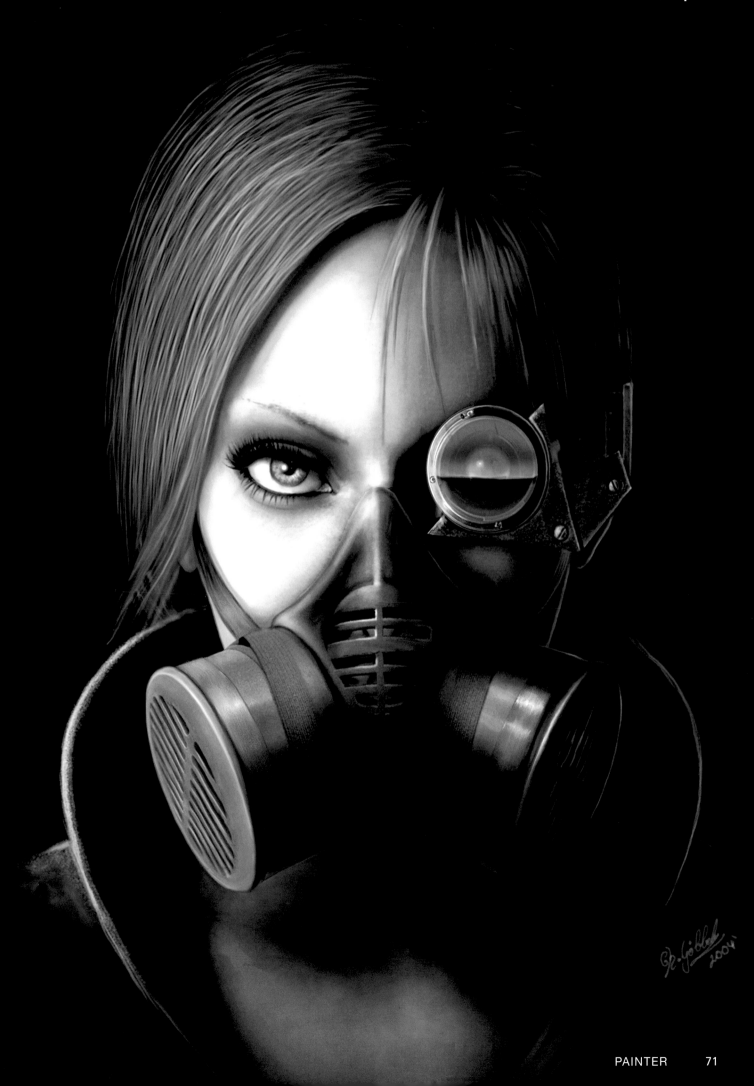

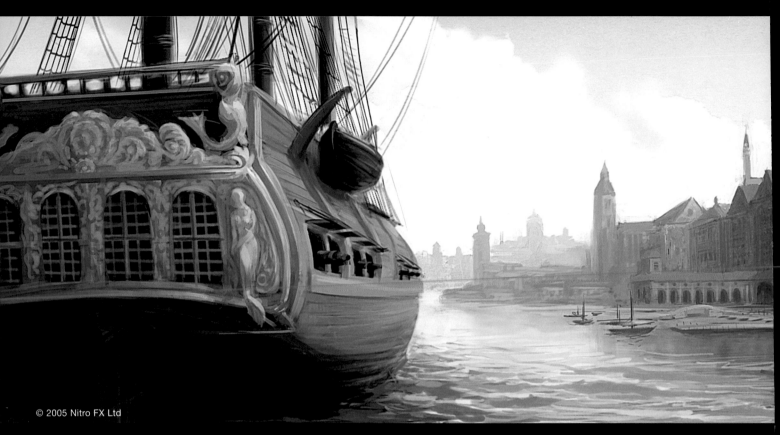

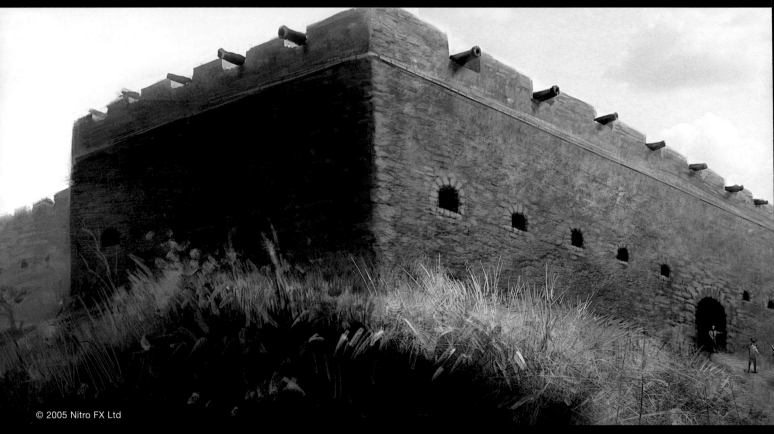

Harbour
Painter
Client: Nitro FX Ltd
Ville Anttonen, FINLAND

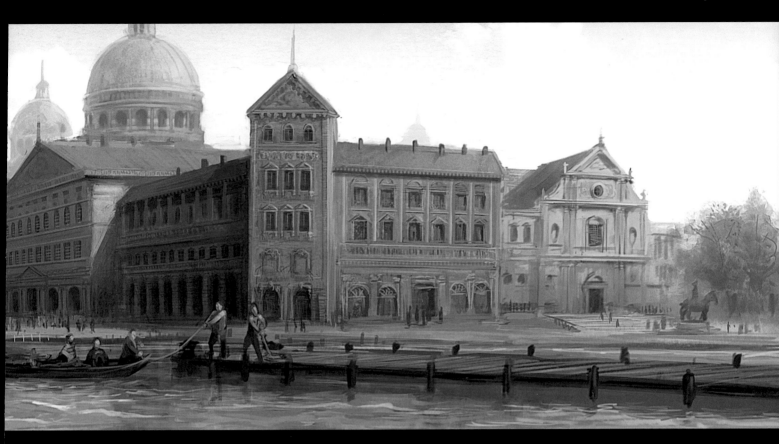

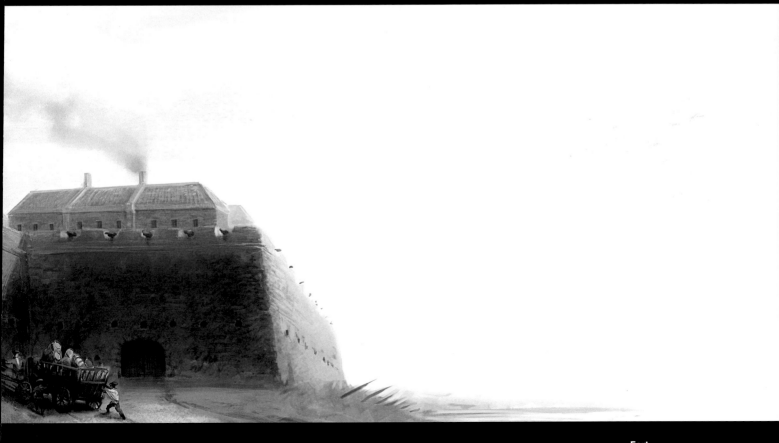

Fort
Painter
Client: Nitro FX Ltd
Ville Anttonen, FINLAND

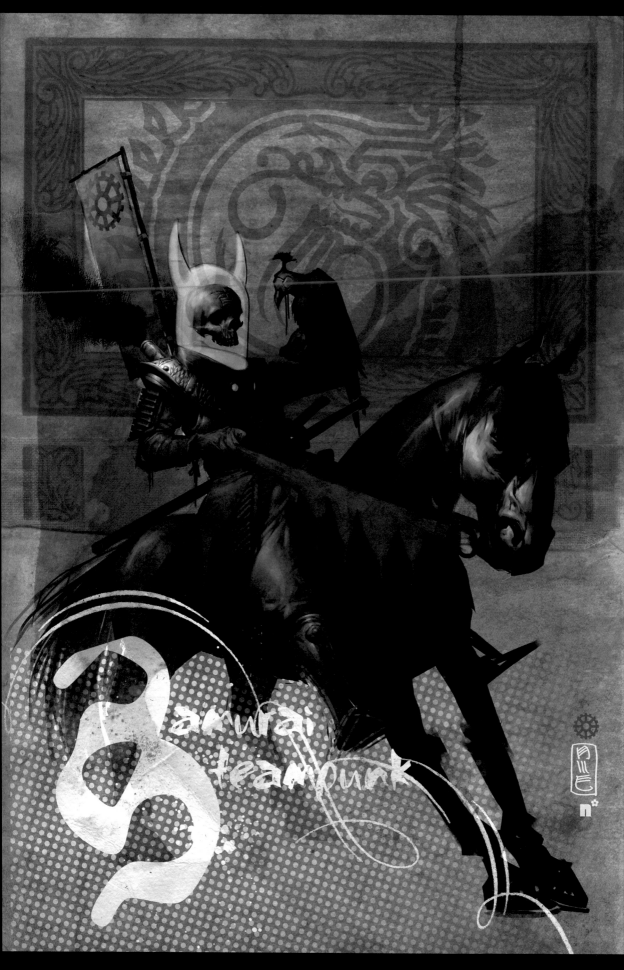

Samurai Steampunk

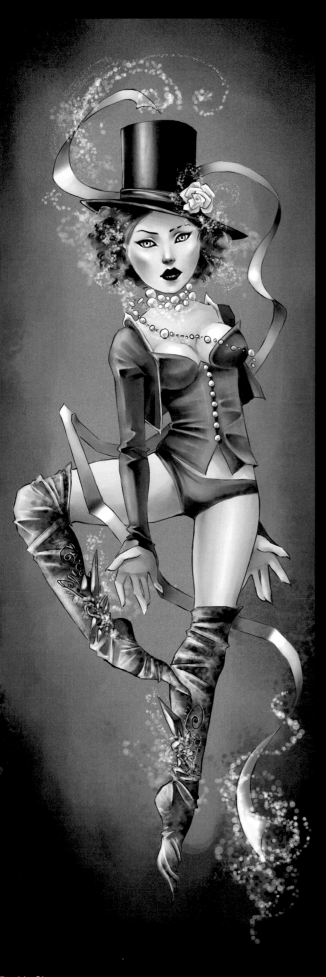

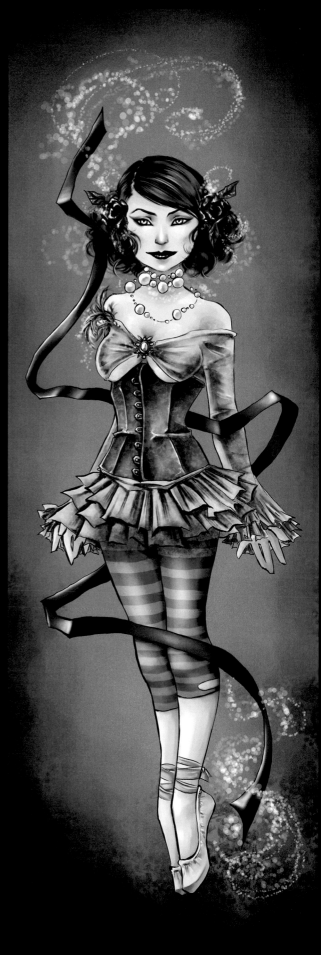

Double Circus
Painter
Gracjana Zielinska, POLAND
[above]

Double Circus
Painter
Gracjana Zielinska, POLAND
[above]

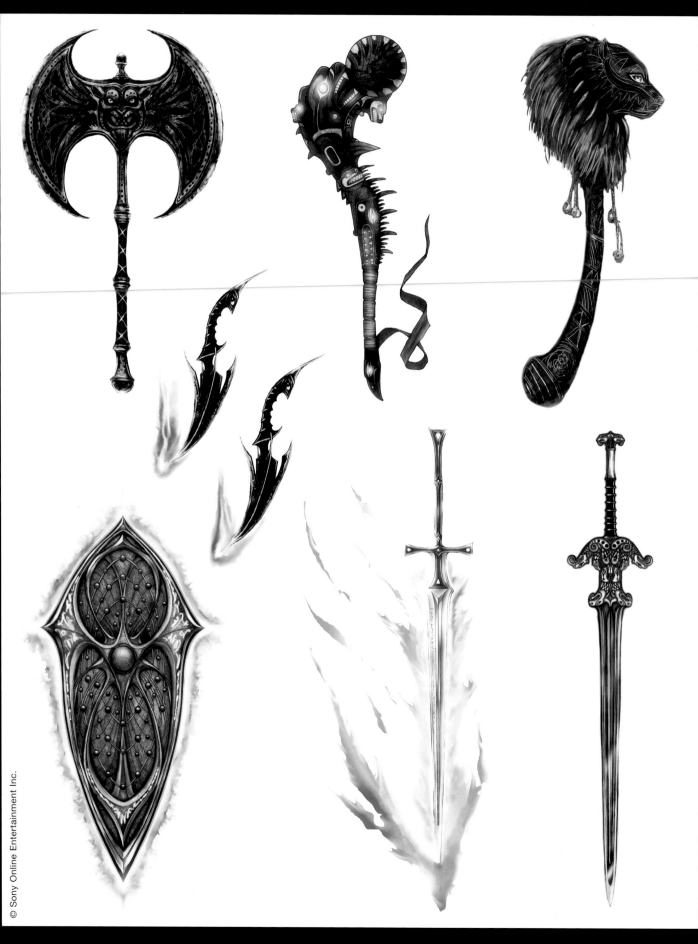

Berserker Axe, Beastlord's Club, Shaman's Club, Rogue Daggers, Cleric's Shield, Paladin Sword, Warrior's Sword
Painter
Client: 'EverQuest: Omens of War'
Stone Perales, USA
[top left to bottom right]

Defender
Painter
Hervé Groussin NURO.
FRANCE
[right]

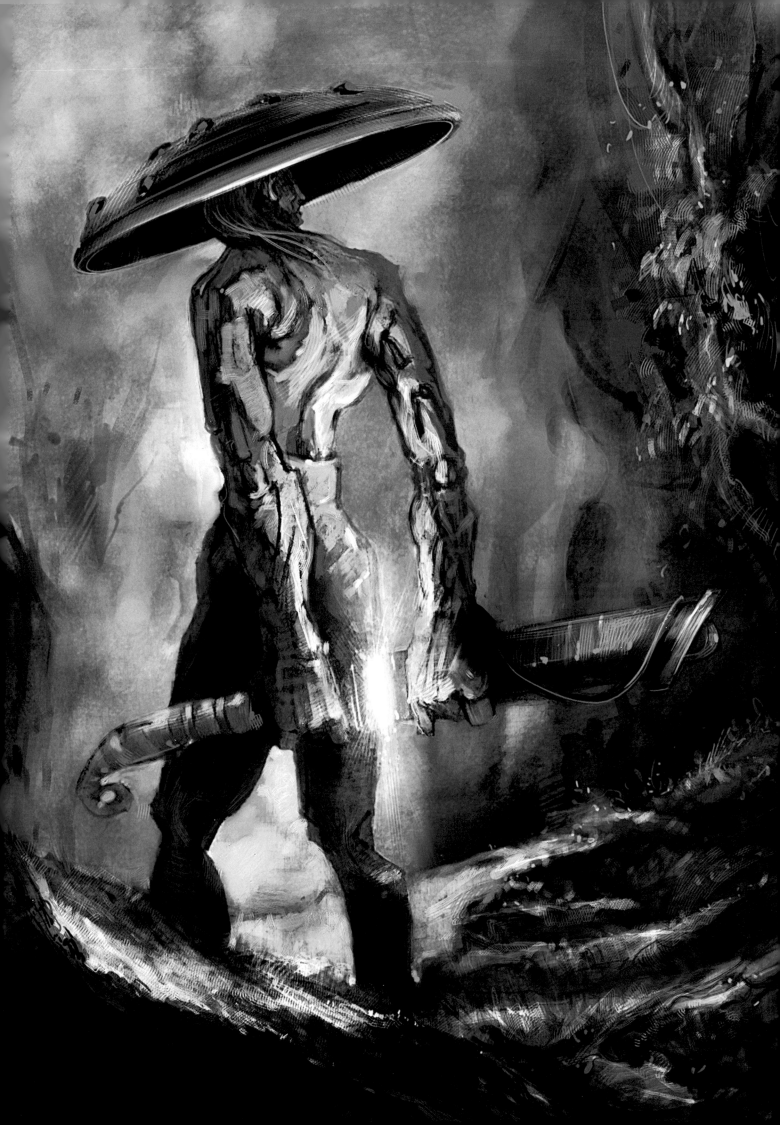

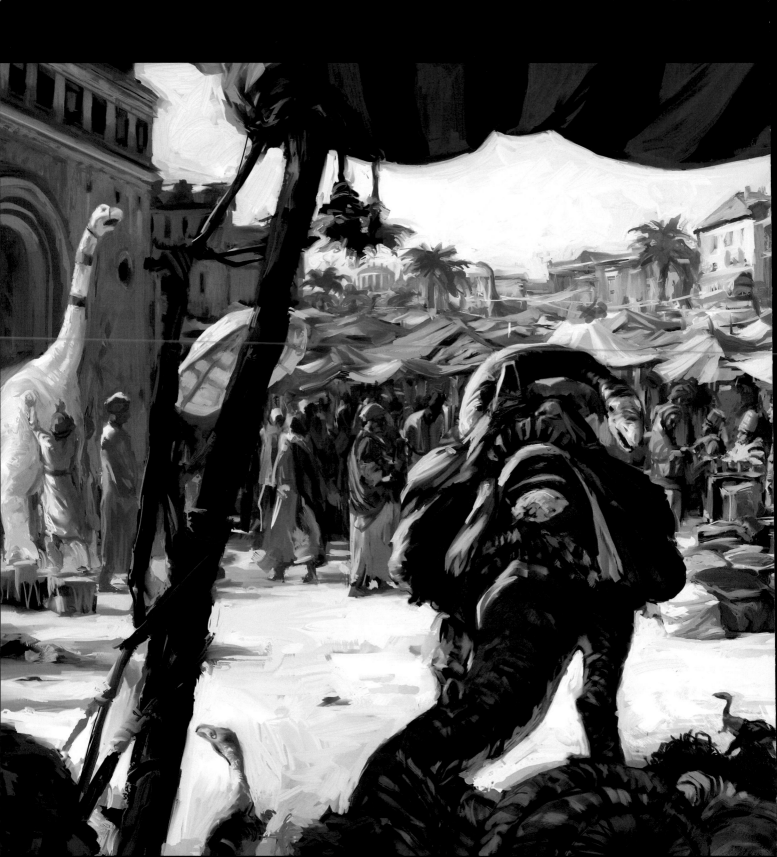

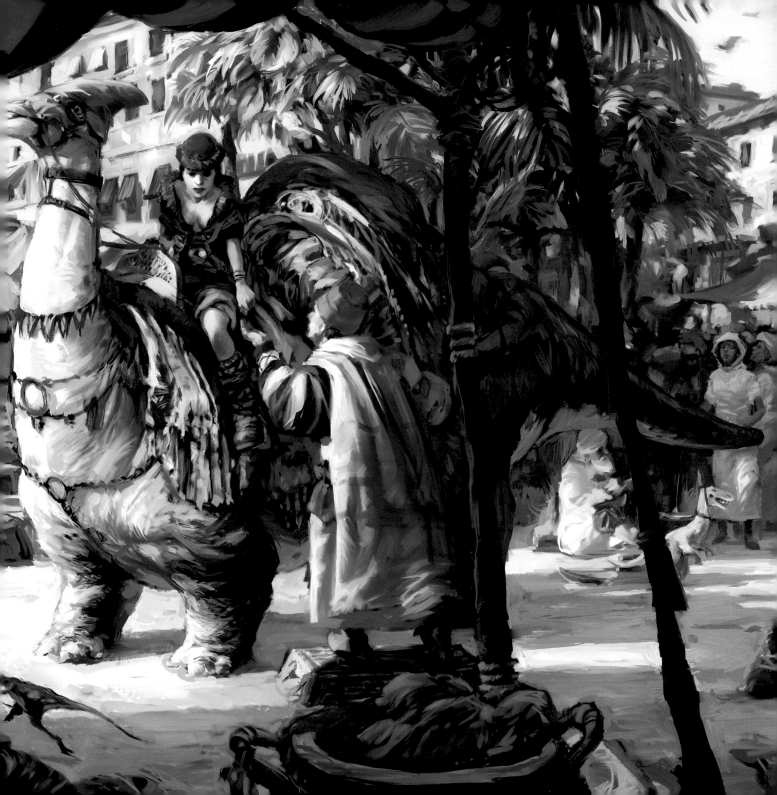

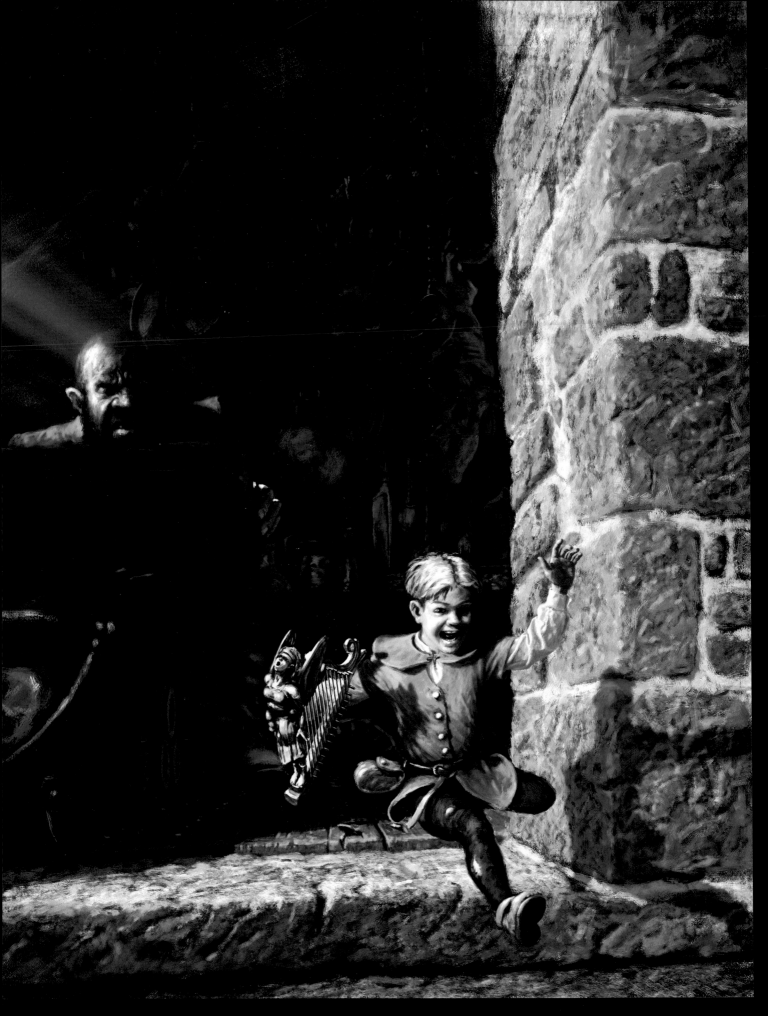

Excellence

Fantasy

Giant Killer
Painter
Chris Beatrice, USA

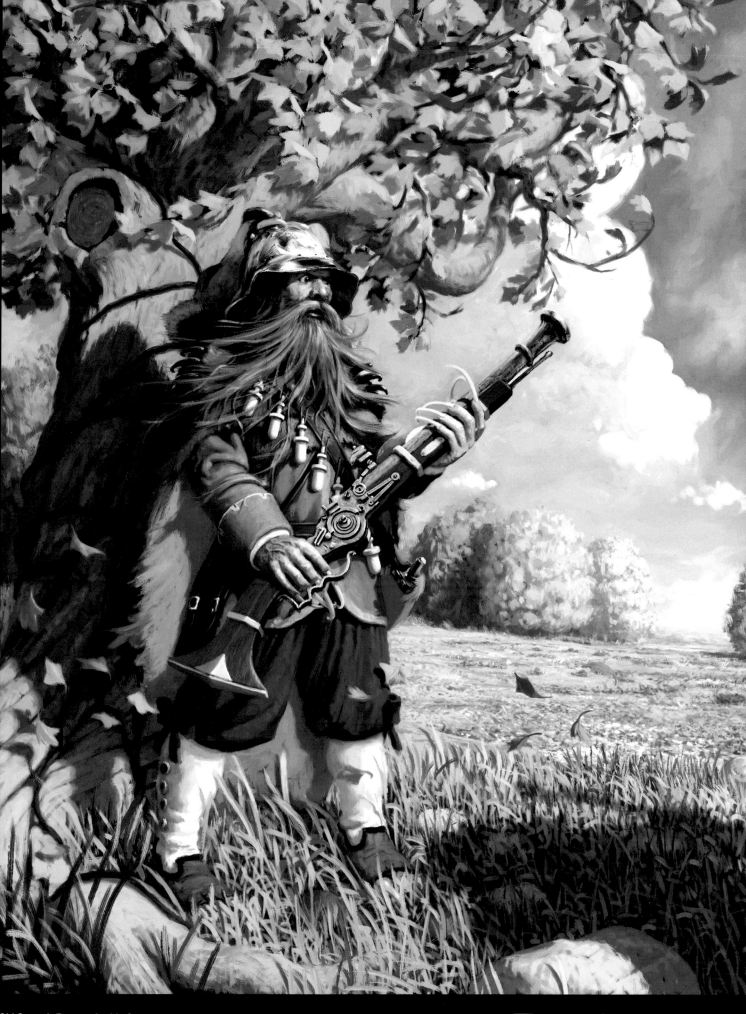

Old Scratch Returns for his Coat
Painter
Chris Beatrice, USA

Excellence

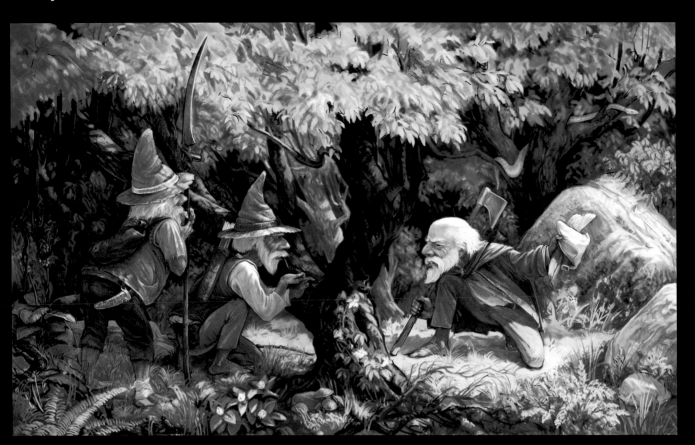

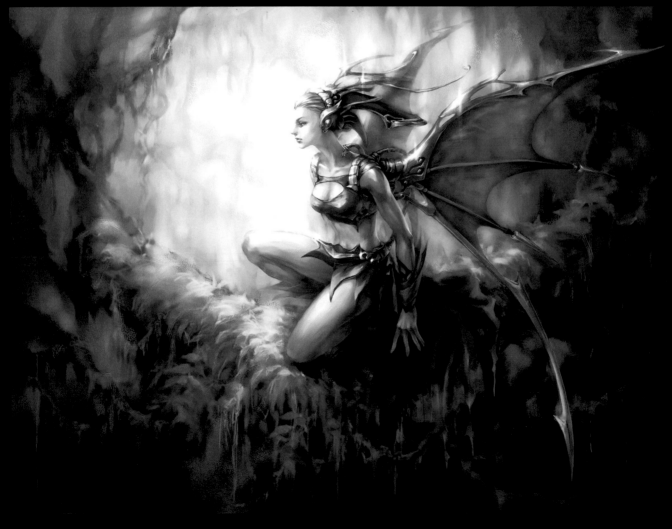

Scouts of a home guard: the report

A Mechanical Fairy

Legend of the Round Table
Painter, Photoshop, ArtRage
Aleksi Briclot, FRANCE

Excellence
Fantasy

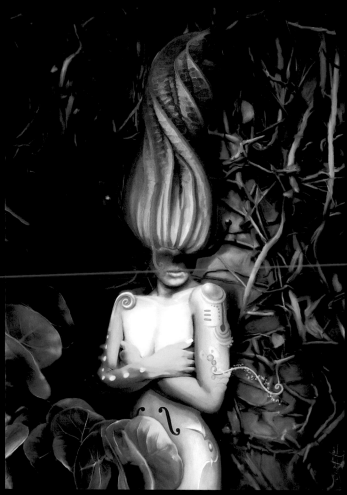

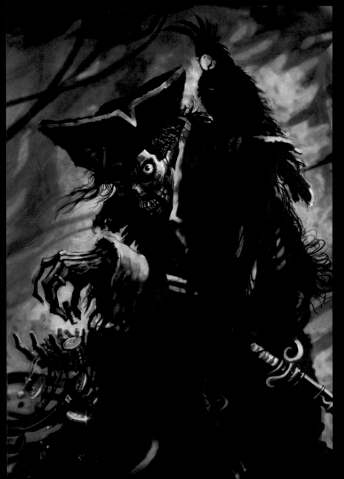

Biology Armature
Painter, Photoshop
Jiansong Chen, CHINA
[above left]

Explant
Painter, Photoshop
Photographer: Hakan Celebi
Oliver Wetter, fantasio fine arts,
GERMANY
[above]

Skeleton Pirate
Painter, Photoshop
Adam Vehige, USA
[left]

Necromancer
Painter, Photoshop
Wei Wang, CHINA
[right]

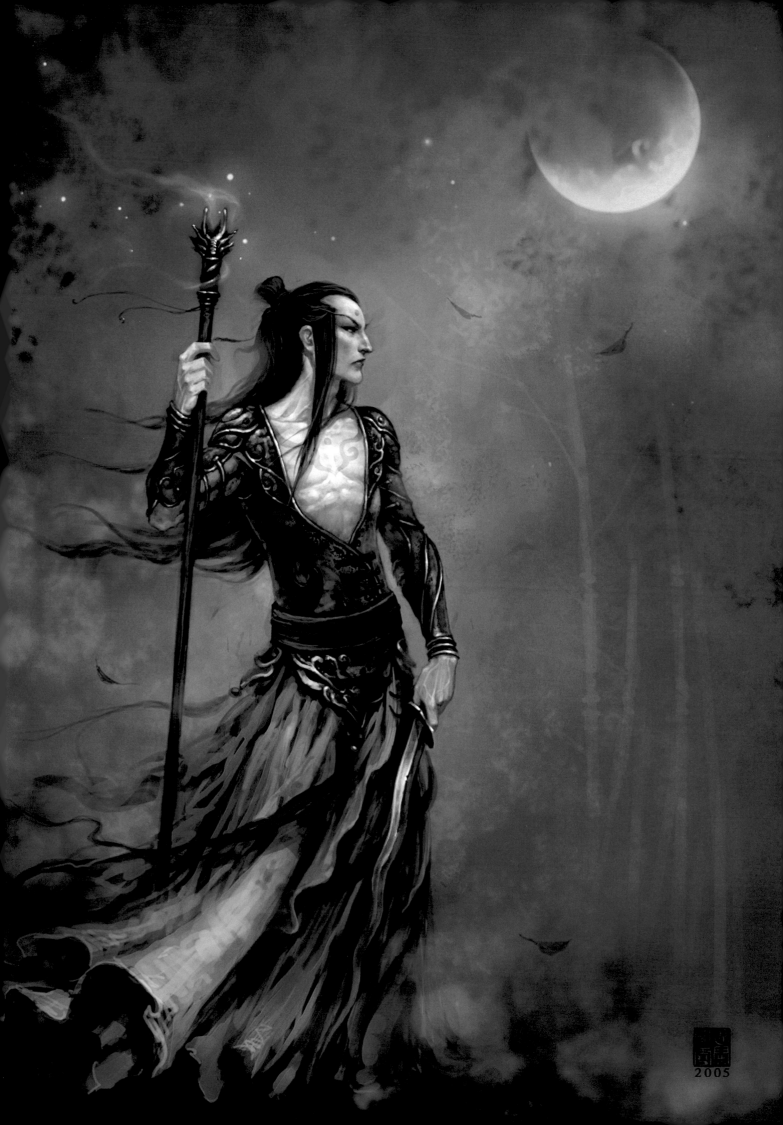

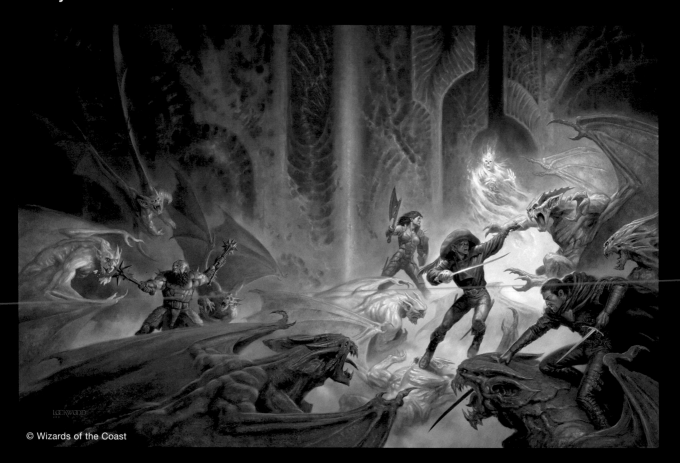

The Witch King **The Last Angel** **My Fairy**

Spring
Painter
David Bolit, USA

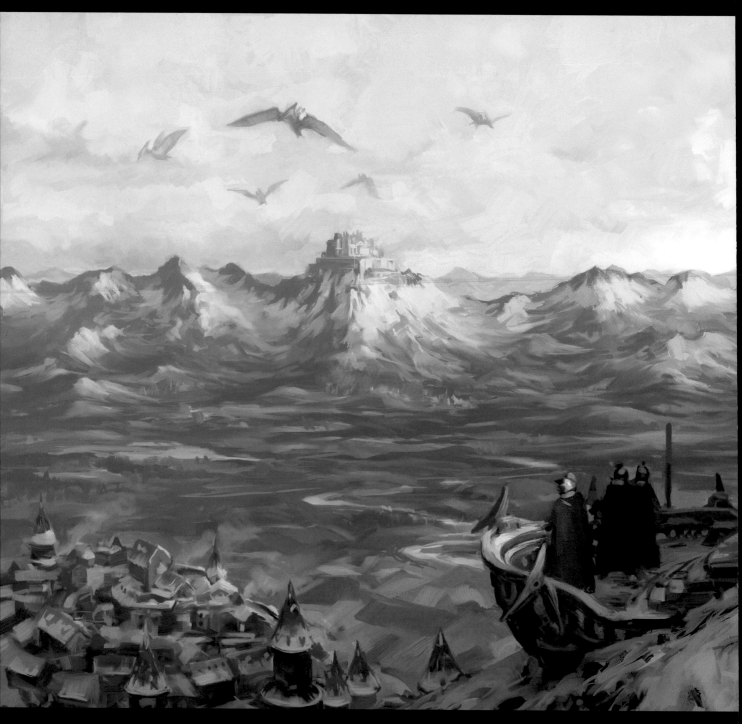

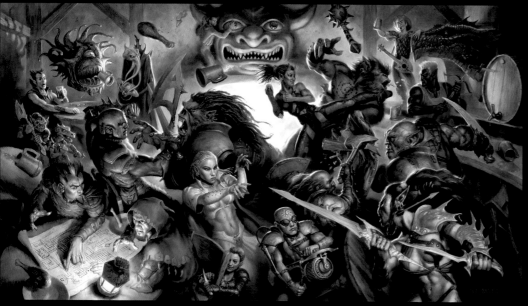

Dinopolis
Painter
Torsten Wolber, GERMANY
[above]

Barfight!
Painter
Todd Lockwood, USA
[left]

D&D cityscape
Painter
Jeff Nentrup, USA
[right]

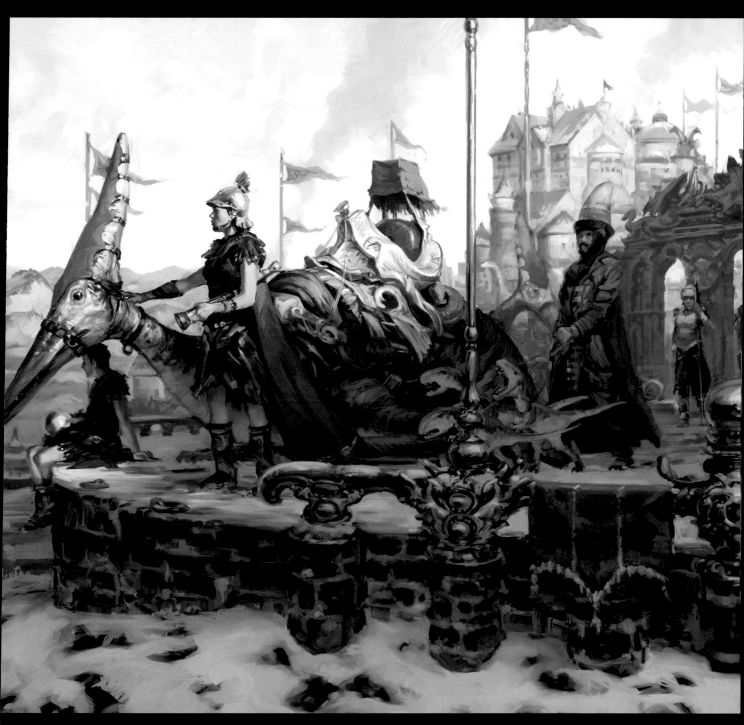

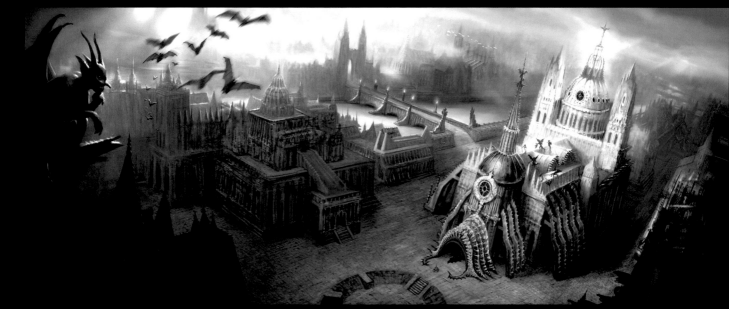

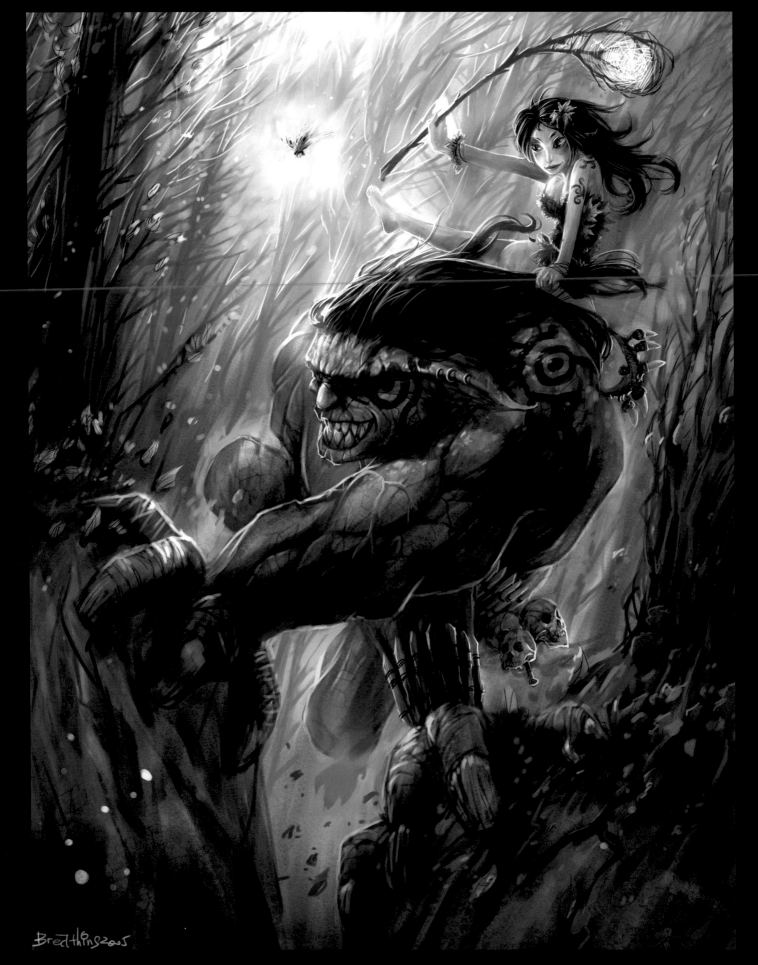

Breathing 2005

Catch the Last Summer

Late Spring

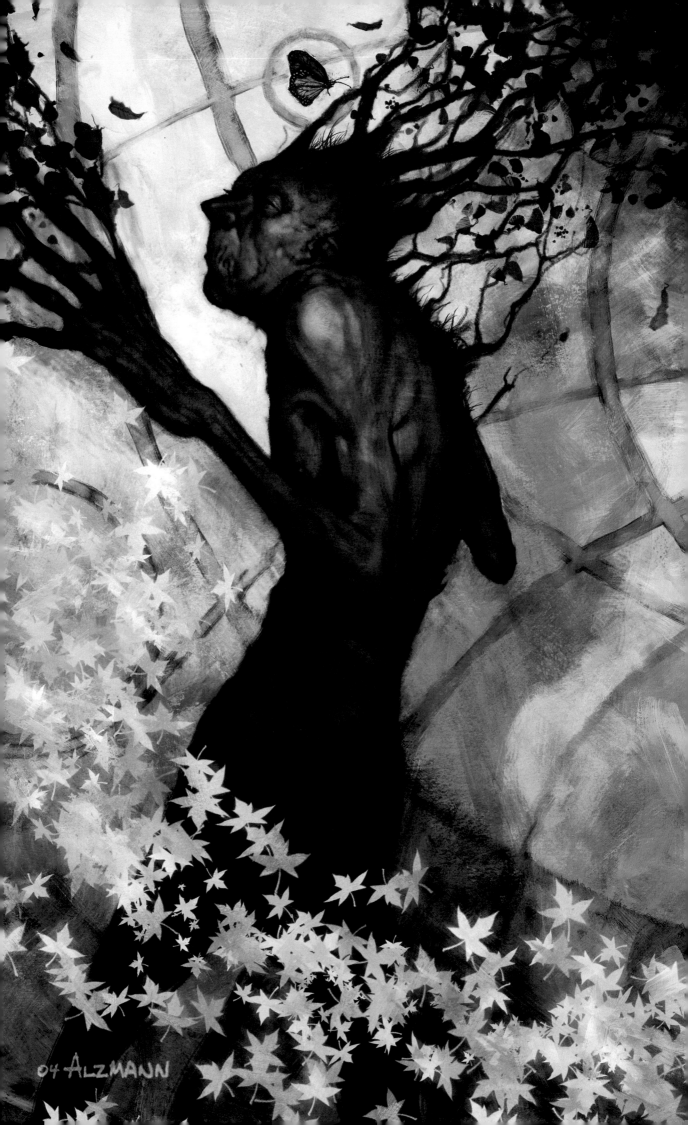

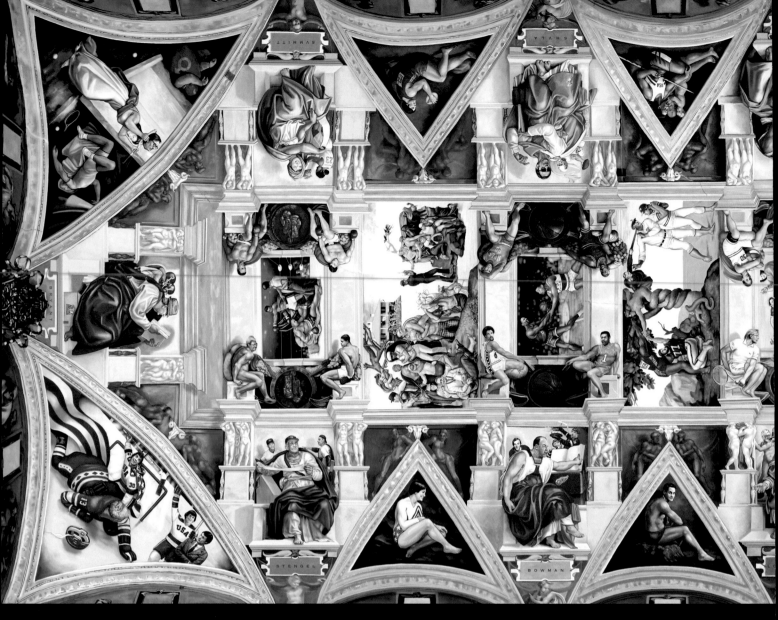

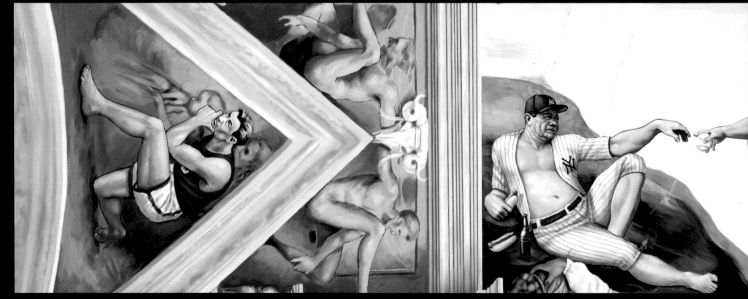

Master

Editorial Illustration

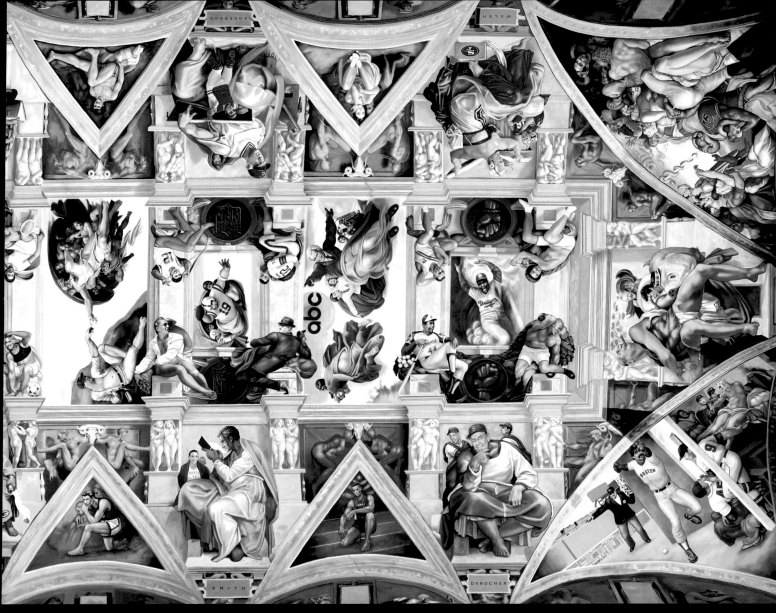

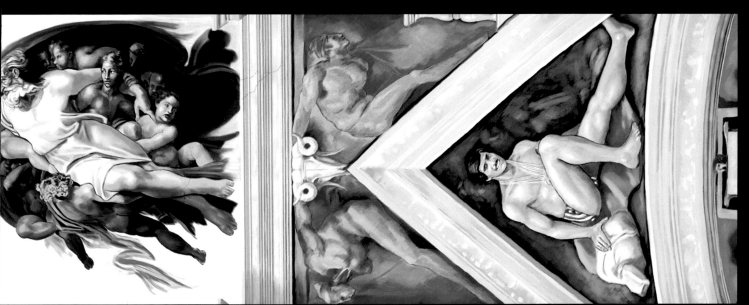

**Sports Illustrated's
Sistine Chapel of Sports**
Painter, Photoshop
Client: Sports Illustrated
Jeff Wong, USA

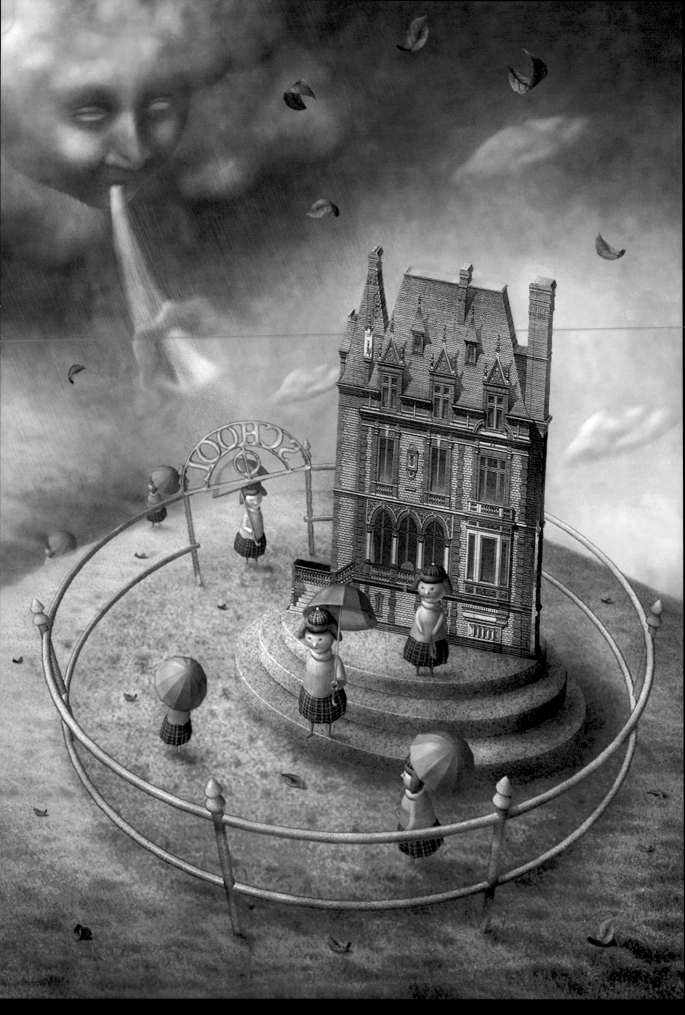

Excellence

Editorial Illustration

**Mrs McMurdo's perspective
correctional School for Wayward Gals**
Painter, ZBrush
Mark Bannerman, GREAT BRITAIN

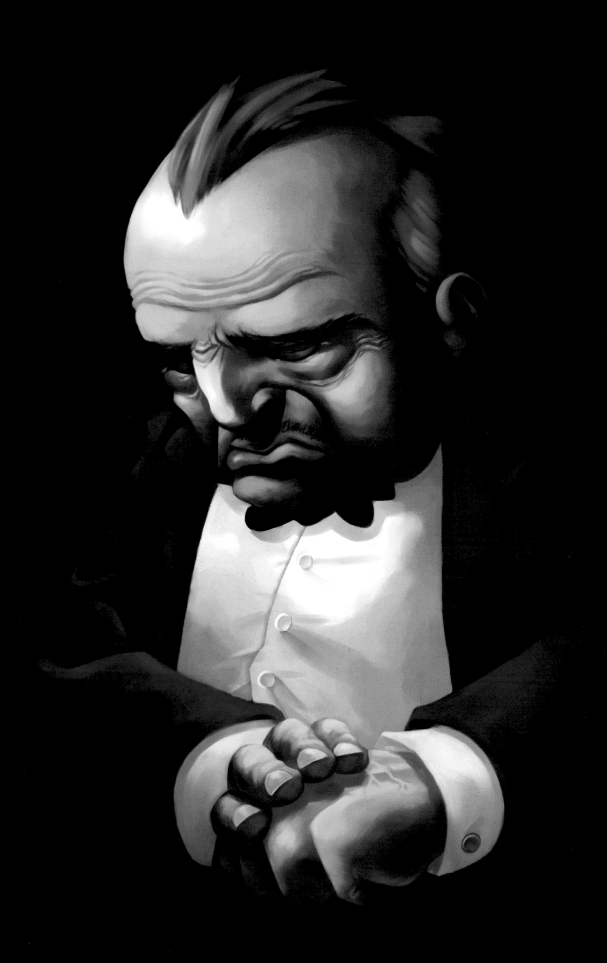

The Godfather
Painter, Photoshop
Ture Ekroos, FINLAND

Excellence
Editorial Illustration

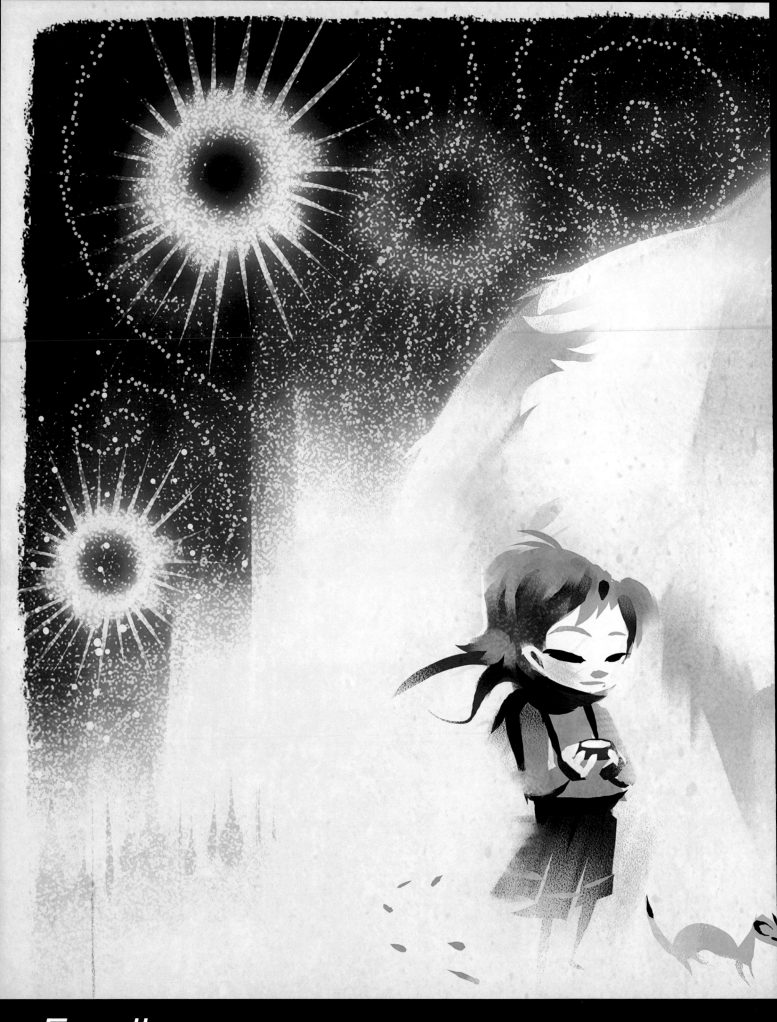

Excellence

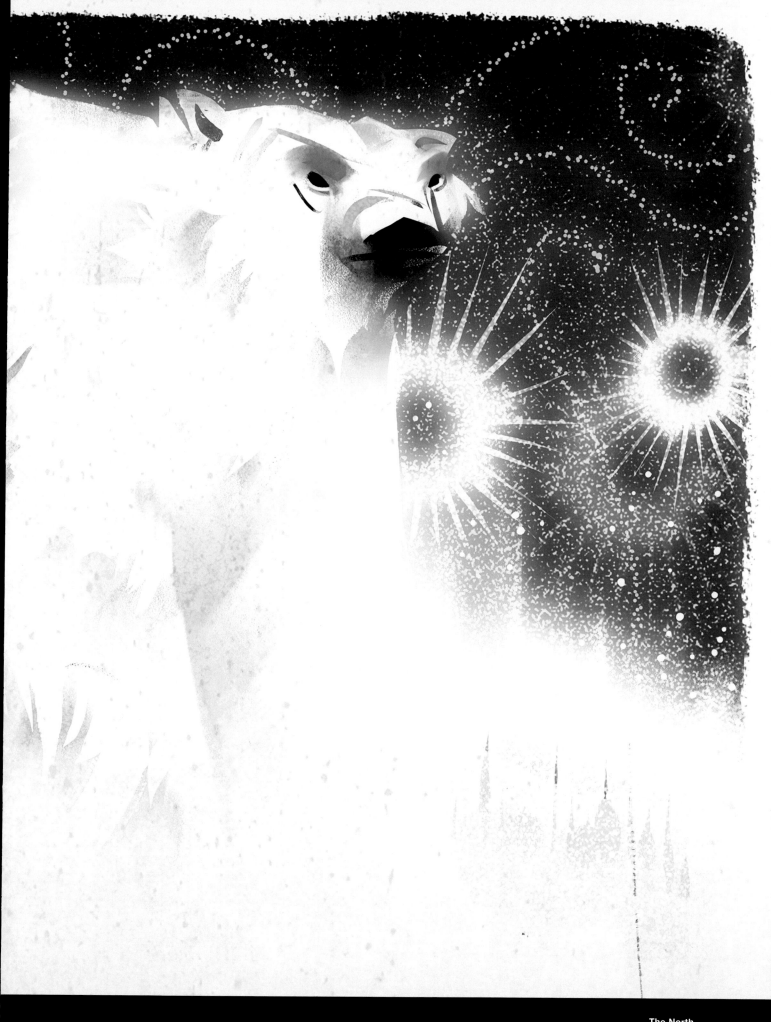

The North
Painter, Photoshop
Kevin Dart, USA

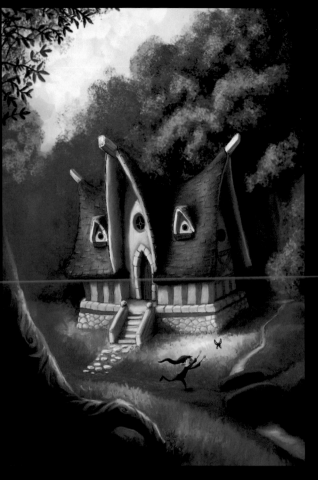
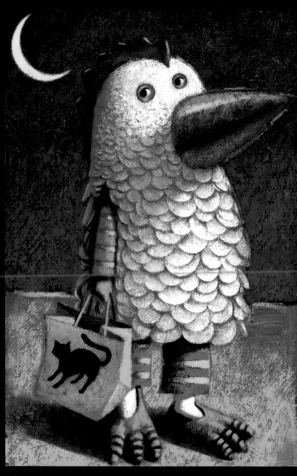
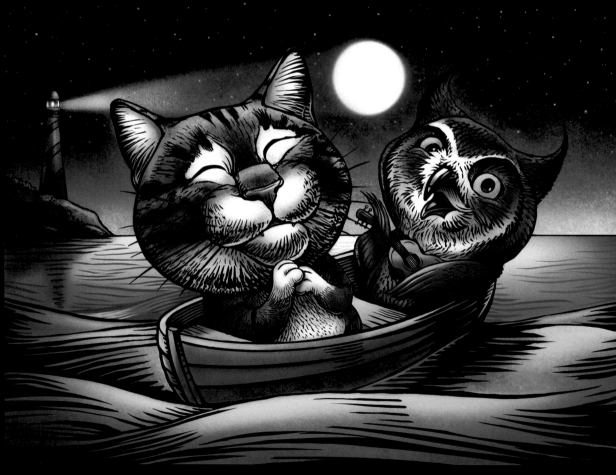

Chasing by the cottage
Painter, Photoshop
Jeremy Vickery,
USA
[top left]

The Owl and the Pussycat
Painter
Chet Phillips,
Chet Phillips Illustration, USA
[above]

Children's Book
Painter
Client: Albert Whitman Publishing
Mike Reed, USA
[top right]

Michael Moore
Painter
Stanley Miller, USA

Autumnal leaves
Painter, Illustrator
Client: Softbank Creative Corp.
Youchan Ito, Togoru Co. Ltd.,
JAPAN
[above]

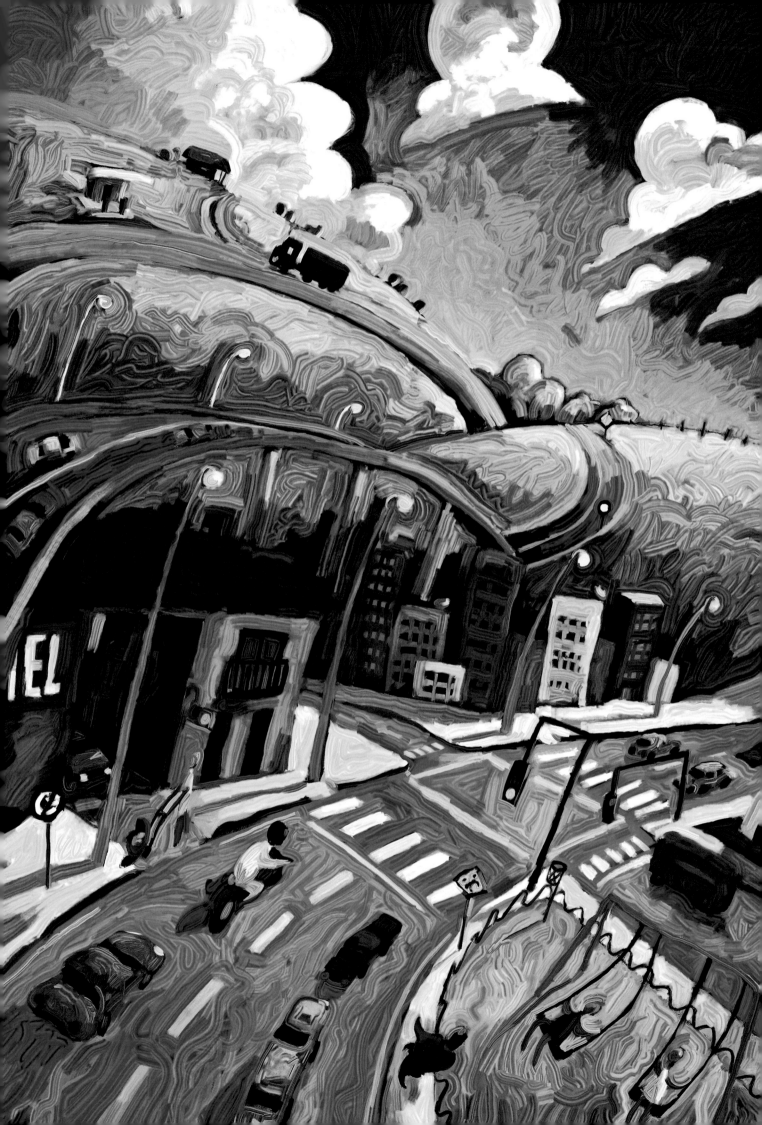

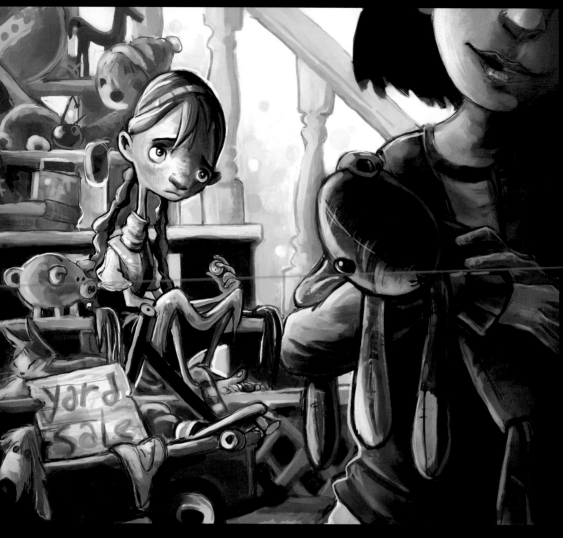

The Yard Sale
Painter
Jennifer Minick Wood
USA
[left]

Treasure Platform
Painter, Photoshop
Christopher Davis,
GREAT BRITAIN
[right]

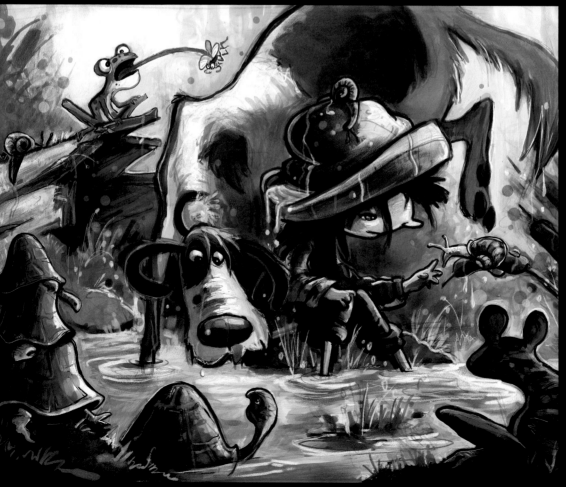

After the Rain
Painter
Jennifer Minick Wood
USA
[left]

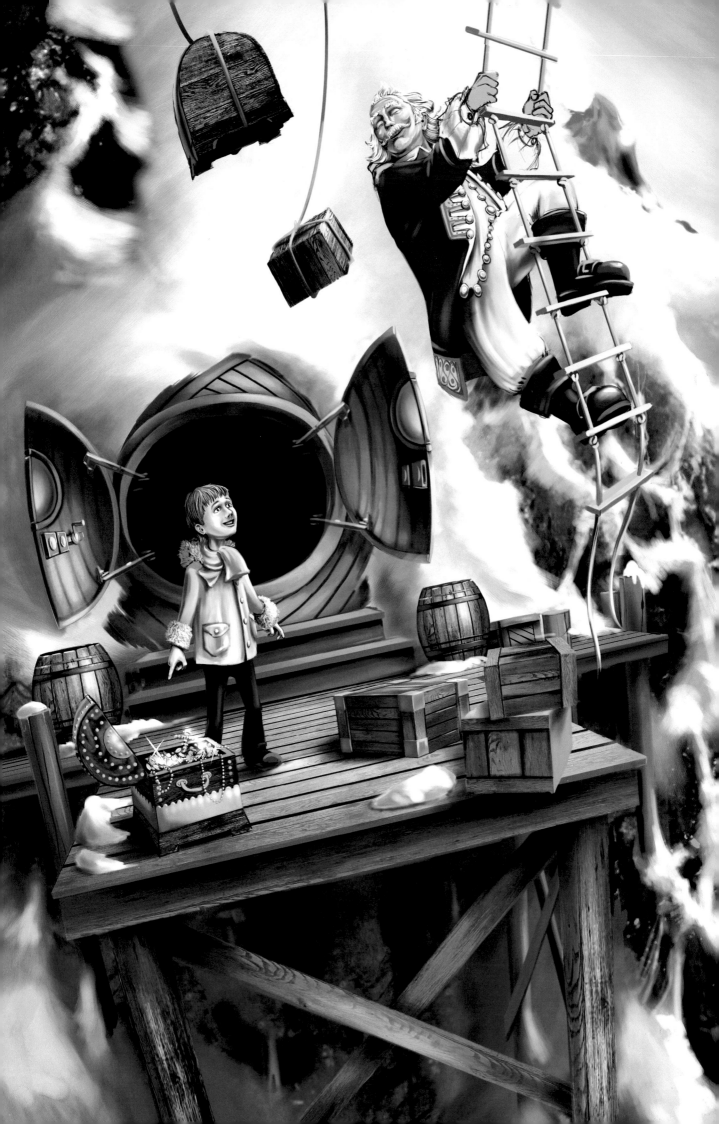

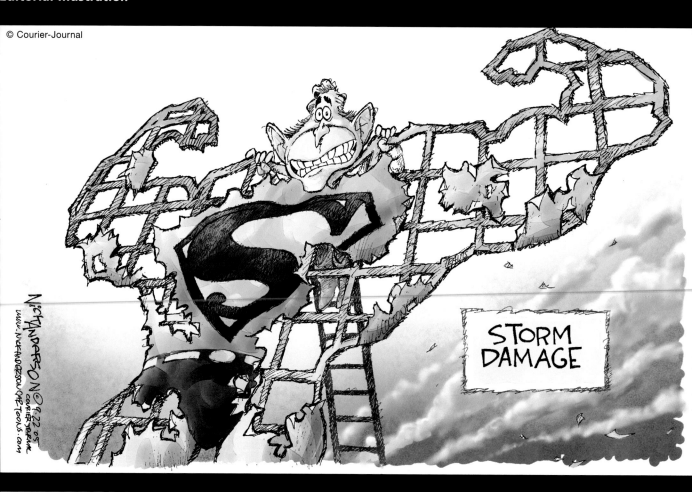

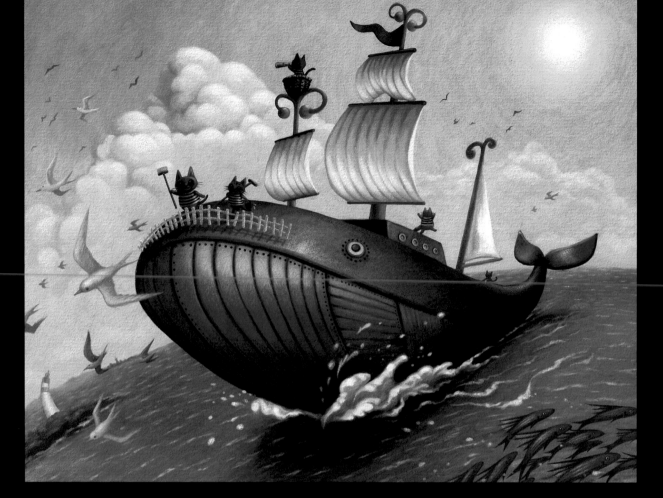

Whale ship
Painter

Reading
Painter

Time Won't Let Me
Painter, Photoshop

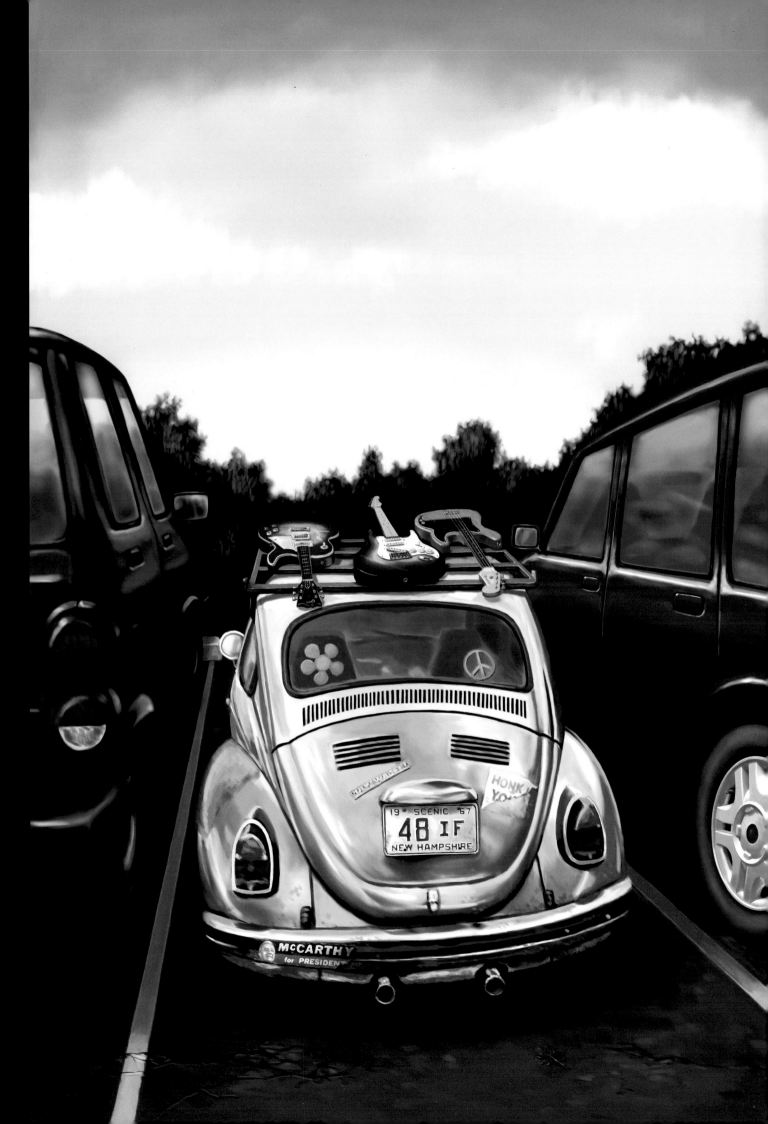

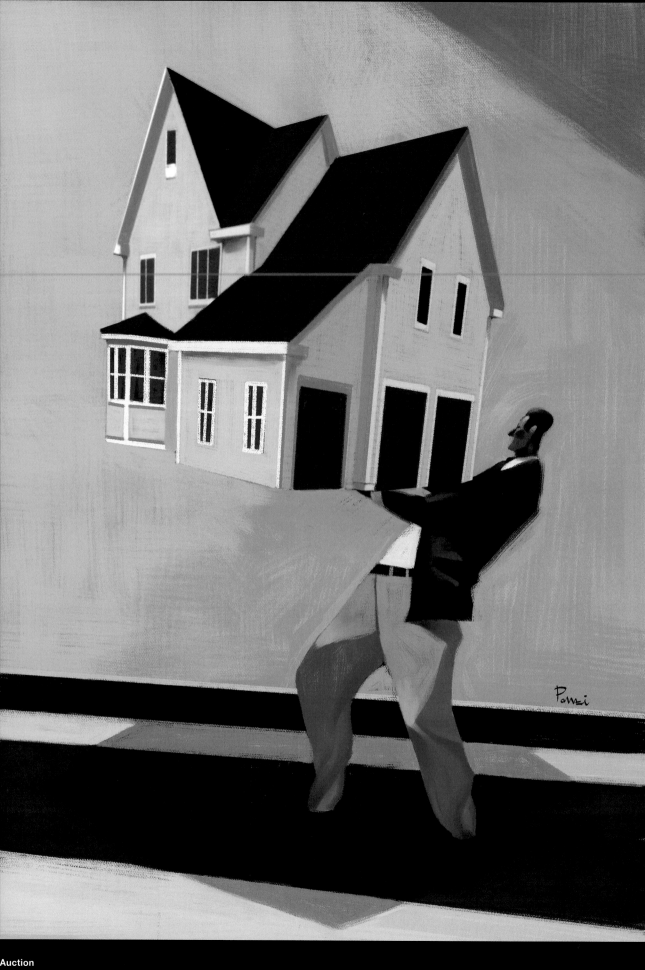

Auction
Painter
Client: Patrimoni Magazine
Emiliano Ponzi, ITALY

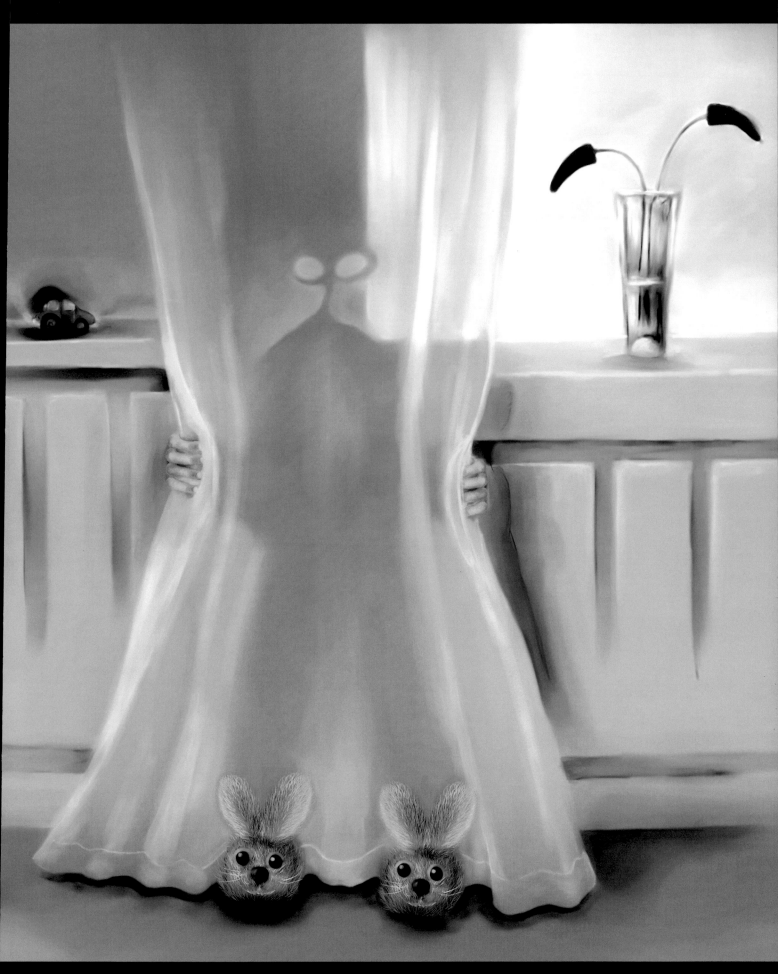

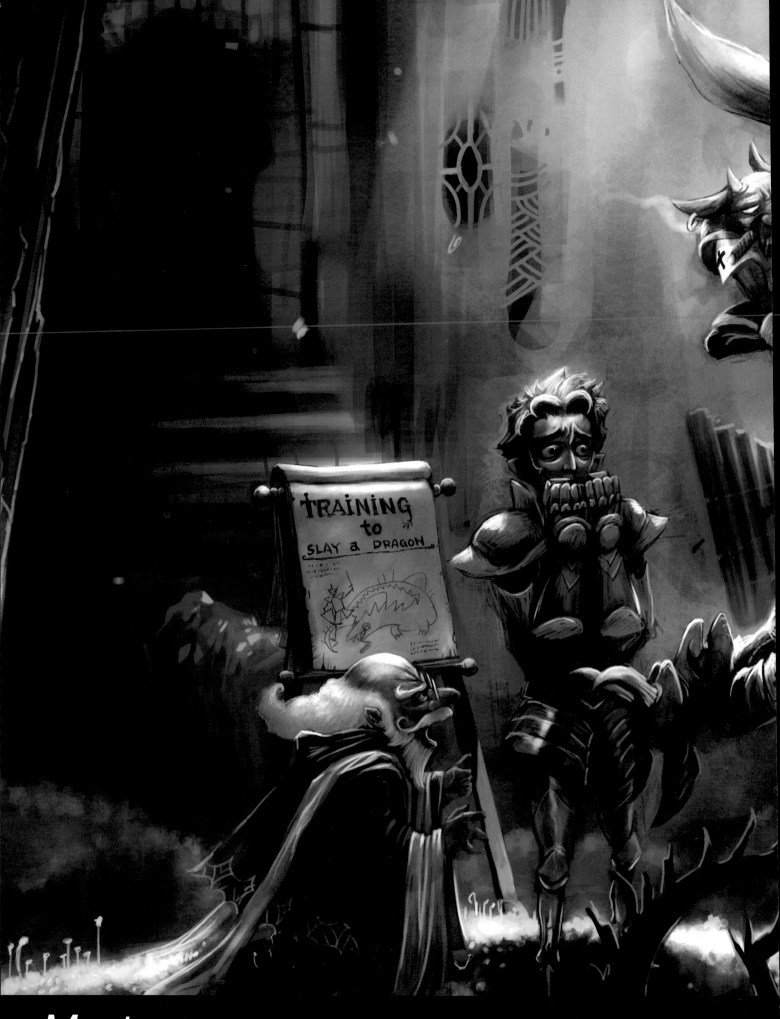

Master

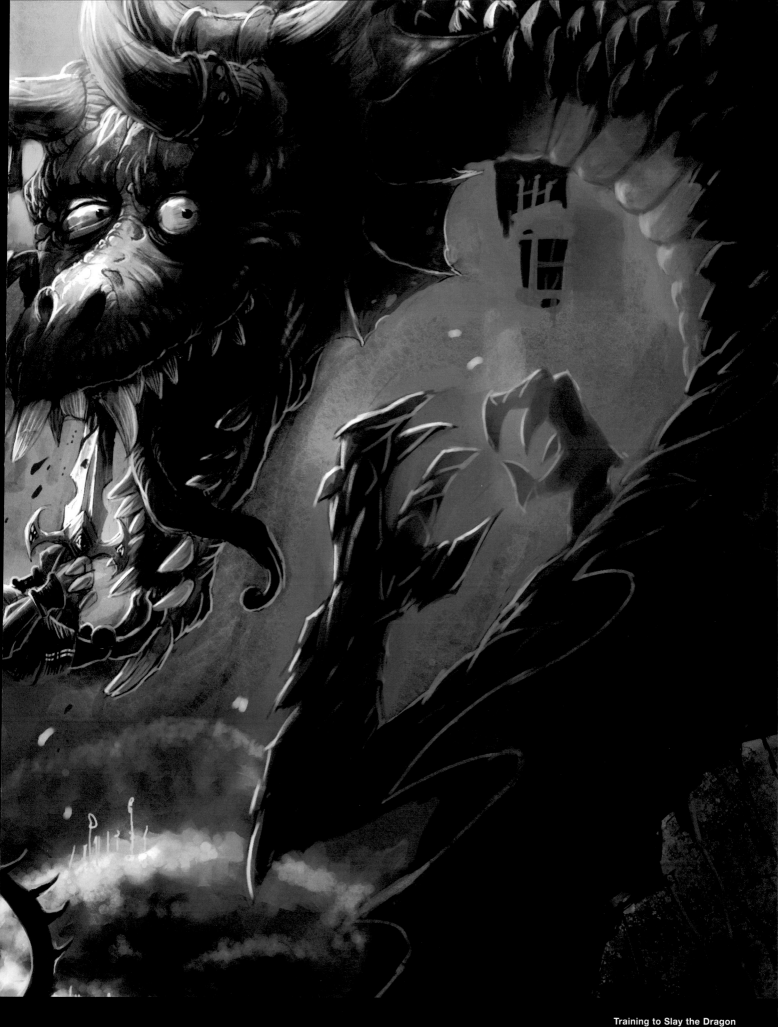

Training to Slay the Dragon
Painter, Photoshop
Jian Guo, CHINA

Excellence
Humorous

Servant of Creation
Painter, Photoshop
Eduardo Schaal, BRAZIL

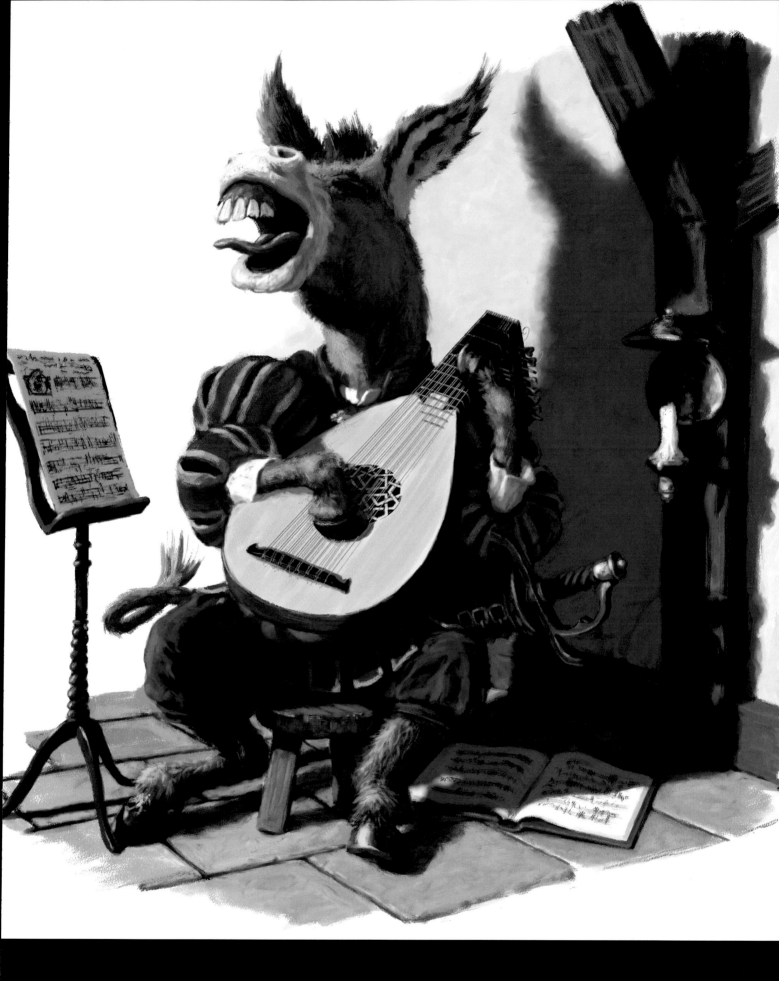

The Lute Player
Painter
Chris Beatrice, USA

Excellence
Humorous

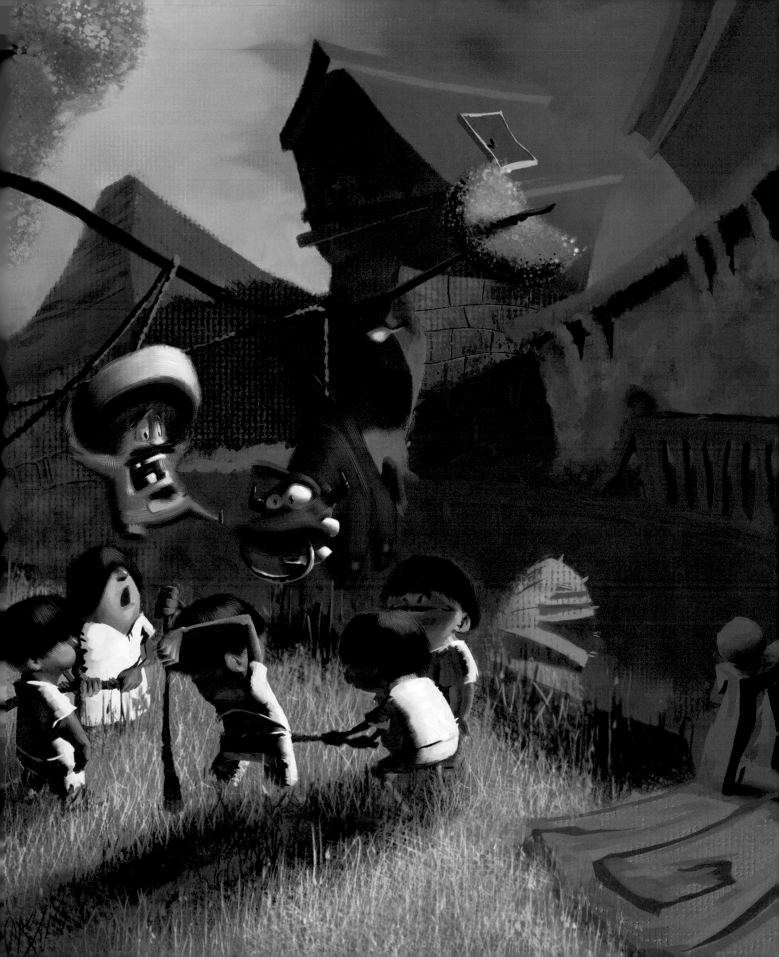

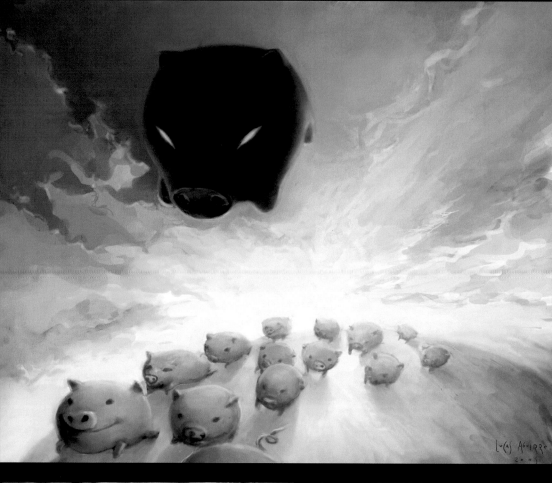

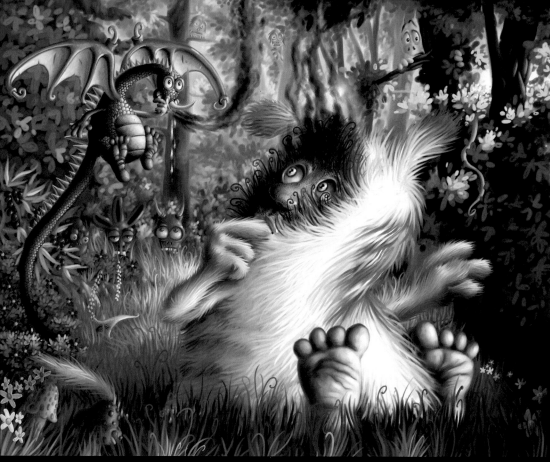

Flying pig
Painter, Photoshop
Client: Llanto de Mudo Publishing
Lucas Aguirre, ARGENTINA
[top]

Gesundheit
Painter
Einar Lunden, USA
[above]

Spacebabes!!!
Painter, Photoshop
Torsten Wolber, GERMANY
[right]

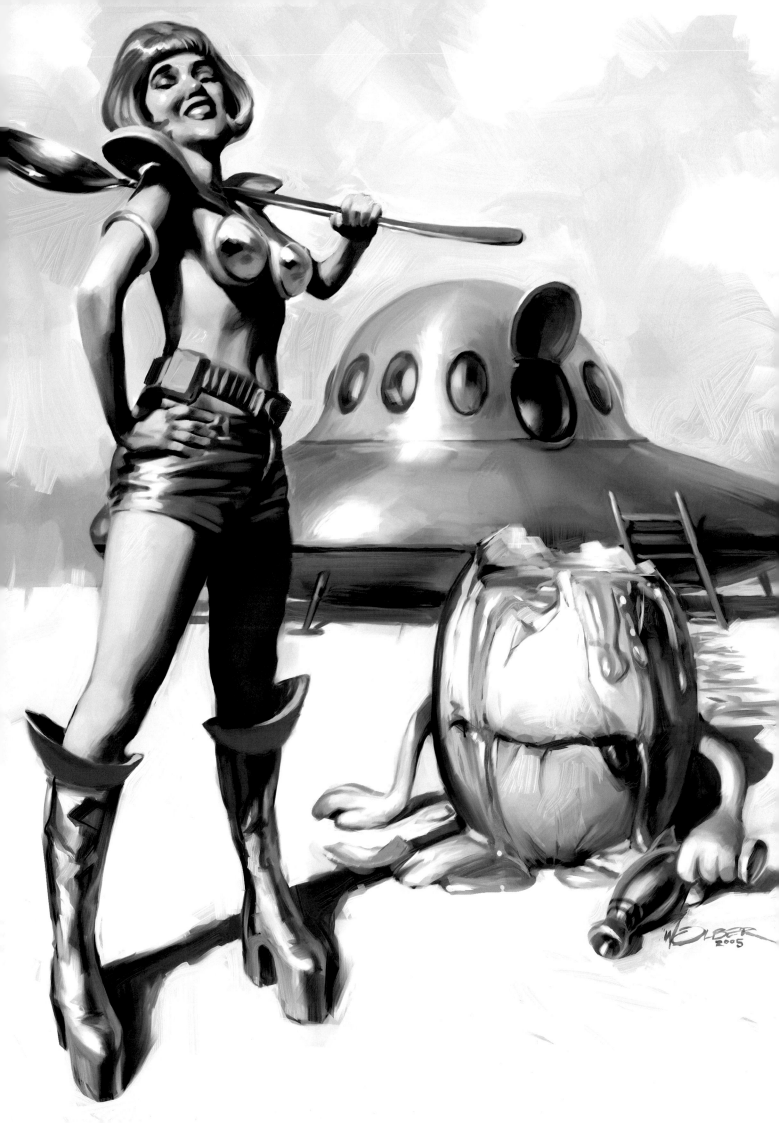

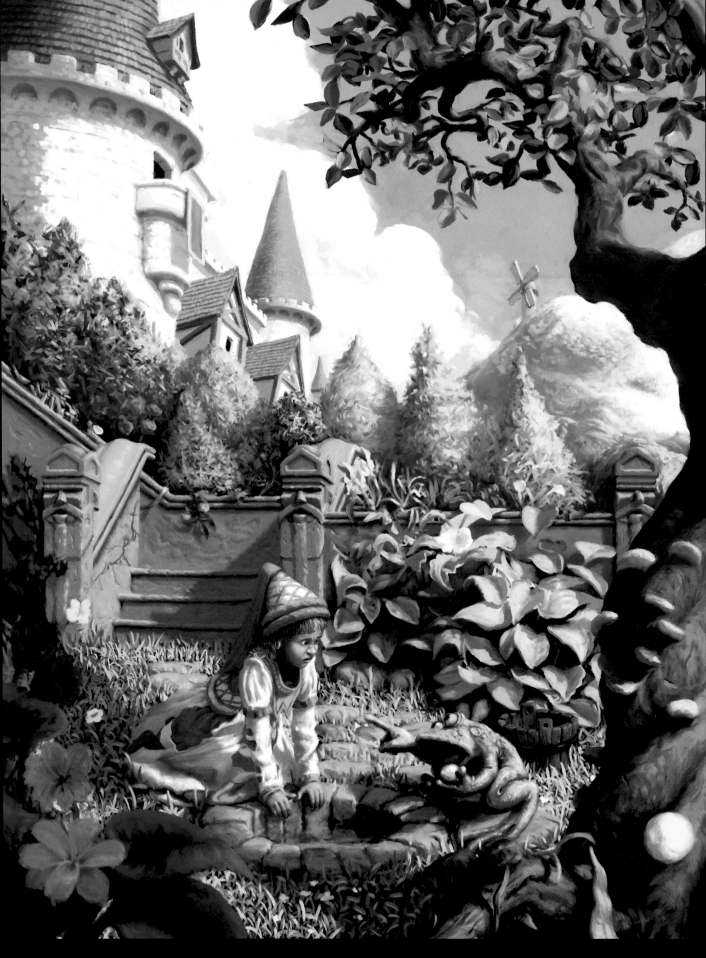

The Frog King
Painter
Chris Beatrice, USA
[above]

Basic instinct...
Painter
Denis Fokin, BonaSource Inc., RUSSIA
[right]

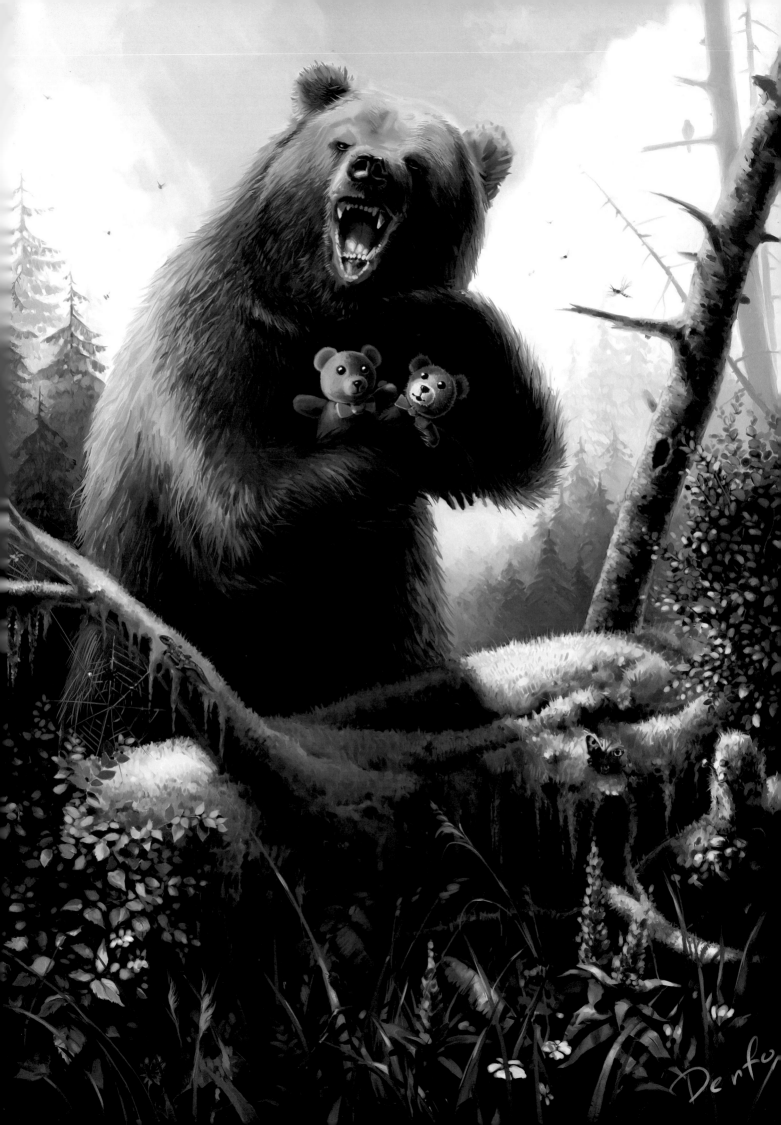

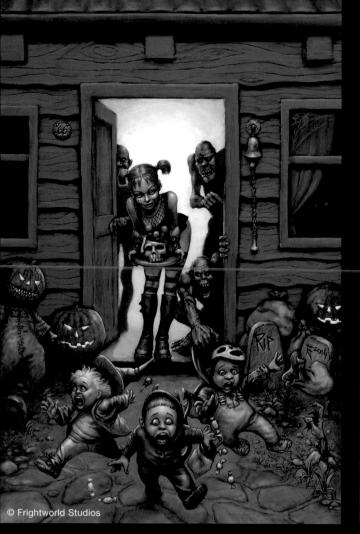

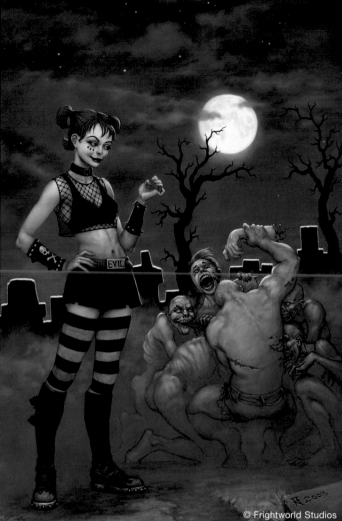

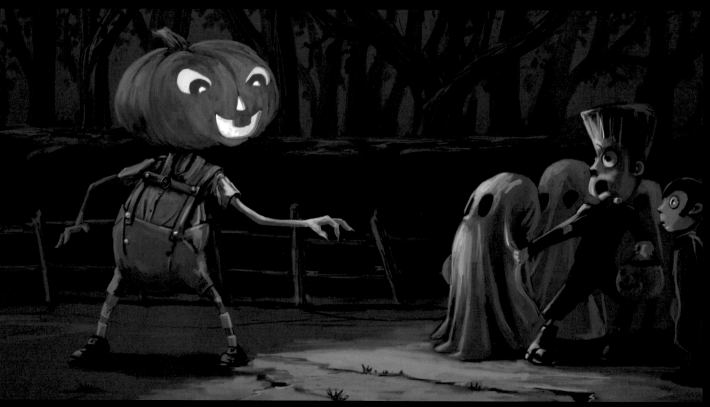

Trick or treat
Painter
Client: Frightworld Studios
Rafal Hrynkiewicz, THE NETHERLANDS
[top left]

Jack
Painter
Cliff Cramp, USA
[above]

Ditch the date
Painter
Client: Frightworld Studios
Rafal Hrynkiewicz, THE NETHERLANDS
[top right]

Humorous

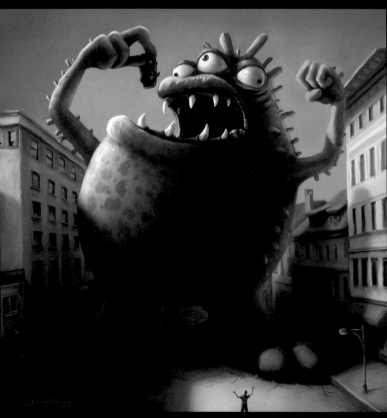

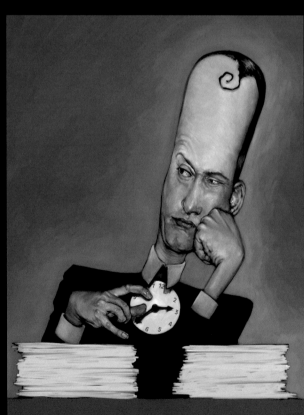

Traffic
Painter
Chuck Grieb,
USA
[top]

Not my car!
Painter, Photoshop
Jeremy Vickery,
USA
[above]

Companions
Painter
Rafal Hrynkiewicz,
THE NETHERLANDS
[top]

Clock man
Painter
Michael Pavlovich,
USA
[above]

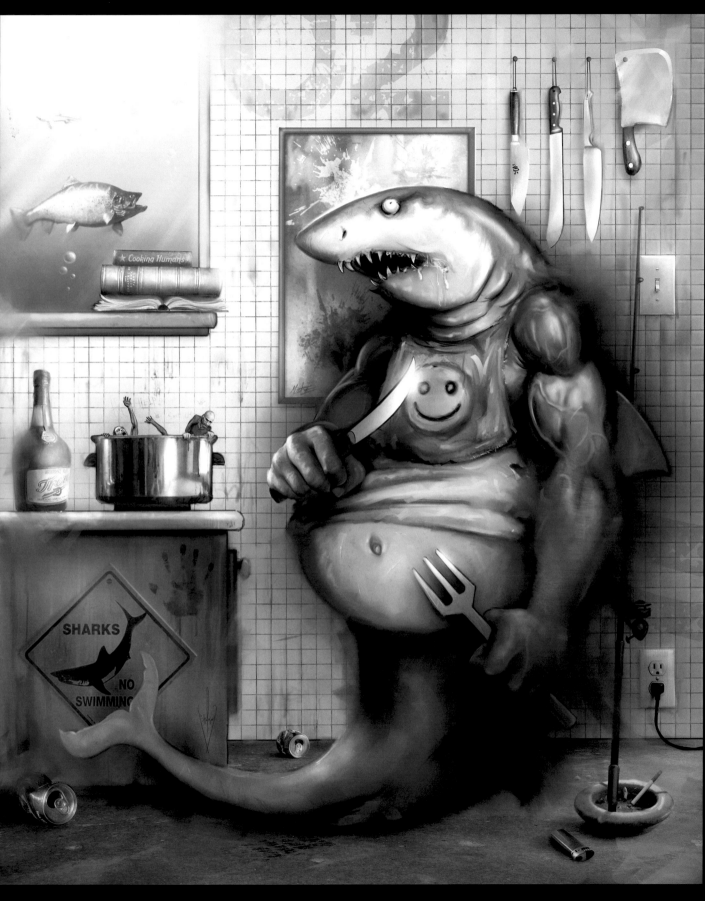

Great white chef
Painter
Phillip W. Anderson,
USA

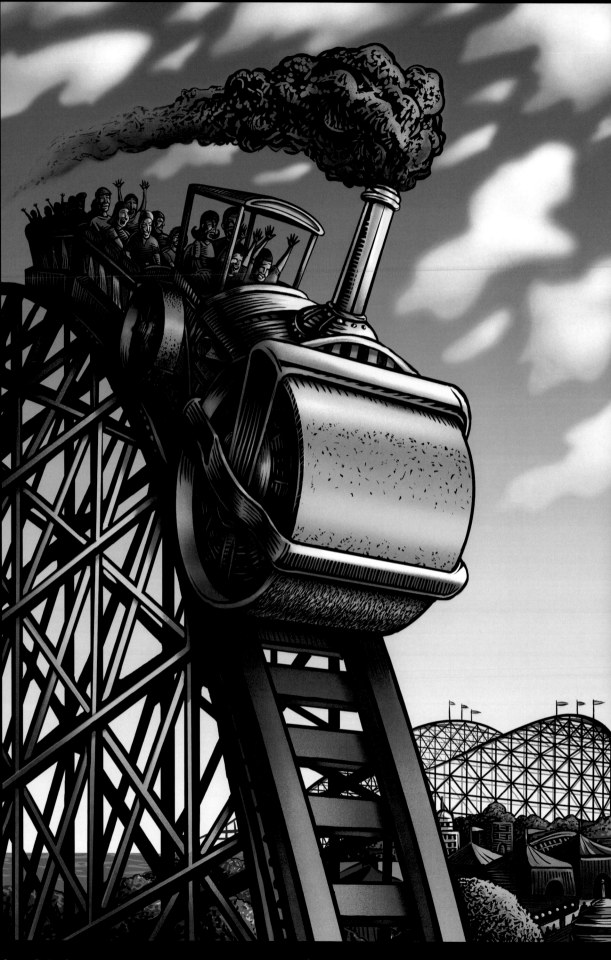

Steam Roller Coaster
Painter
Chet Phillips,
Chet Phillips Illustration, USA
[above]

I love Sushi
Painter
Chet Phillips,
Chet Phillips Illustration, USA
[right]

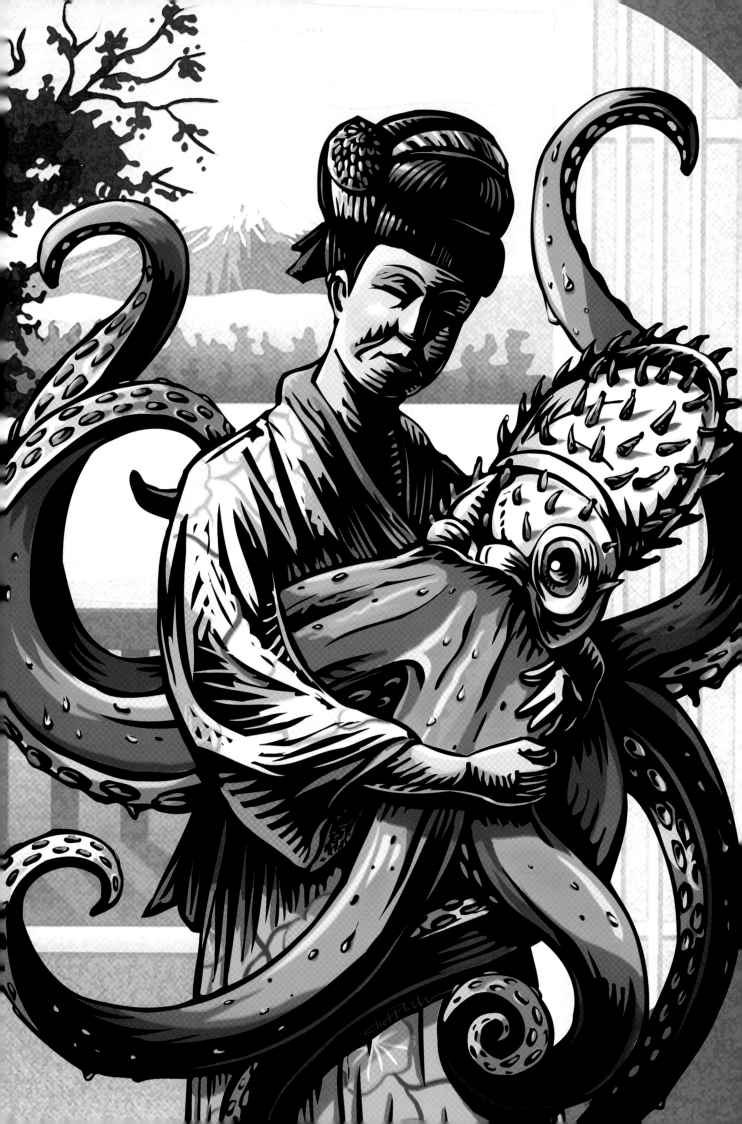

The City
Painter, Photoshop
Marek Olejarz, CANADA

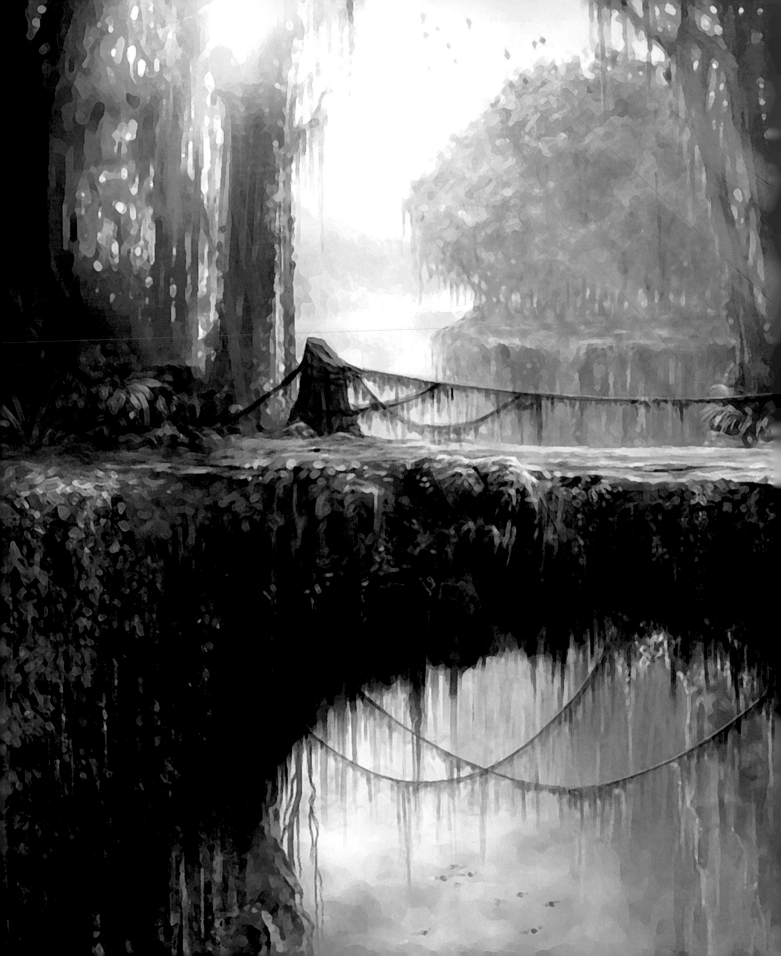

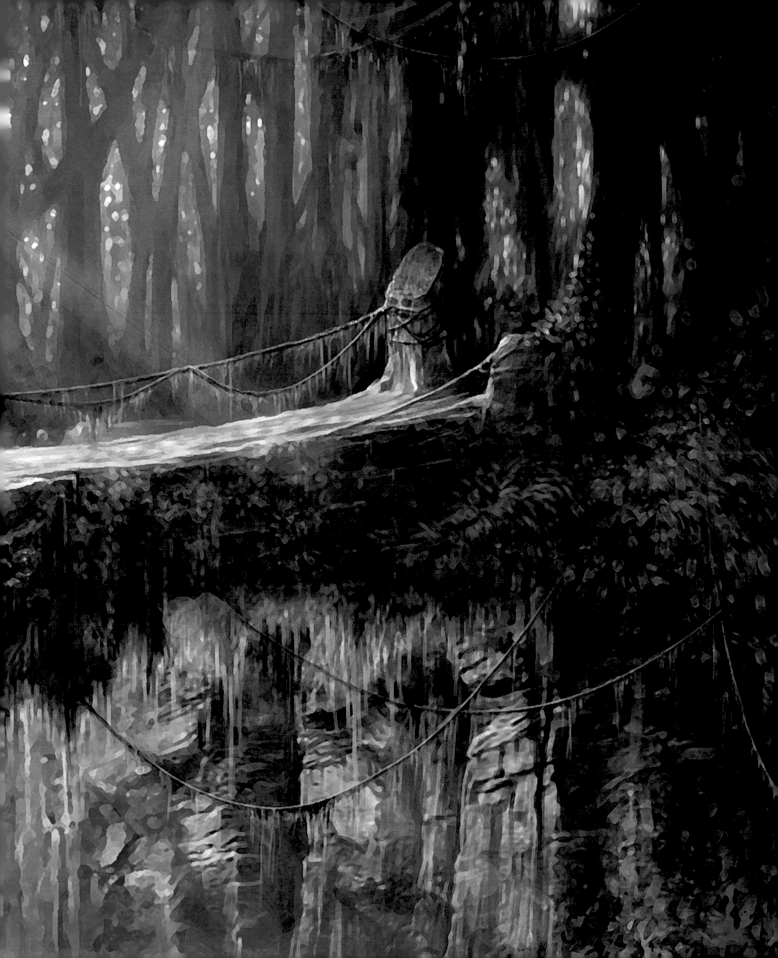

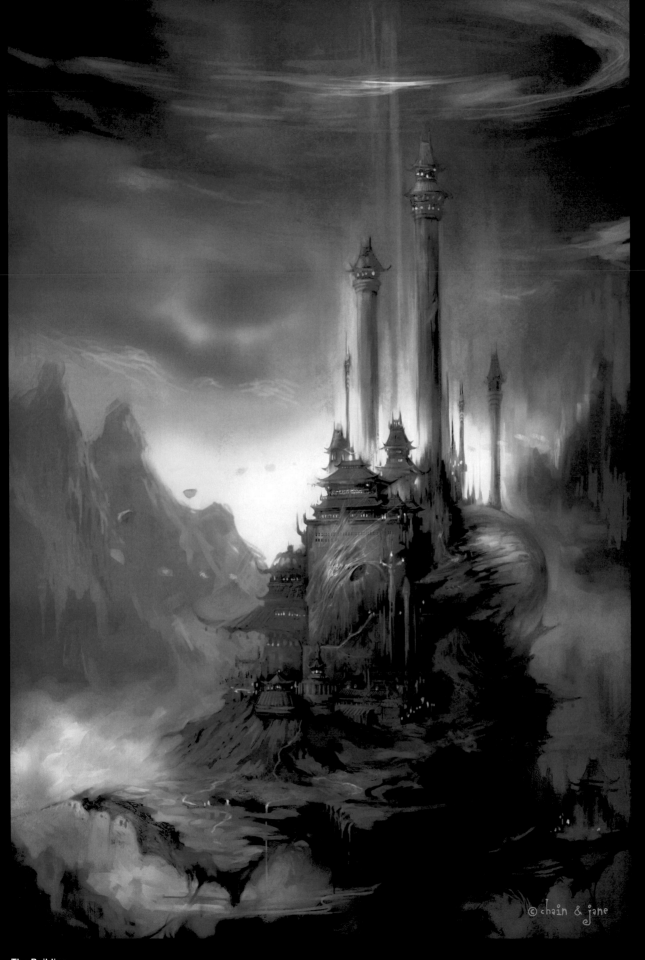

The Building
Painter, Photoshop
Jiansong Chen, CHINA

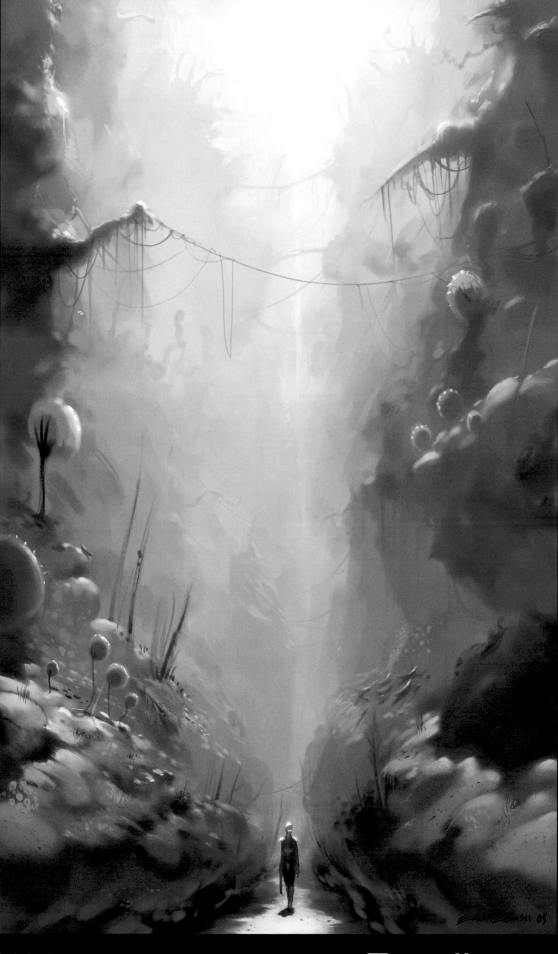

In the jungle
Painter
Emrah Elmasli, TURKEY

Excellence
Environment

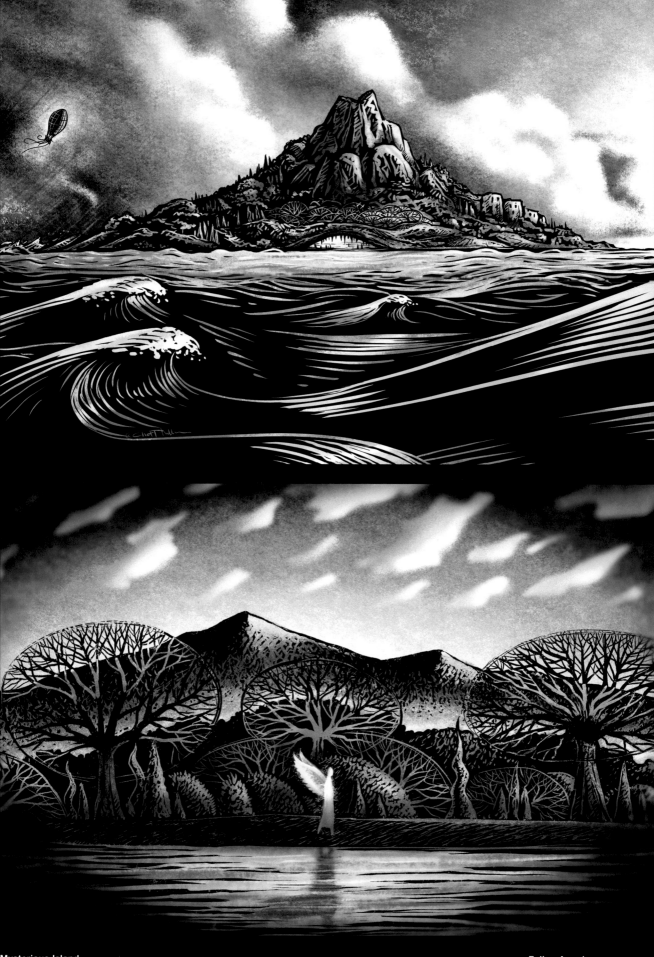

Mysterious Island
Painter

Fallen Angel
Painter

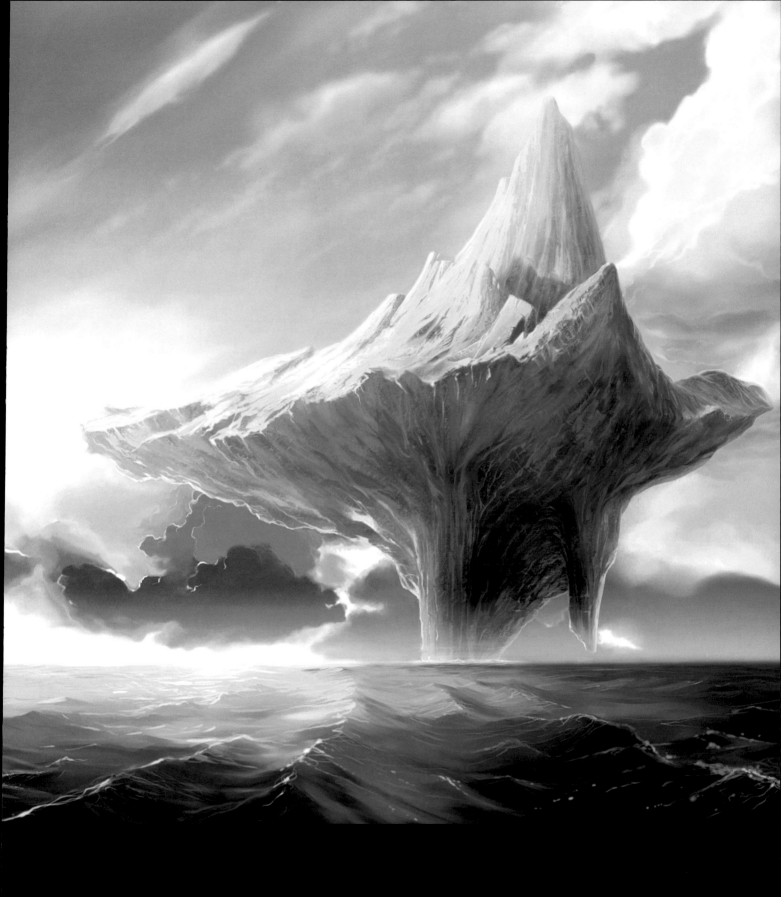

Carlendour
Painter
Zhimin Wang, CANADA

Excellence

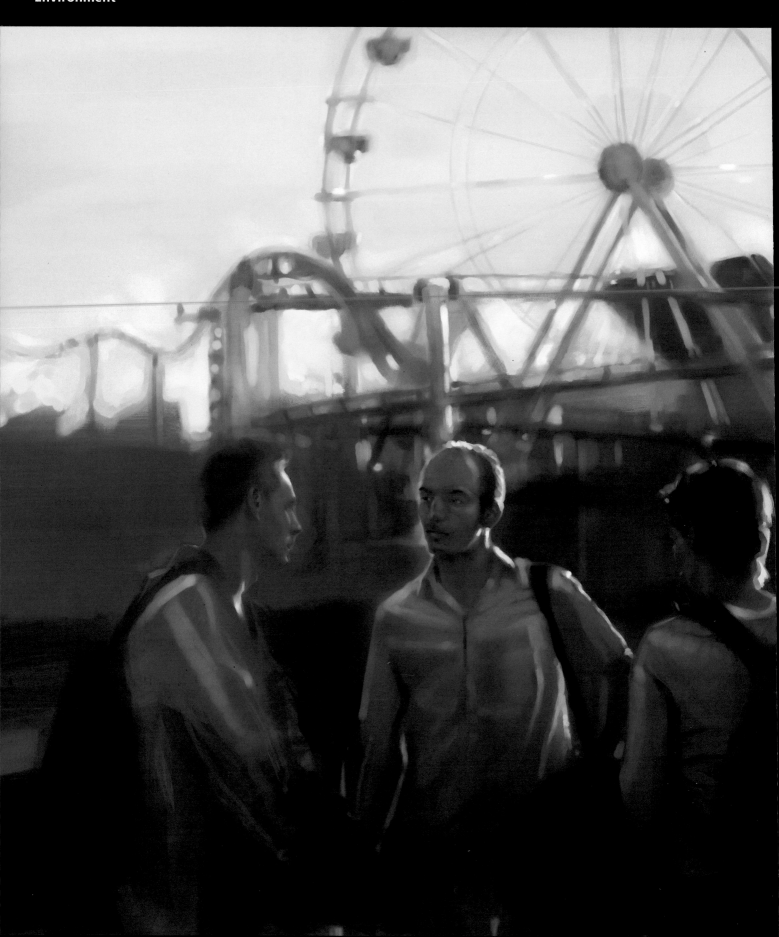

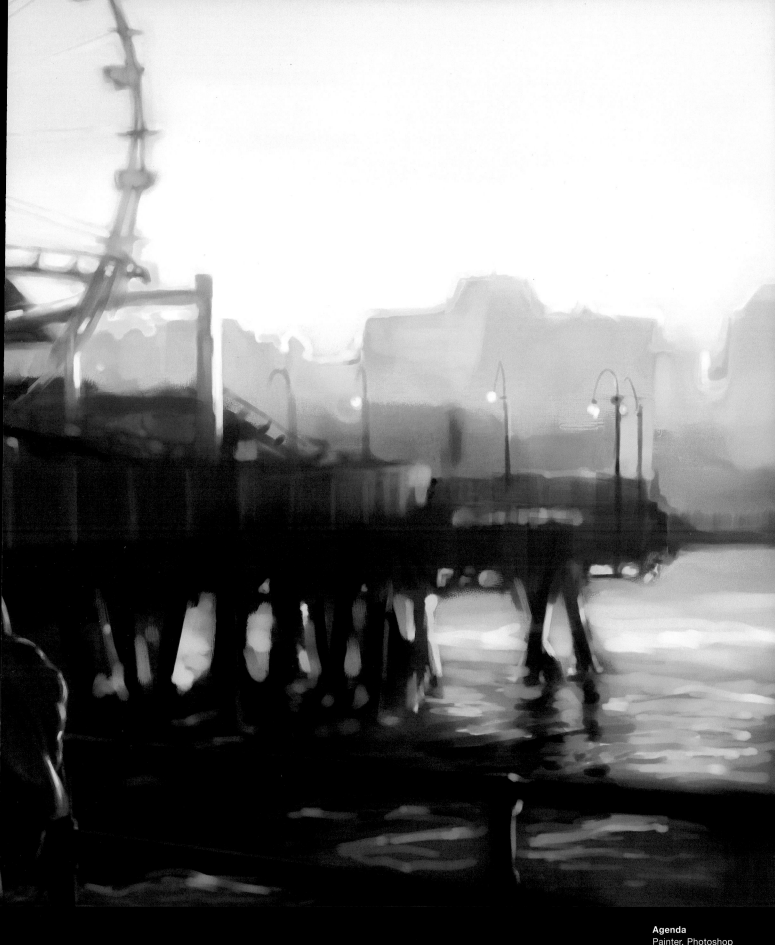

Agenda
Painter, Photoshop
Micah Henrie, USA

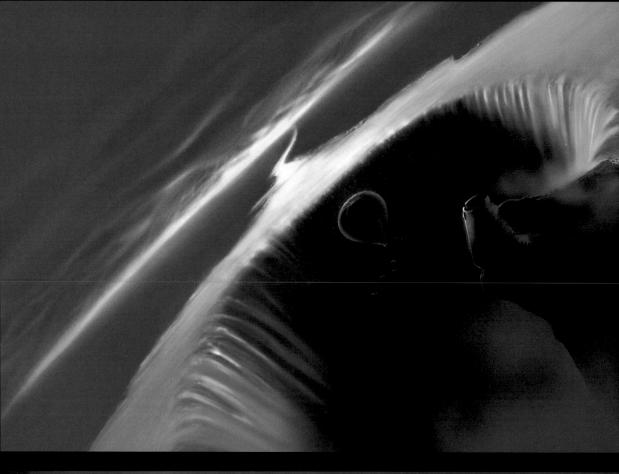

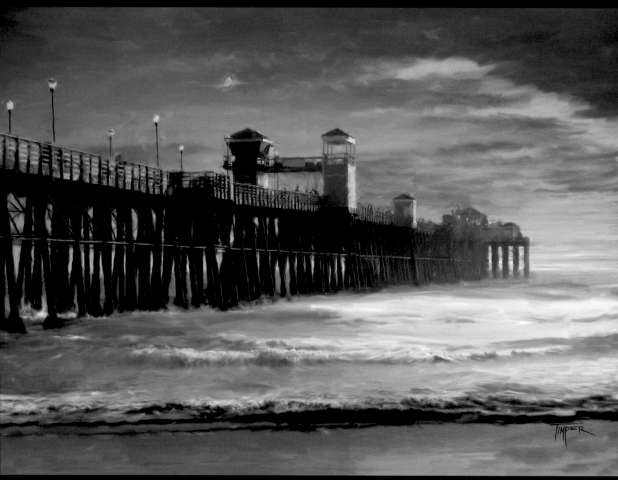

Late flight Oceanside pier Lost city

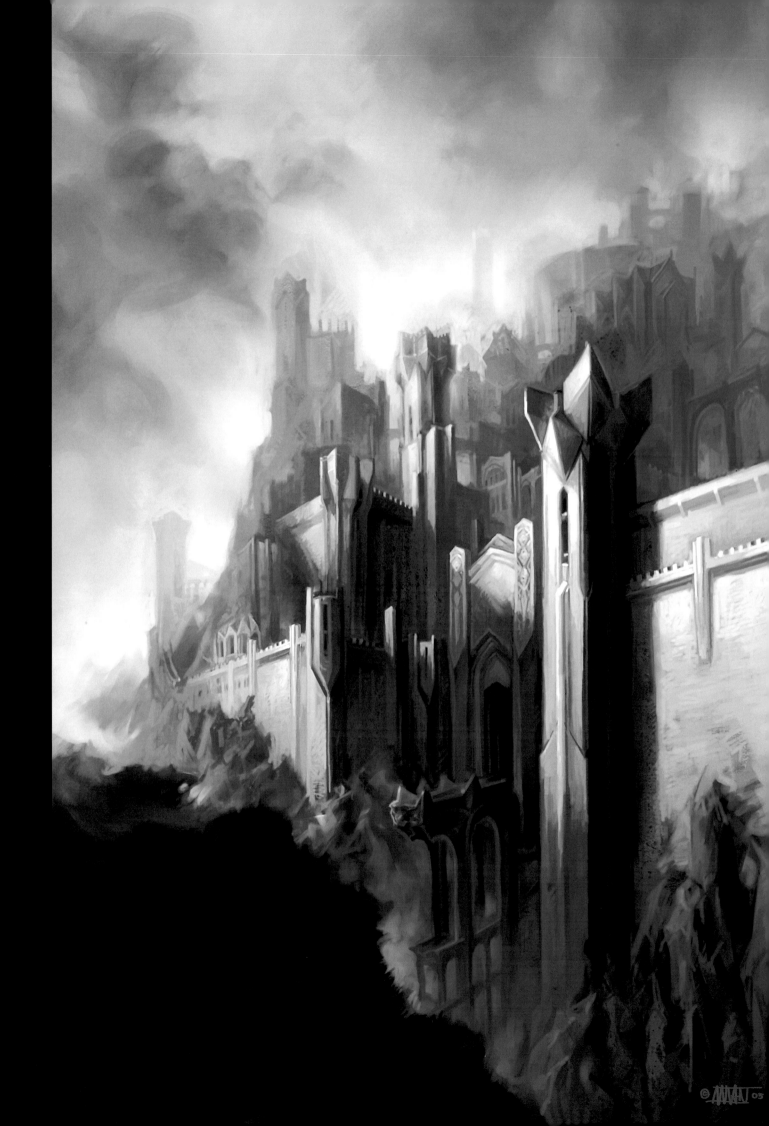

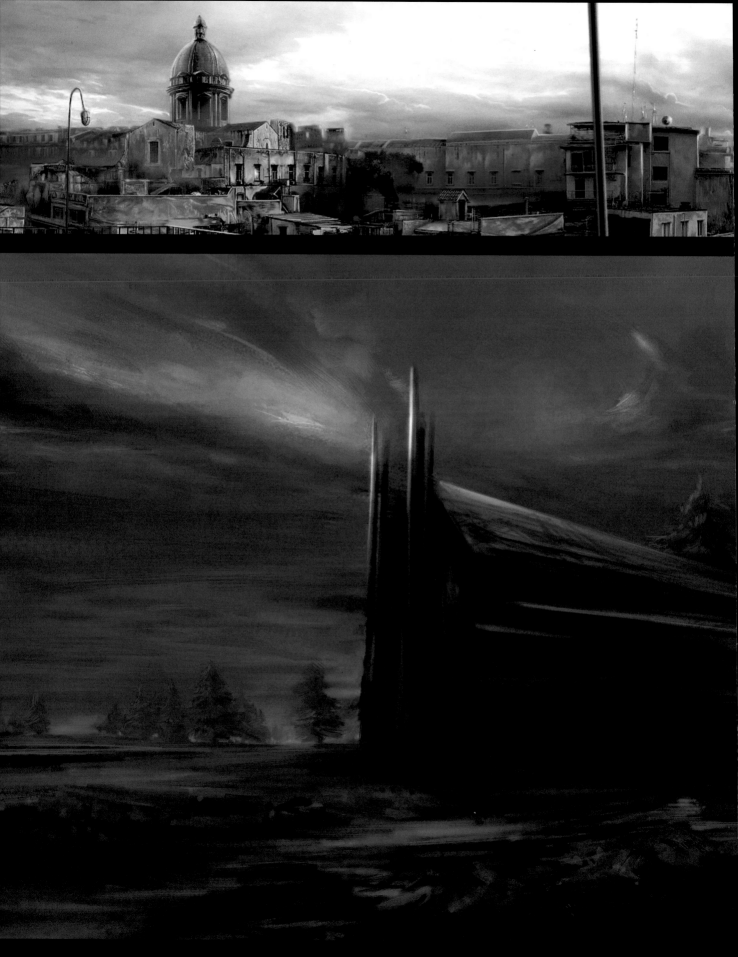

Sunset in Naples

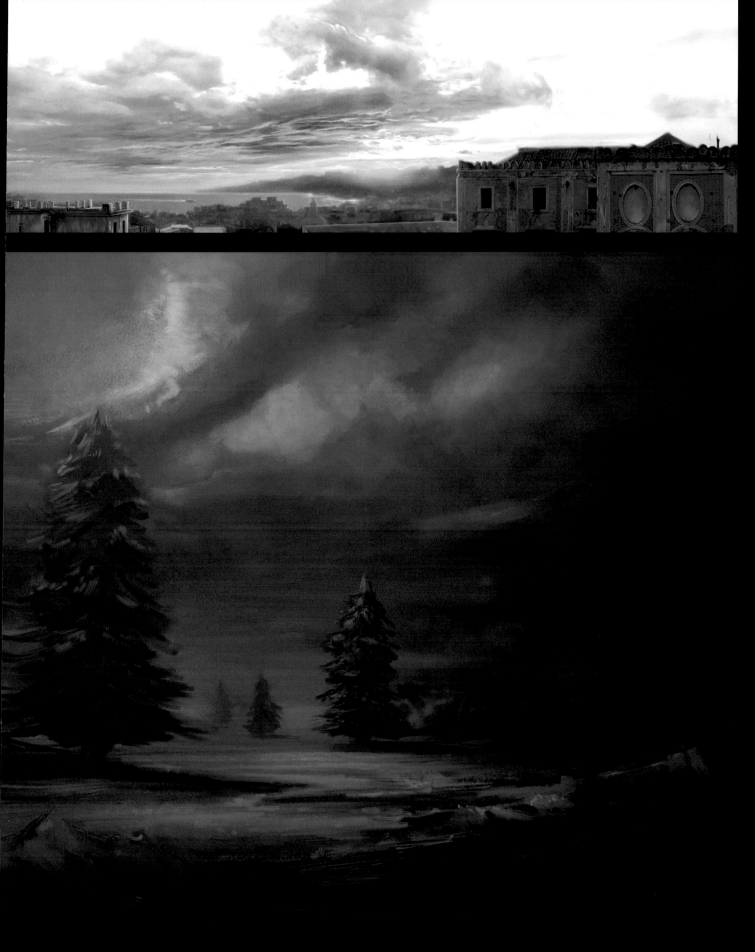

Forsaken field

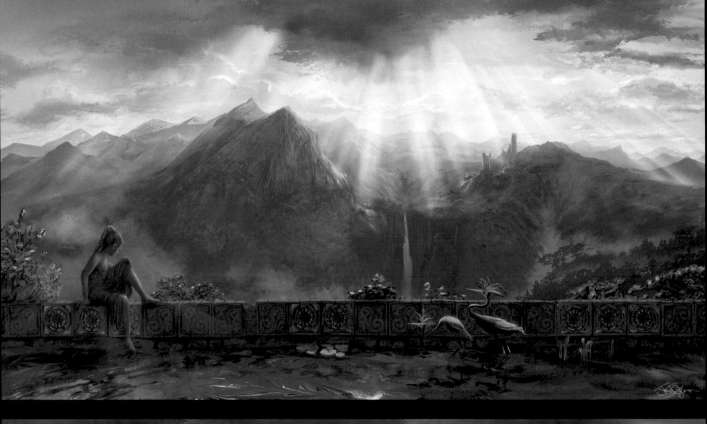

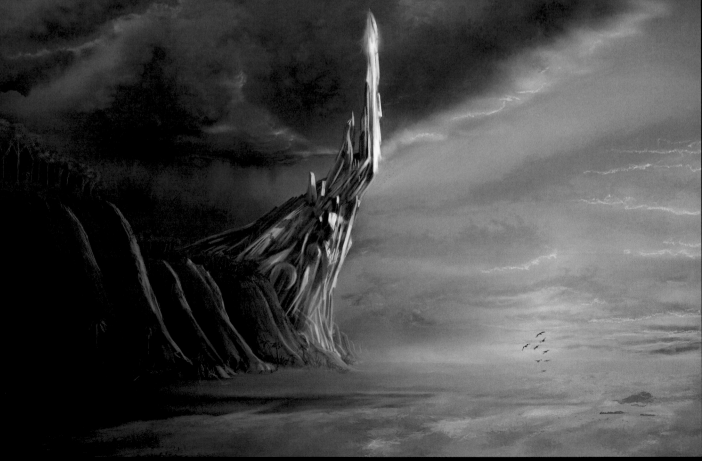

Grace
Painter

Sanctuary
Painter

Bridge of Life
Painter, Photoshop

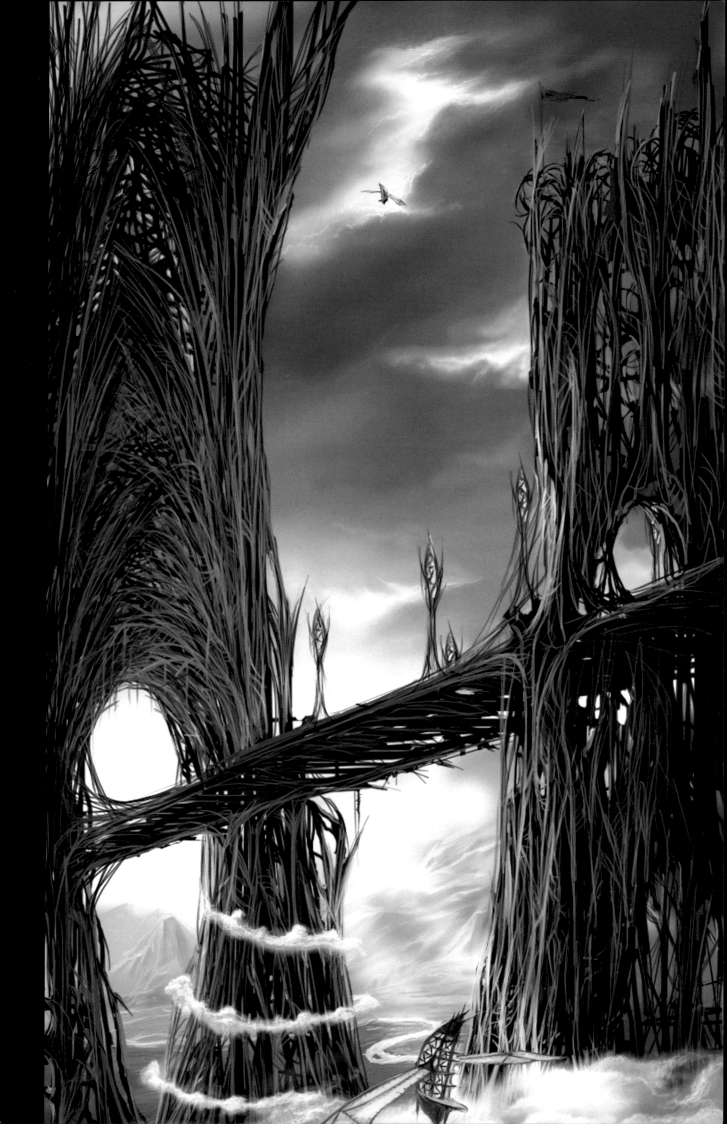

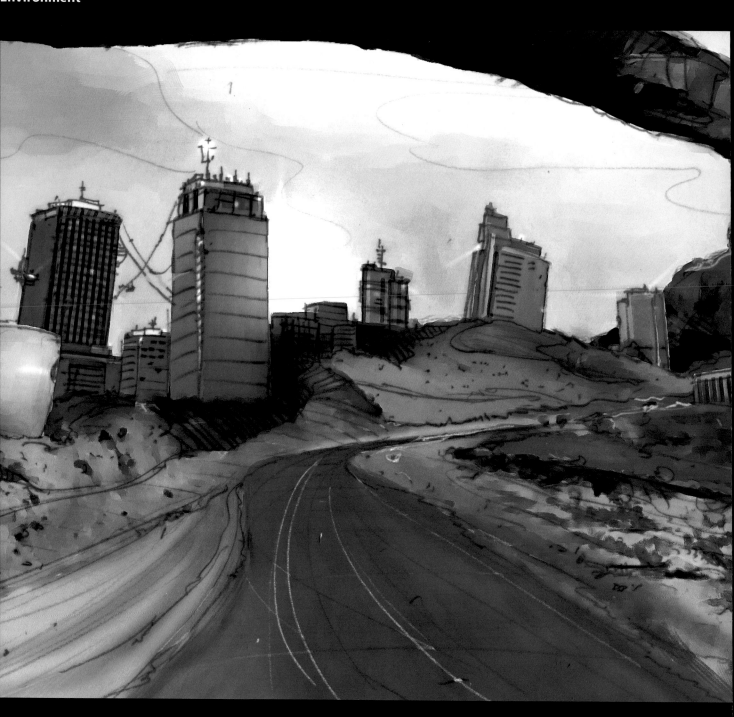

Buried city
Painter, Photoshop
Damien Thaller, AUSTRALIA
[above]

Blood relatives
Painter, Photoshop
Robin Chyo, USA
[left]

Spires
Painter, Photoshop
Patrick Parish, CANADA
[right]

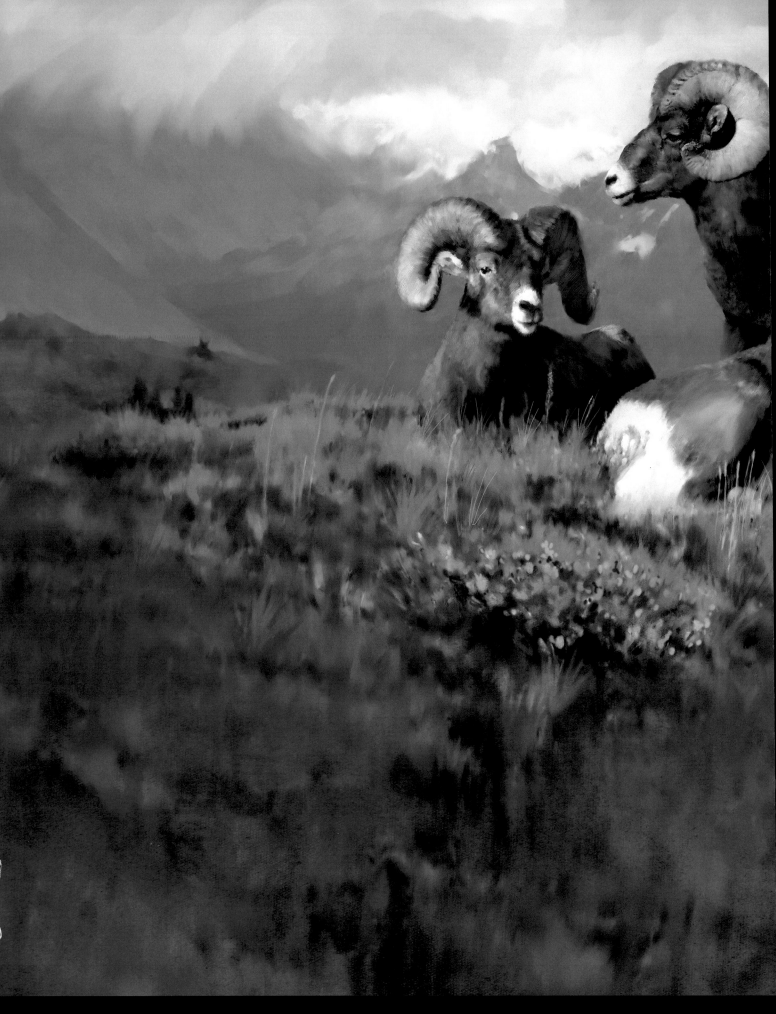

Master

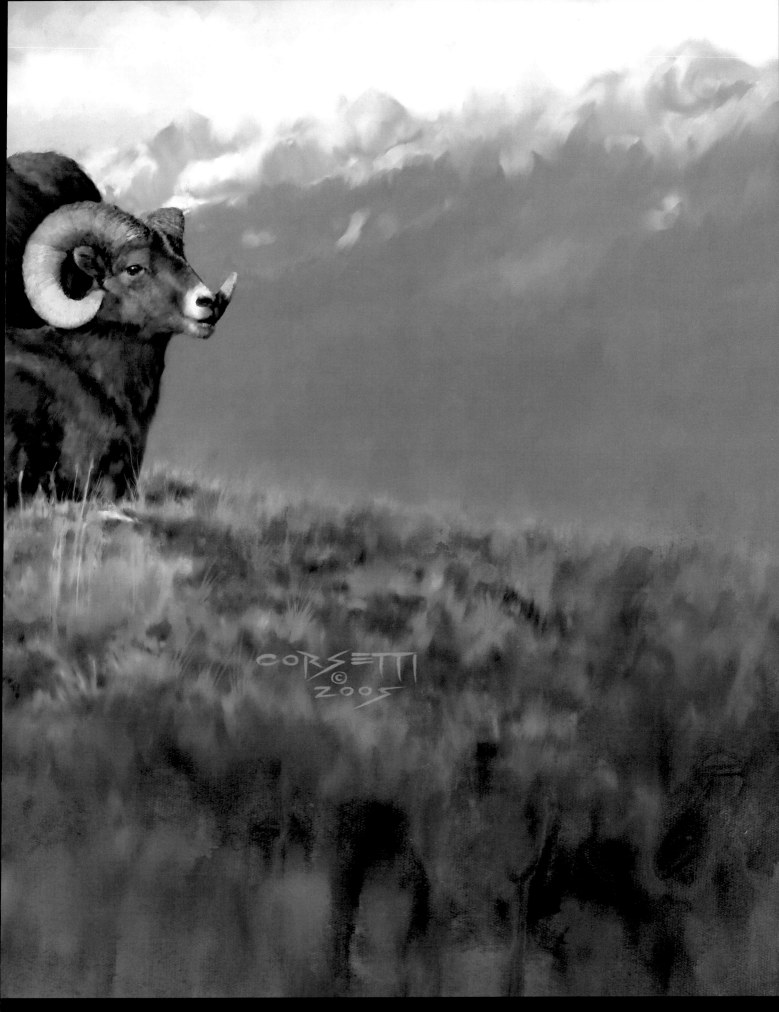

Corsetti © 2005

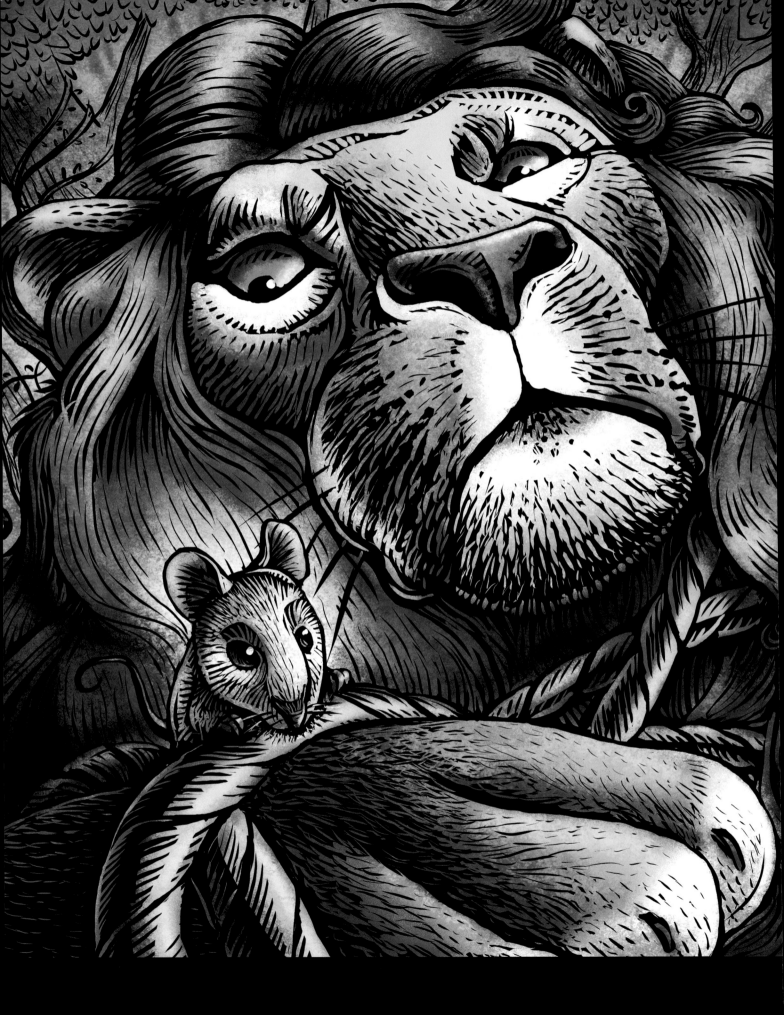

Excellence
Wildlife

The Lion and the Mouse
Painter
Chet Phillips,
Chet Phillips Illustration, USA

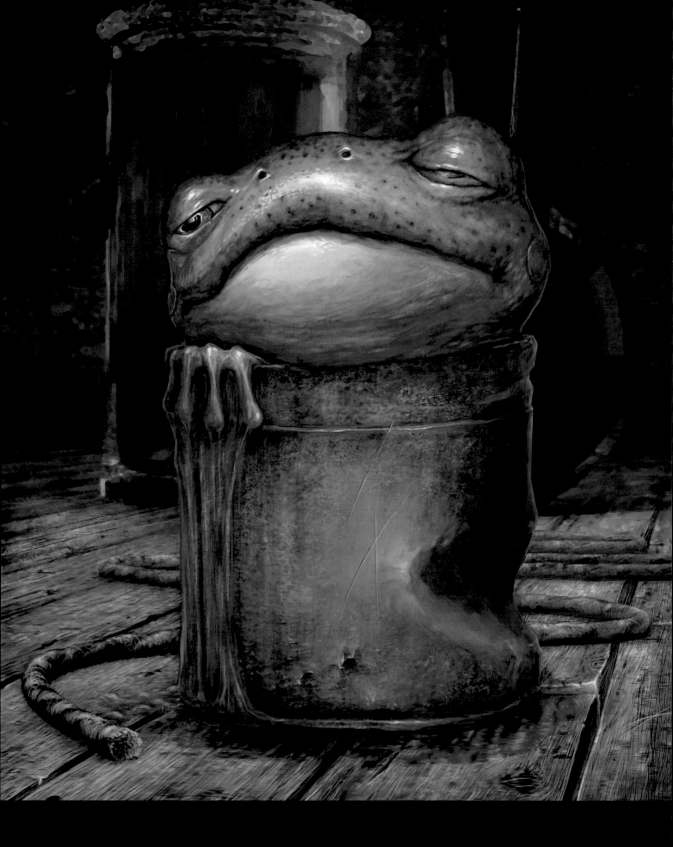

Helpless
Painter
Weiye Yin, CHINA

Excellence
Wildlife

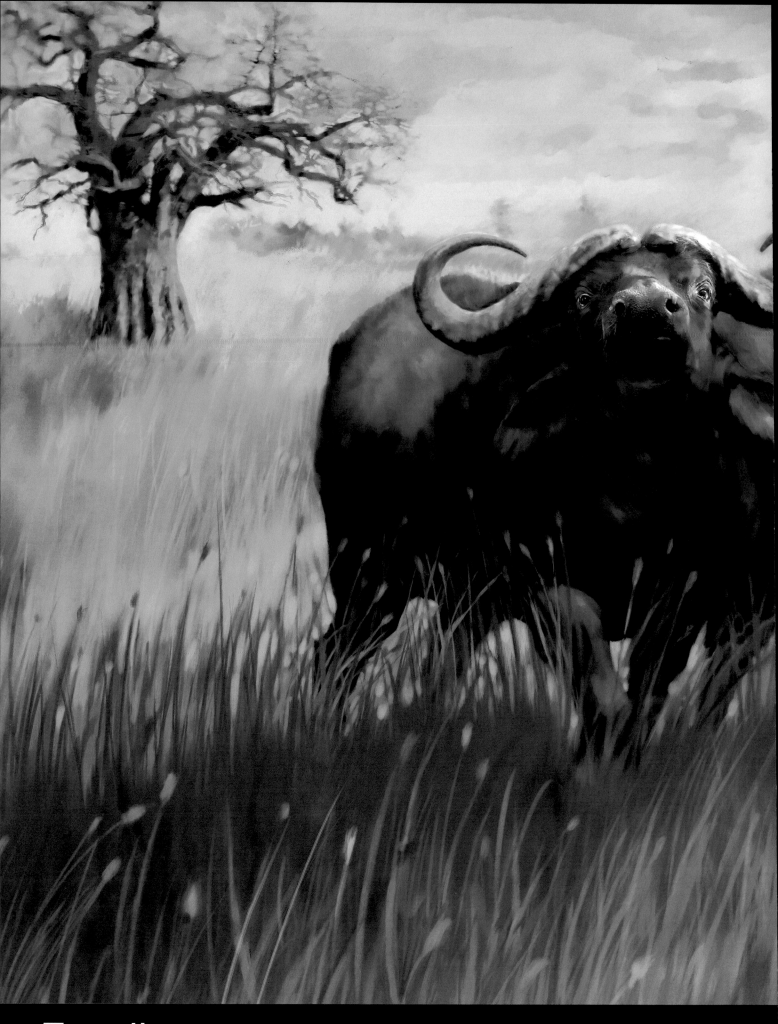

Excellence

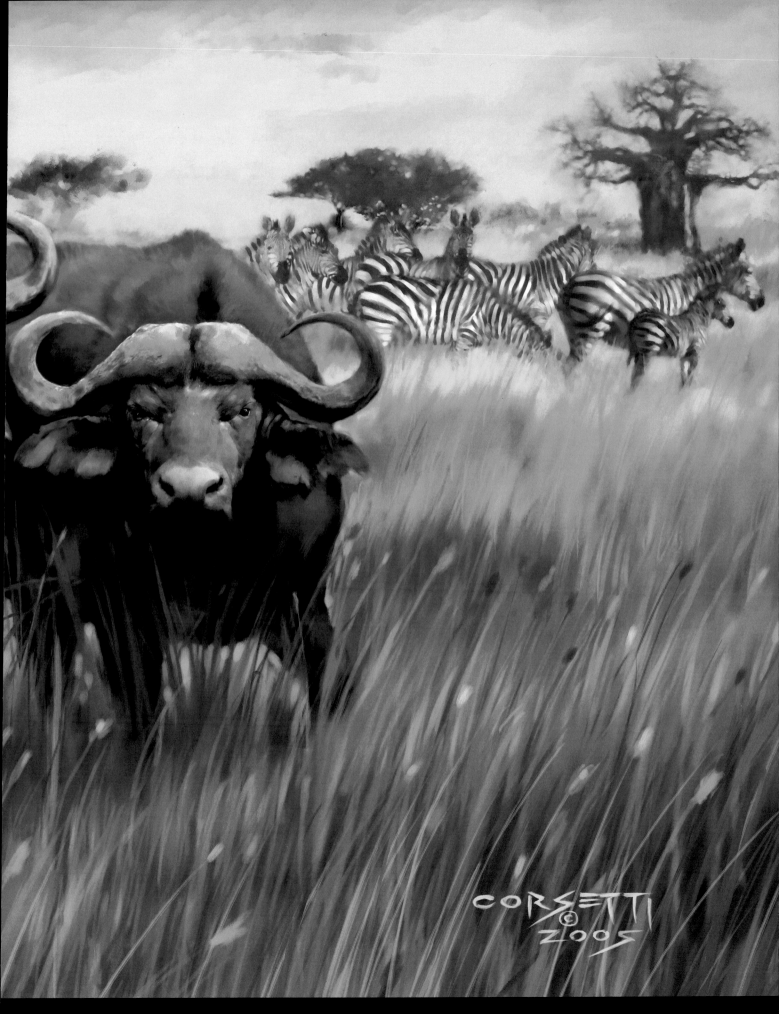

Two bad duga boys
Painter

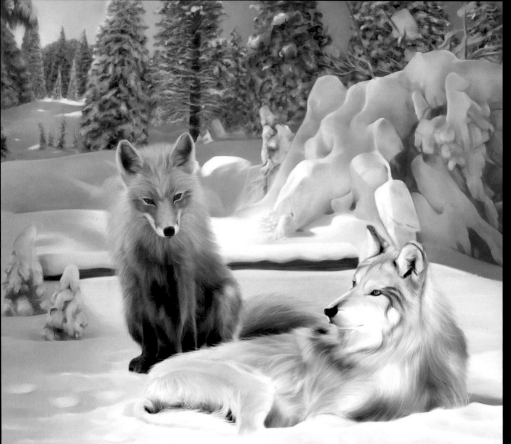

Winter sisters
Painter, Photoshop
Mayrhosby Yeoshen
VENEZUELA
[left]

Cat napping
Painter
Tina Harkin,
GREAT BRITAIN
[right]

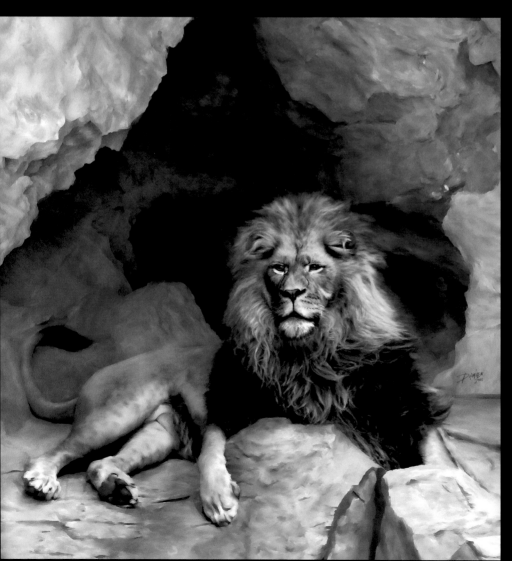

Simhana
Painter
Damien Thaller,
AUSTRALIA
[left]

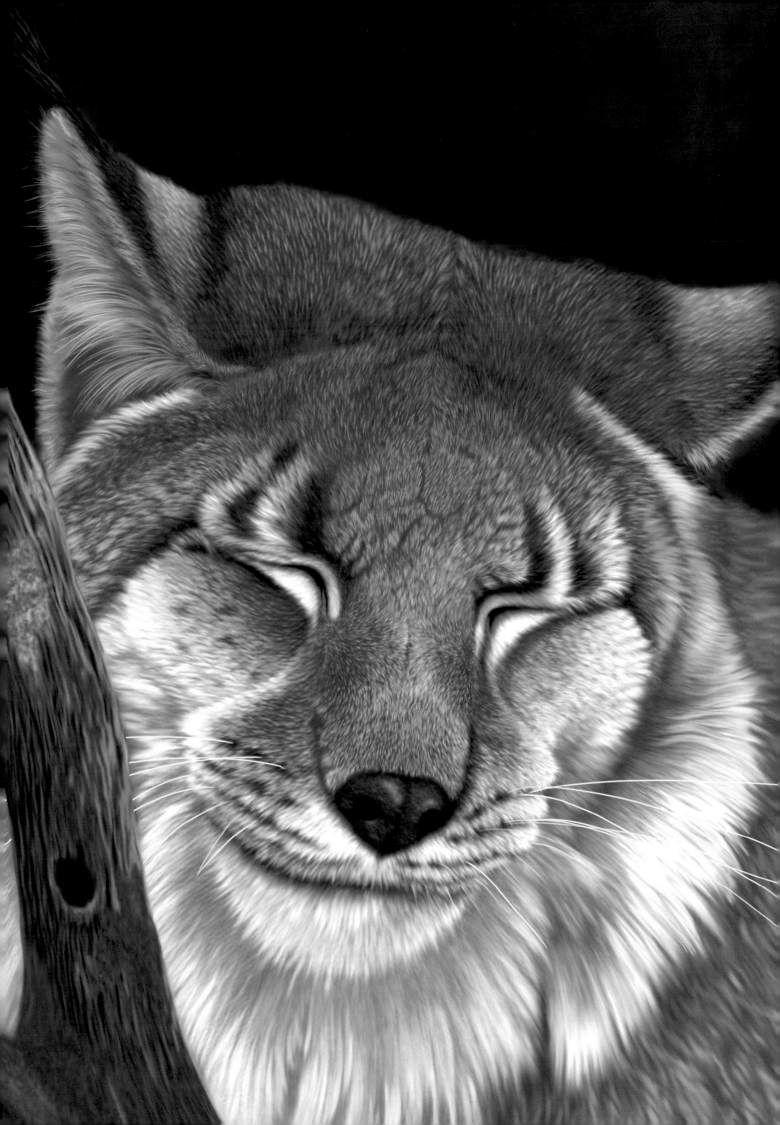

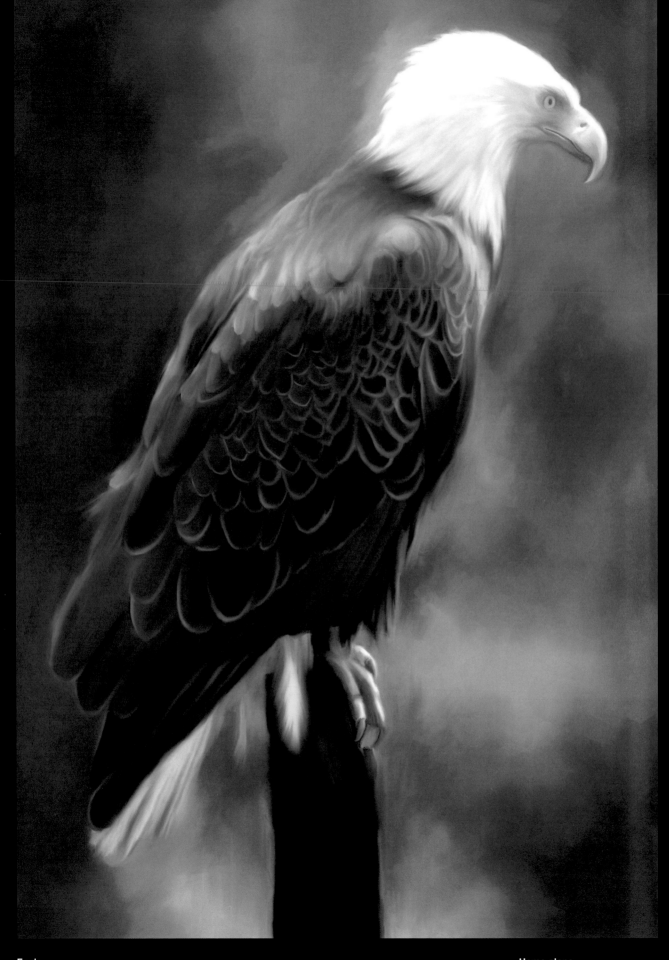

Eagle
Painter
Levent Bozkurt, Limon Design,

Home alone
Painter
Bobby Chiu, Imaginism Studios,

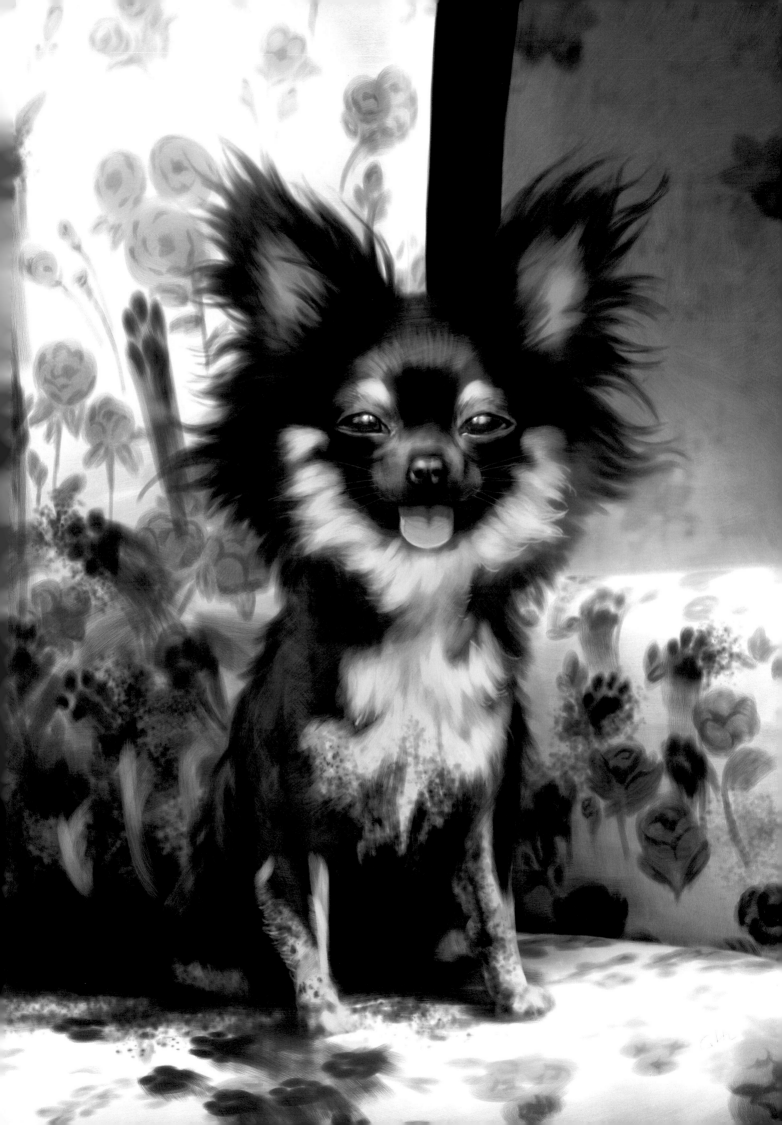

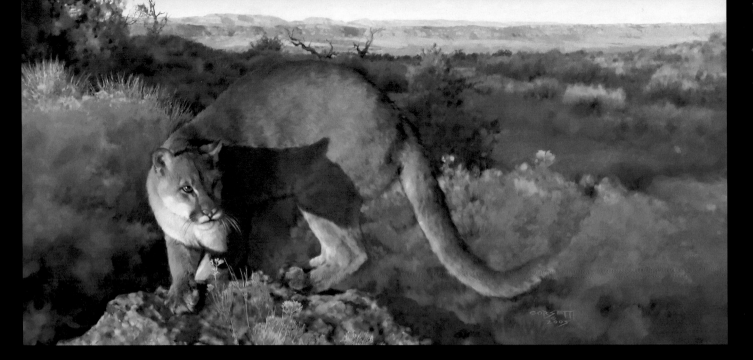

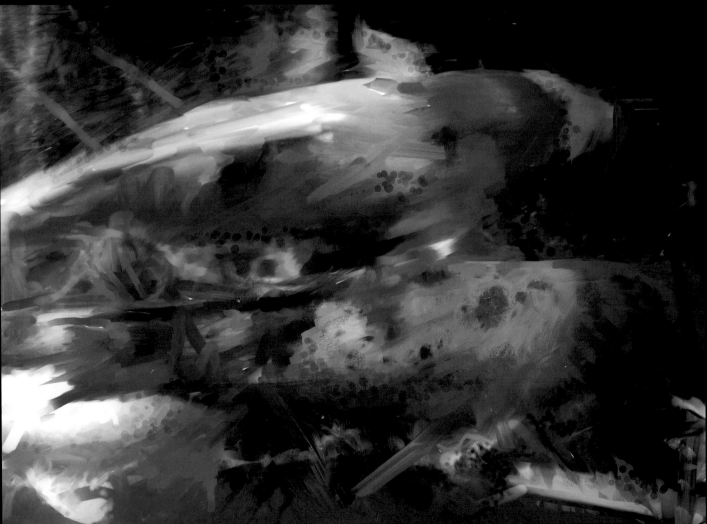

Cat stretch
Painter

Iluminata A1422
Painter

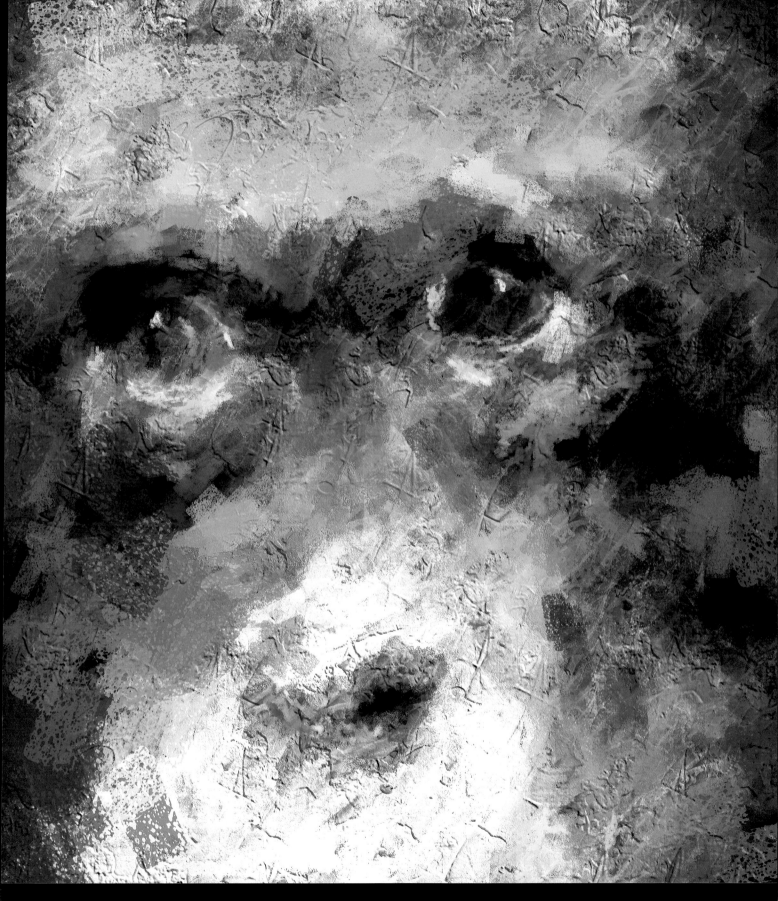

Old Blue Eyes
Painter

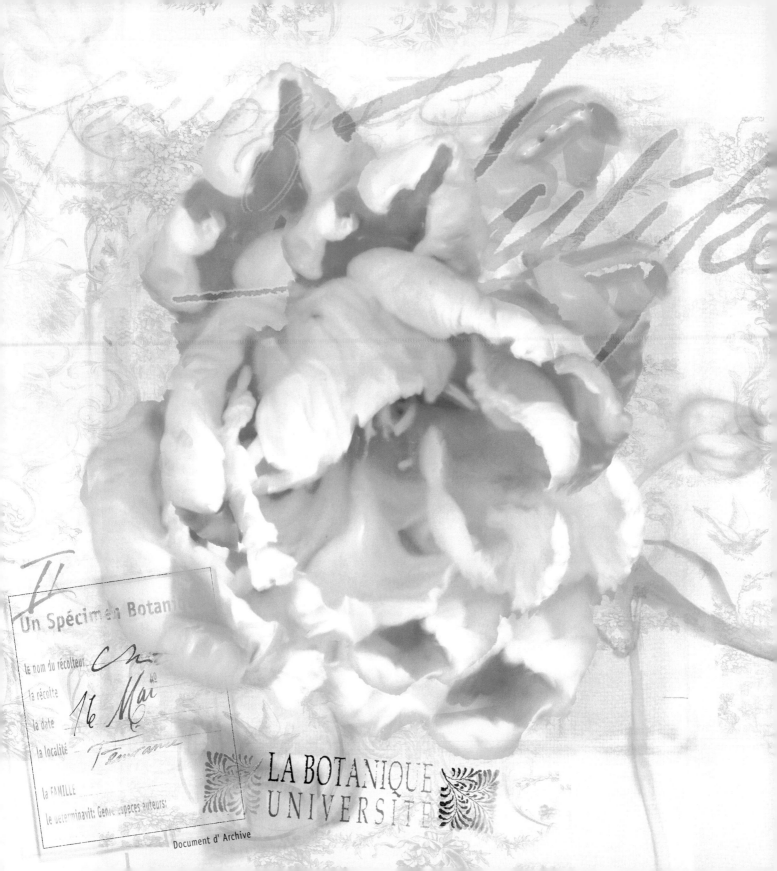

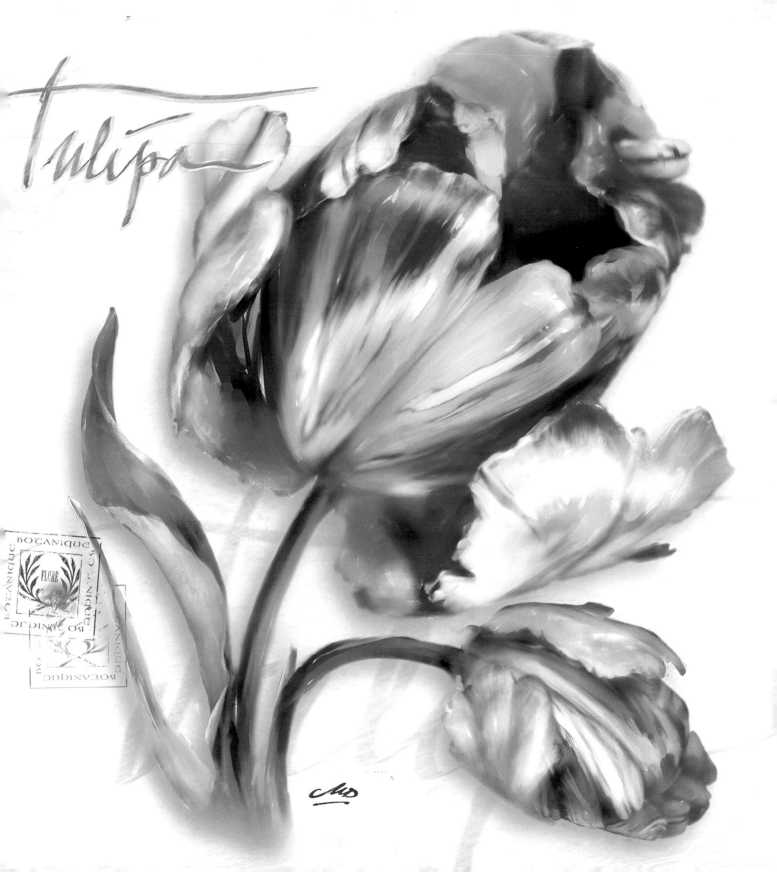

Tulipa

BOTANIQUE
FLORE
BOTANIQUE

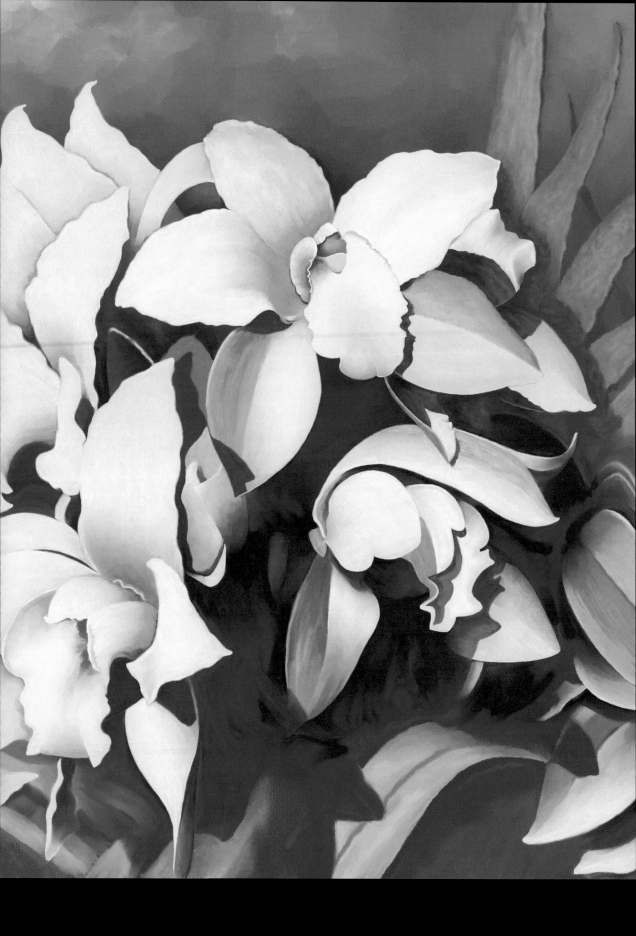

Excellence

Still Life

Flowers in light and shadow
Painter
Dennis Orlando, USA

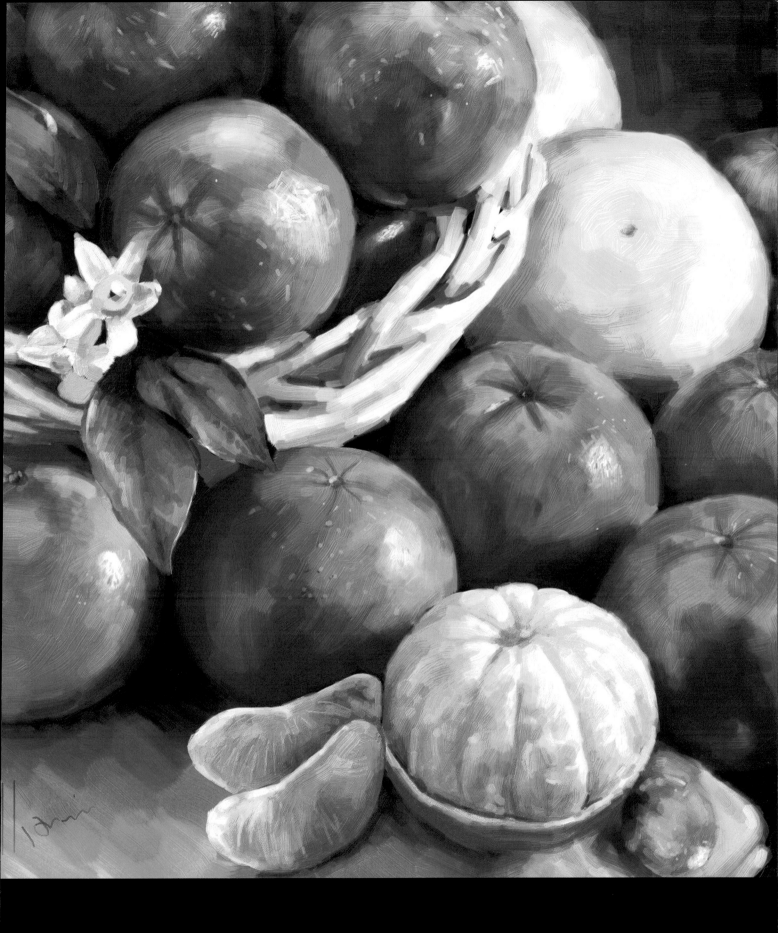

Oranges
Painter
Maria Khurram, PAKISTAN

Excellence

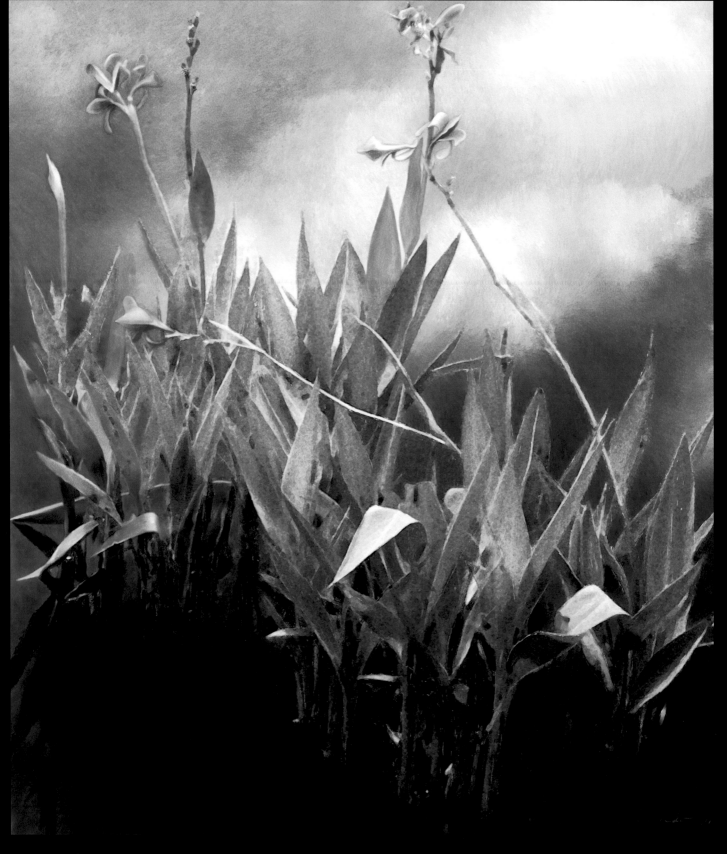

The Water Flowers
Painter
Dennis Orlando, USA
[top]

The Lillypads
Painter
Dennis Orlando, USA
[right]

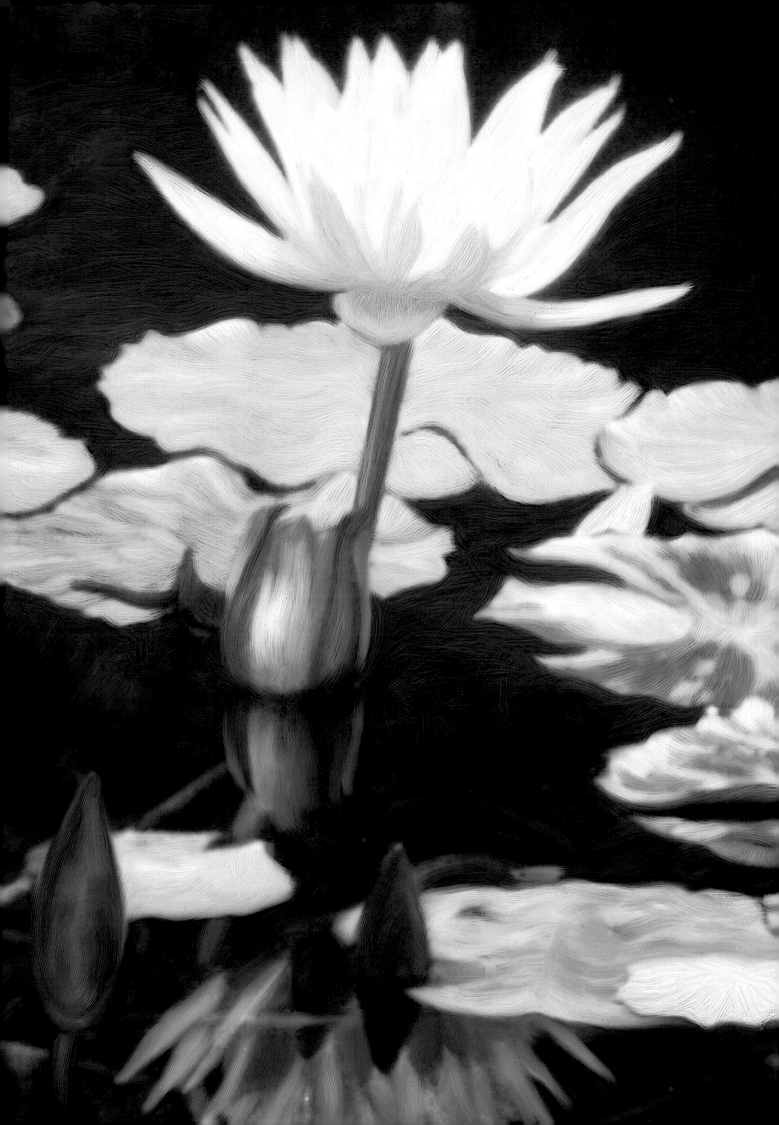

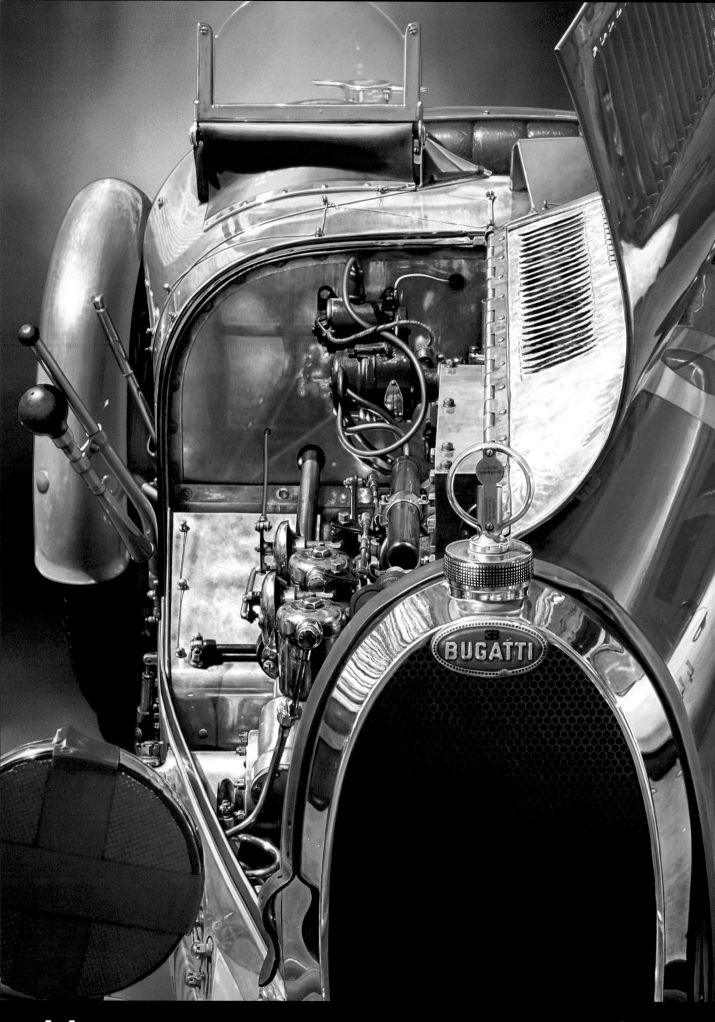

Master

Race time
Painter
Wu-Huang Chin, USA

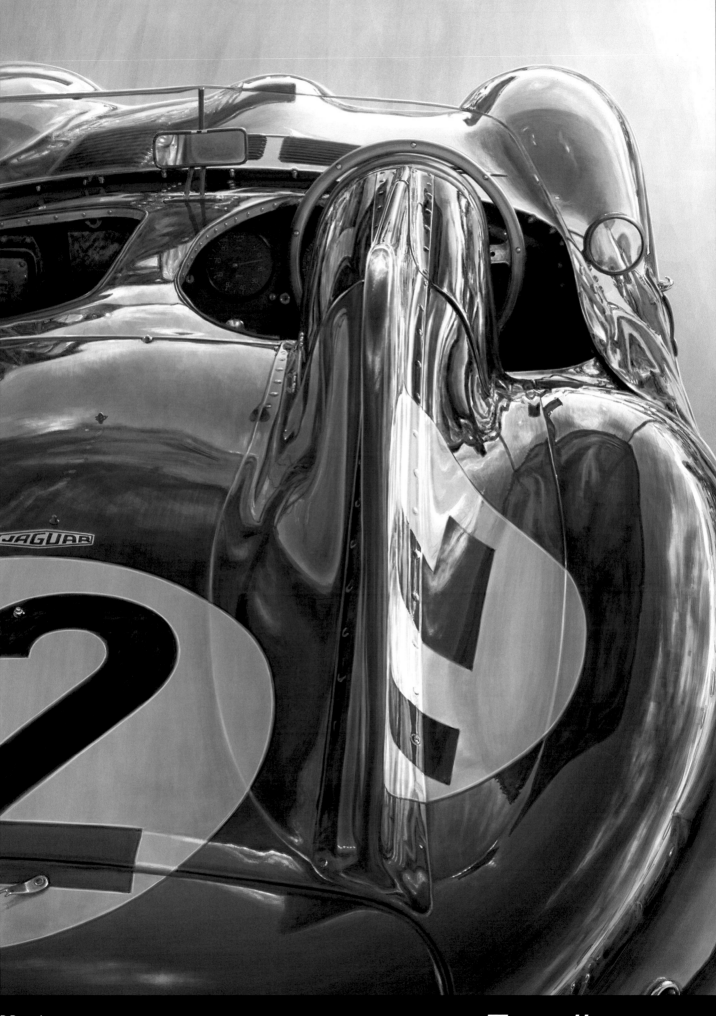

D Dreaming
Painter
Wu-Huang Chin, USA

Excellence
Transport

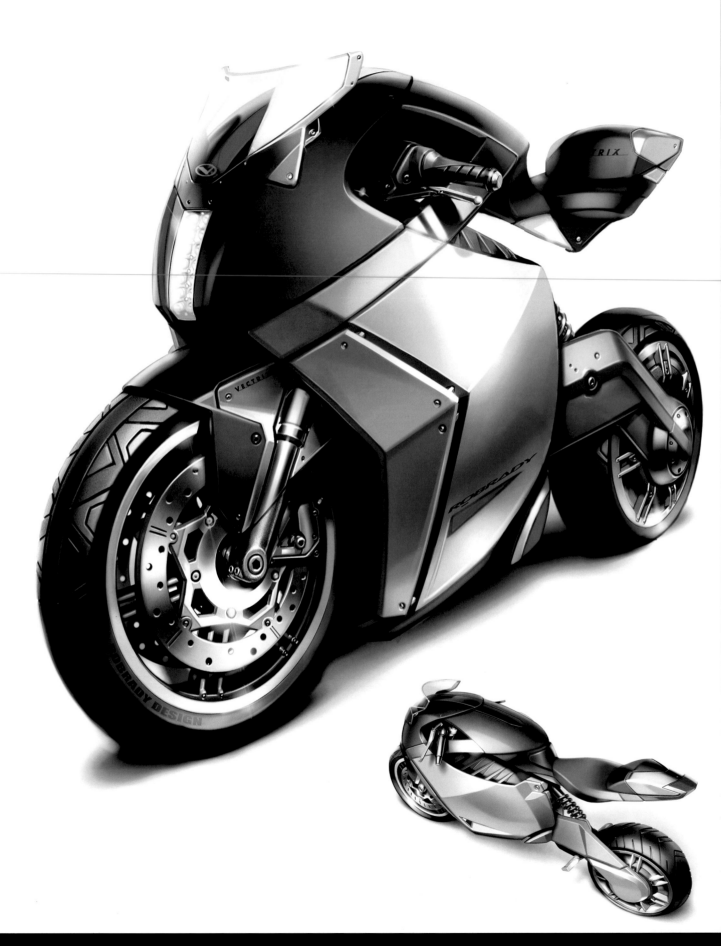

Excellence

Transport

ROBRADY Design Rmoto Concept
Painter
Erik Holmen, USA

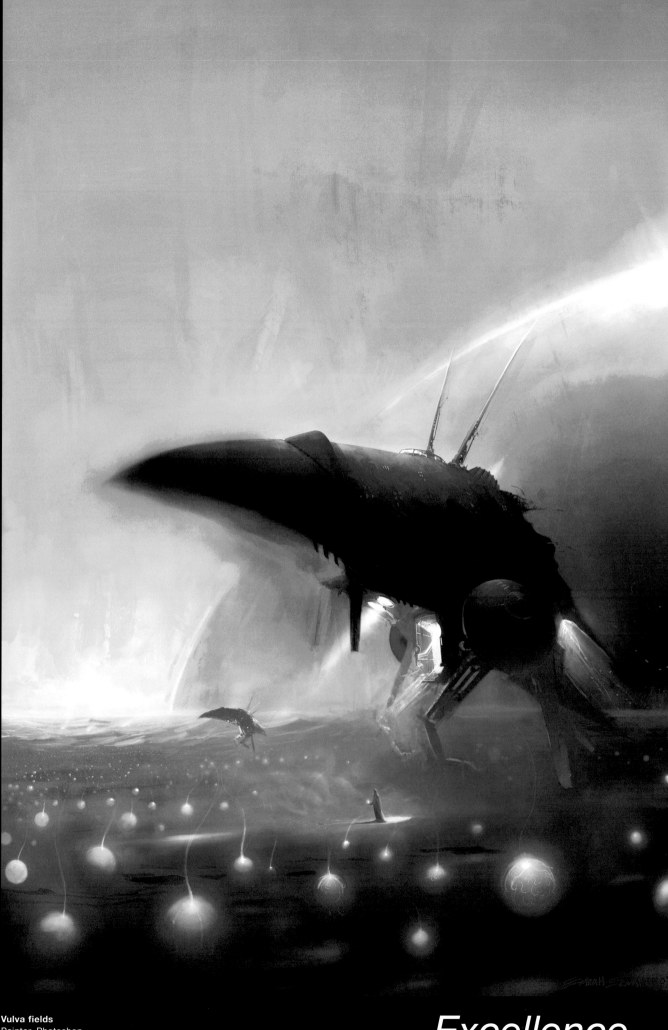

Vulva fields
Painter, Photoshop
Emrah Elmasli, TURKEY

Excellence
Transport

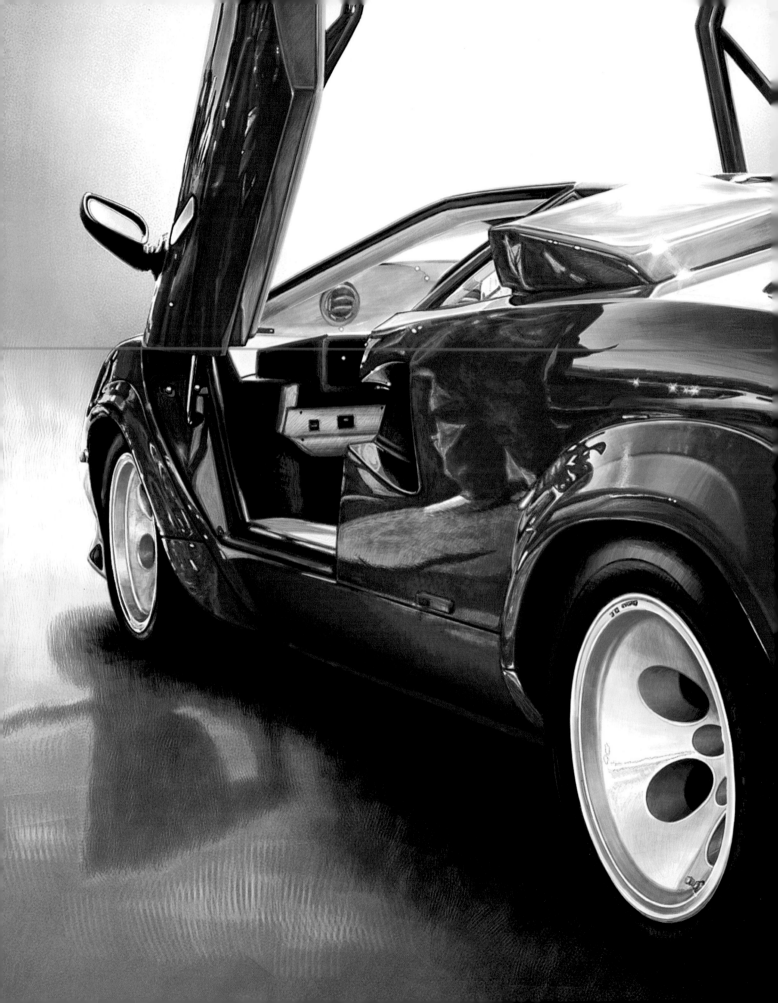

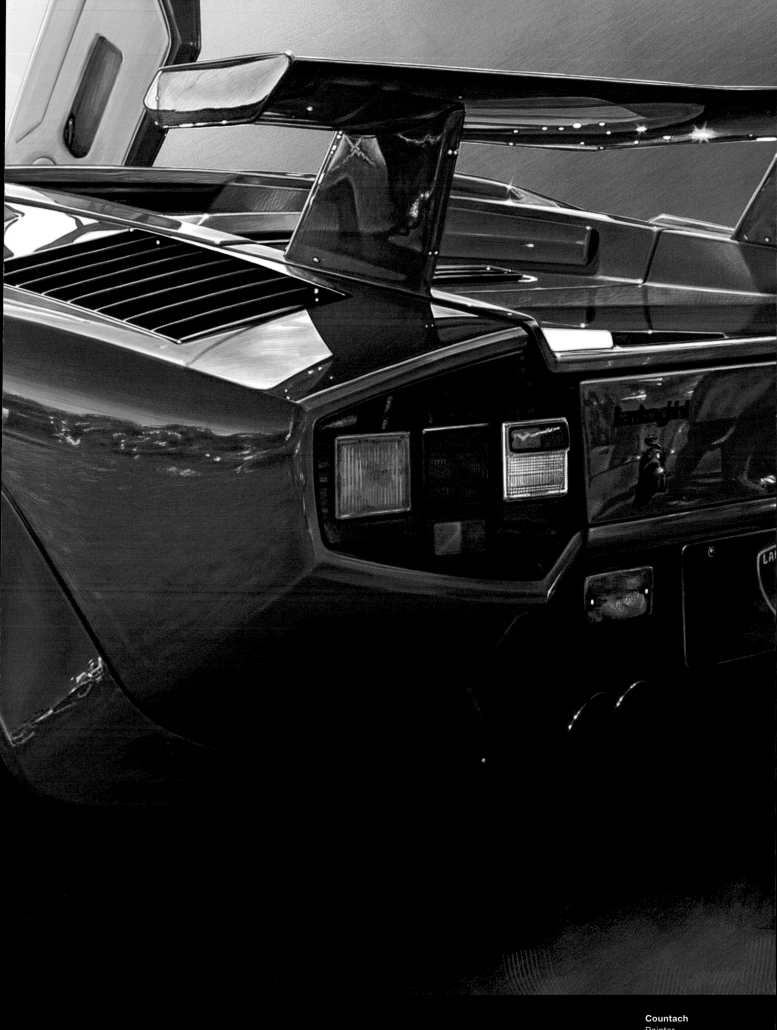

Countach
Painter
Wu-Huang Chin, USA

Blue car
Painter, Photoshop
Tommy Forsgren, GERMANY
[top]

Chase
Painter
Damien Thaller, AUSTRALIA
[above]

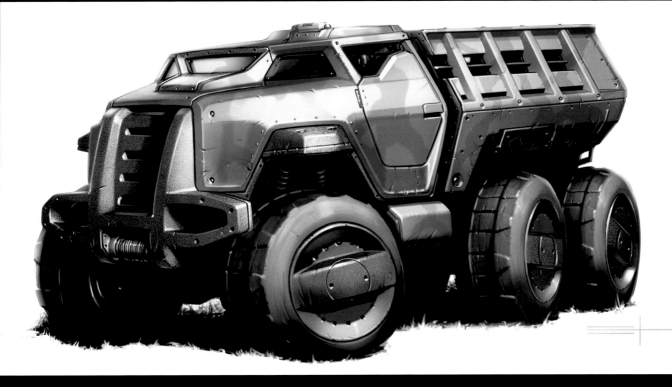

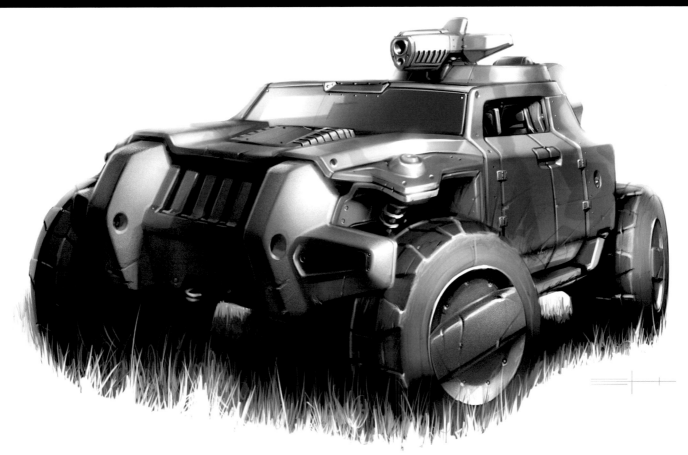

Double Duce
Painter
Erik Holmen, USA
[top]

<div align="right">

Heavy Armor
Painter
Erik Holmen, USA
[above]

</div>

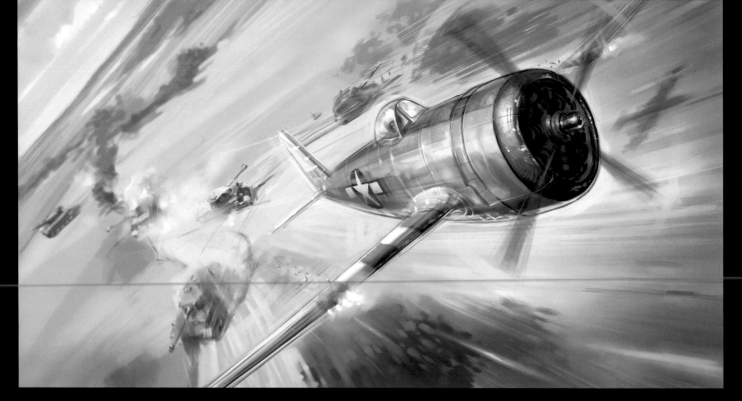

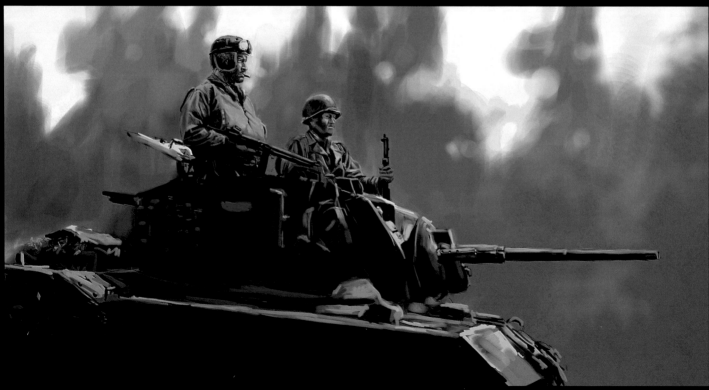

Jabo **M-5 Stuart tanker** **Abordage**

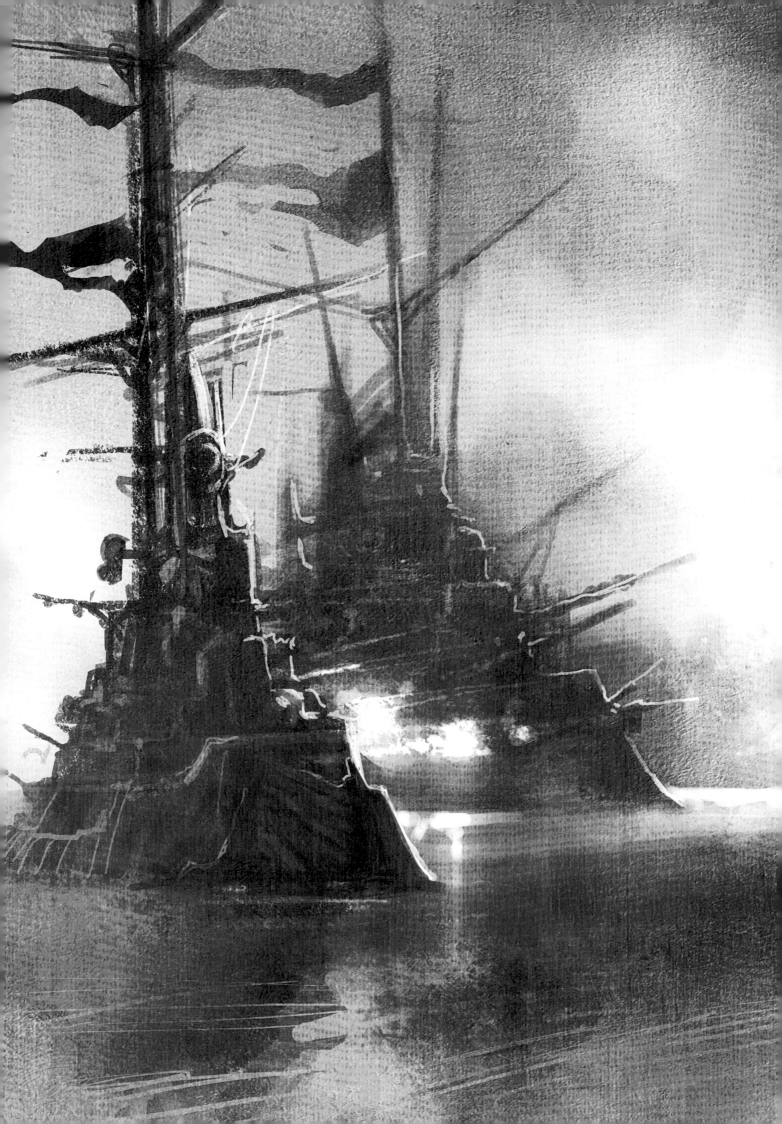

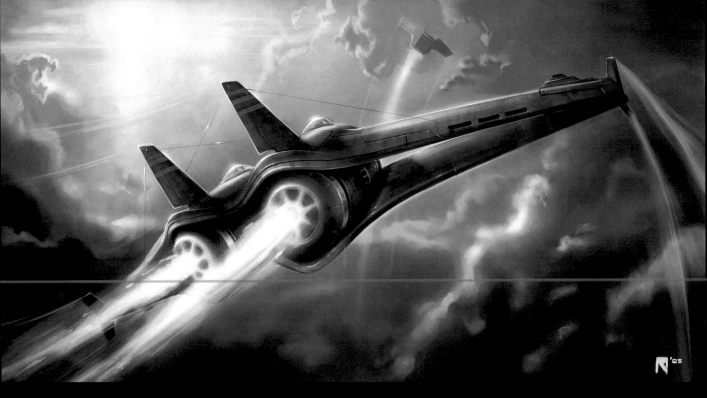

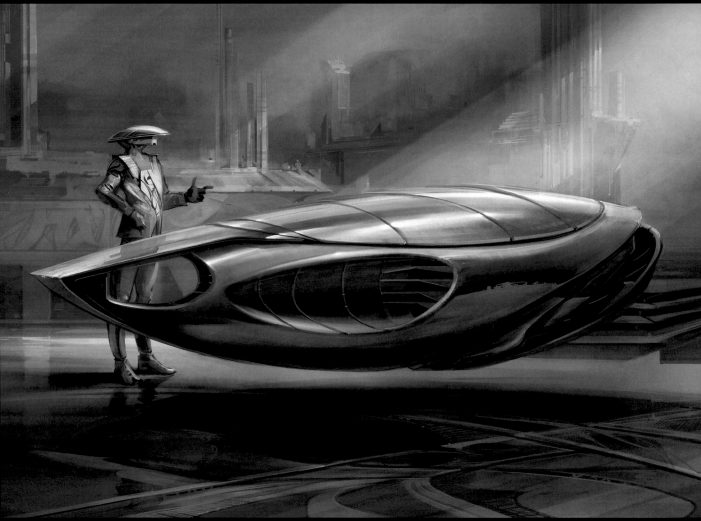

Bomber - the journey home?
Painter
Robert Melville, GREAT BRITAIN
[top]

Berline
Painter
Hervé Groussin NURO, FRANCE
[above]

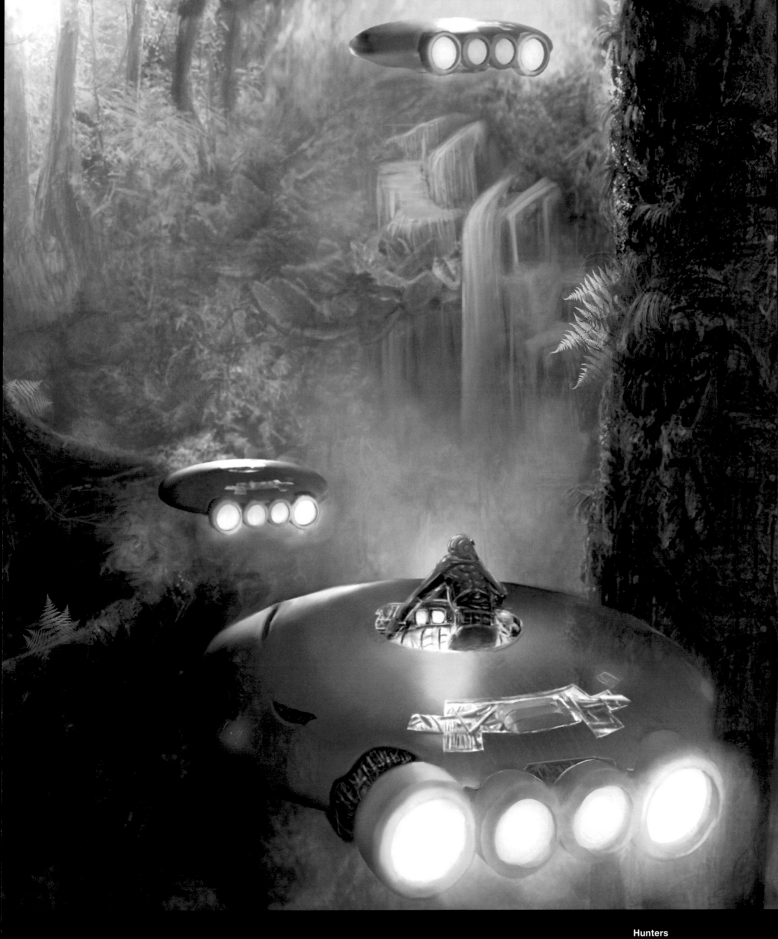

Hunters
Painter, Photoshop
Patrick Parish, CANADA

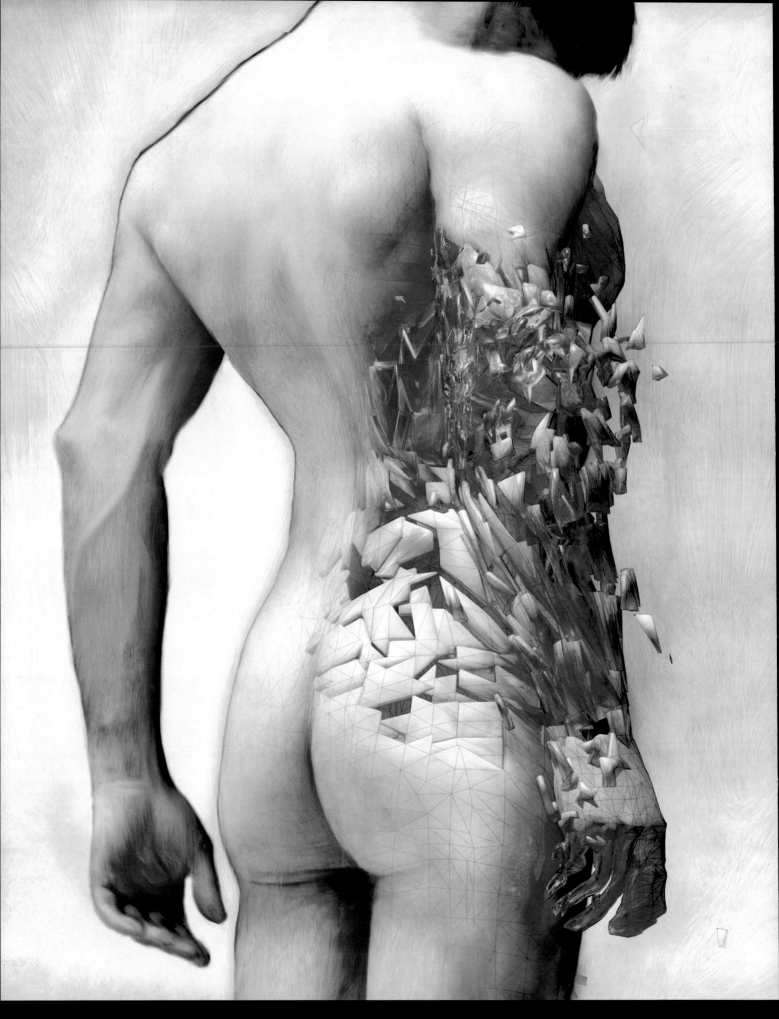

Master

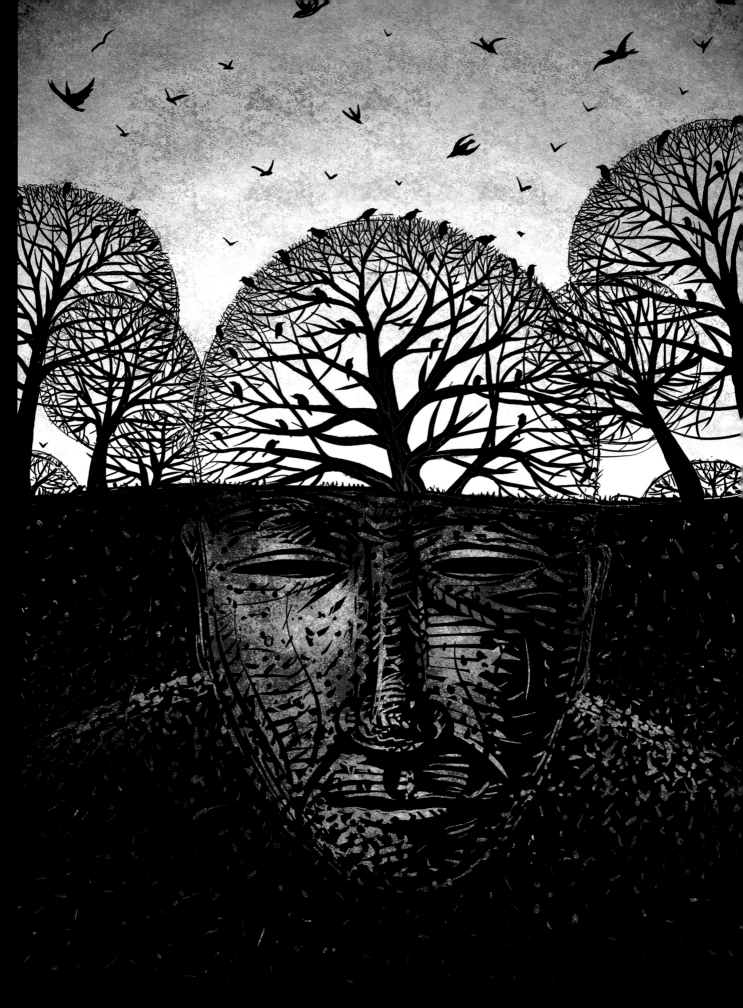

Thought Process
Painter
Chet Phillips,
Chet Phillips Illustration, USA

Excellence
Abstract & Surreal

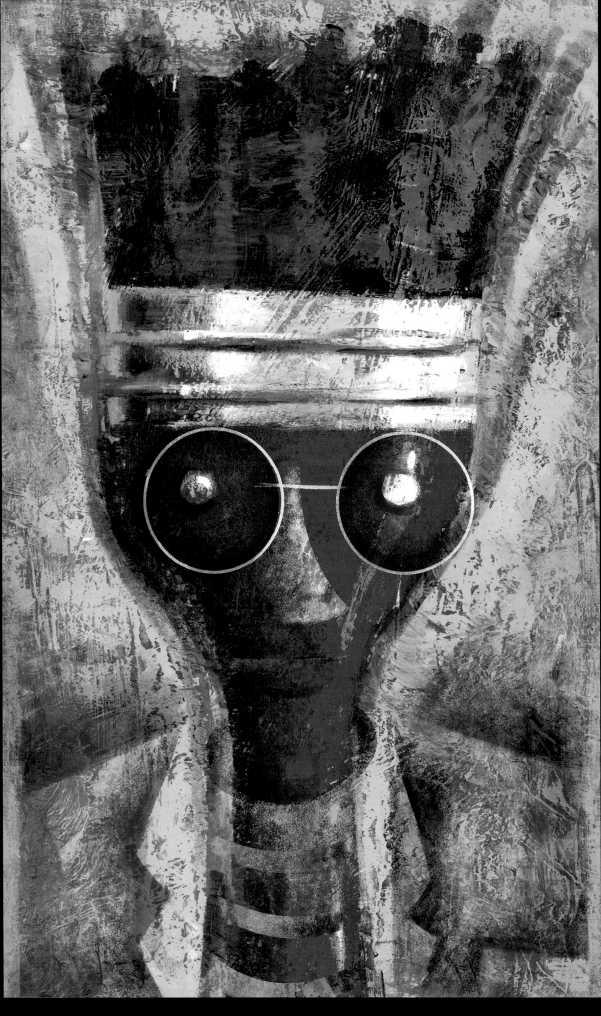

Excellence
Abstract & Surreal

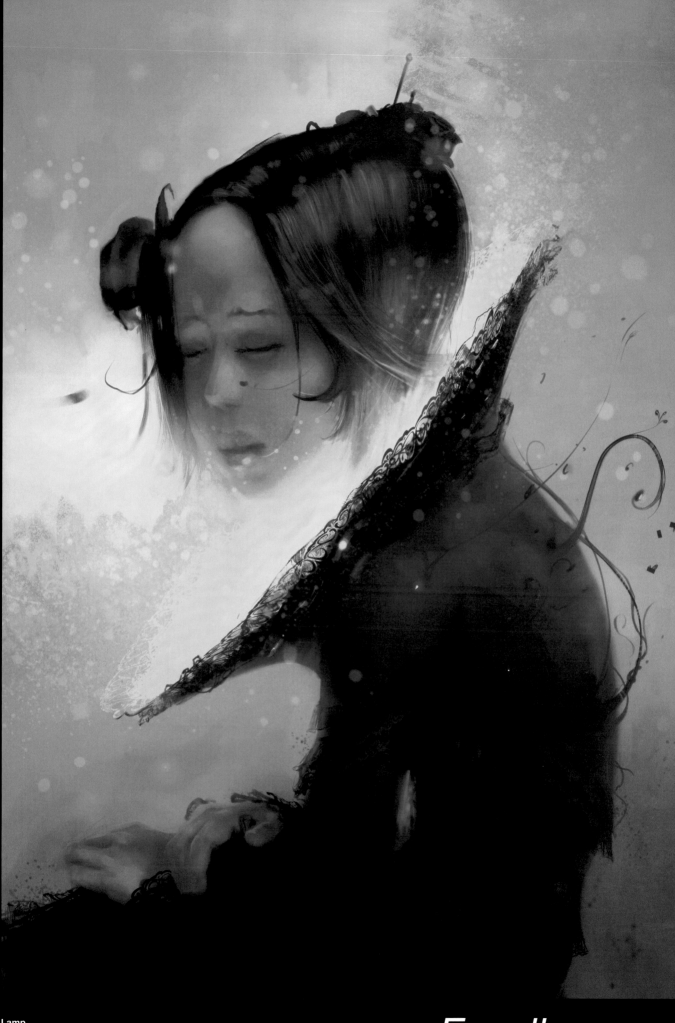

Lamp
Painter, Photoshop
Rafal Wojtunik, POLAND

Excellence
Abstract & Surreal

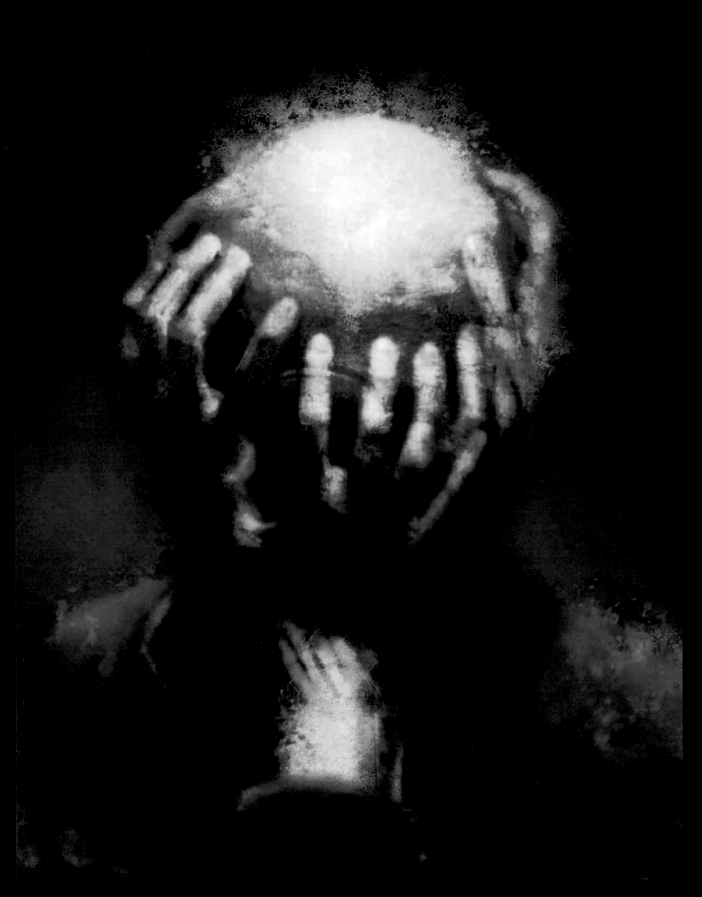

Enfer clos
Painter, Photoshop

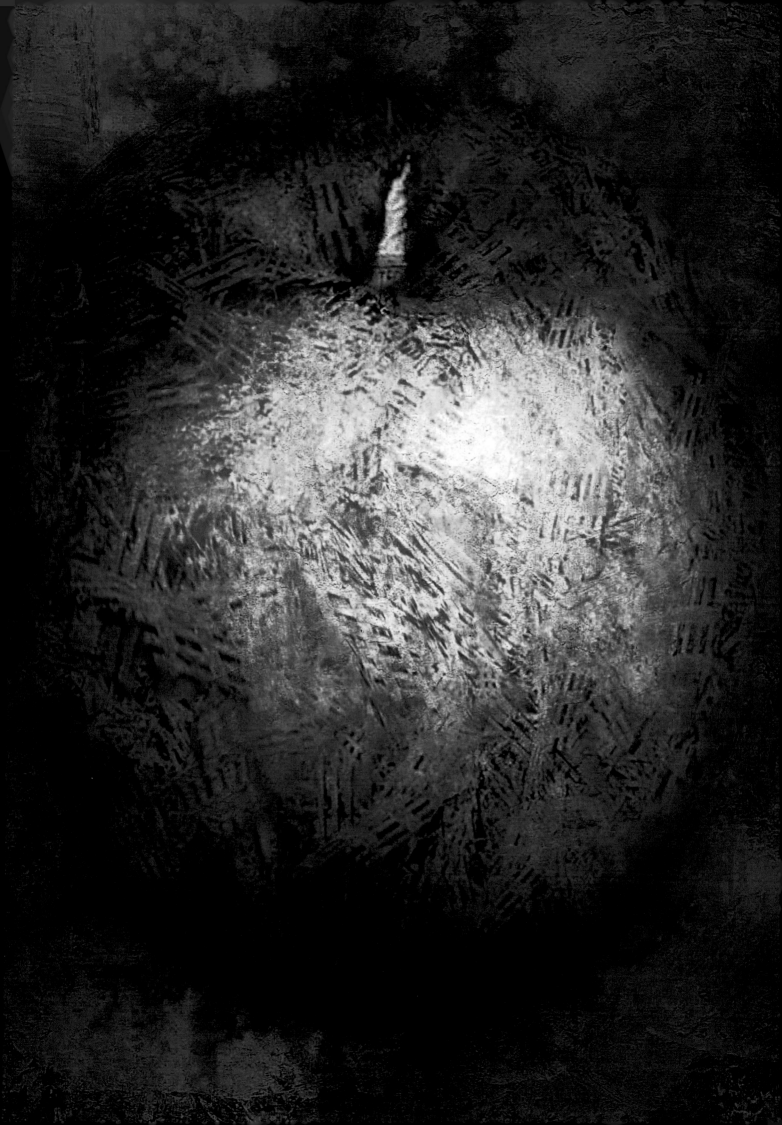

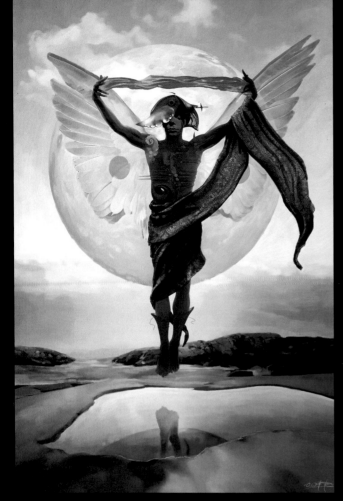

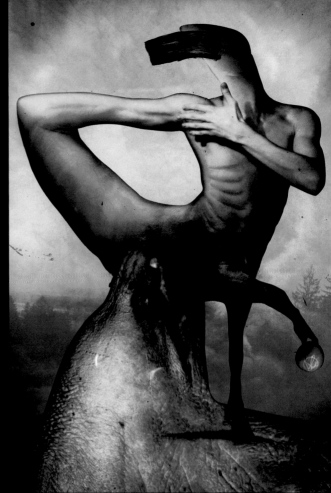

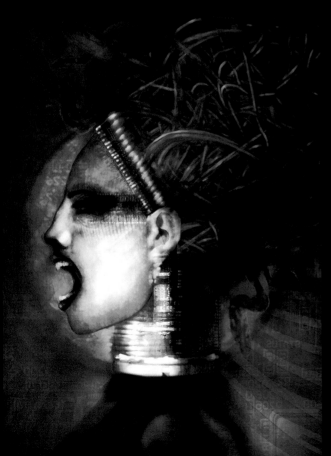

Inner works
Painter, Photoshop
Photographer: Akif 'Hakan' Celebi
Oliver Wetter, GERMANY
[above left]

Das traumbild 2
Painter, Photoshop
Domen Lombergar, SLOVENIA
[above]

Digital Medusa
Painter, Photoshop
Anjin, USA
[left]

Three days the devil danced
Painter, Photoshop
Client: GrafikaPress
Luis Diaz, USA
[right]

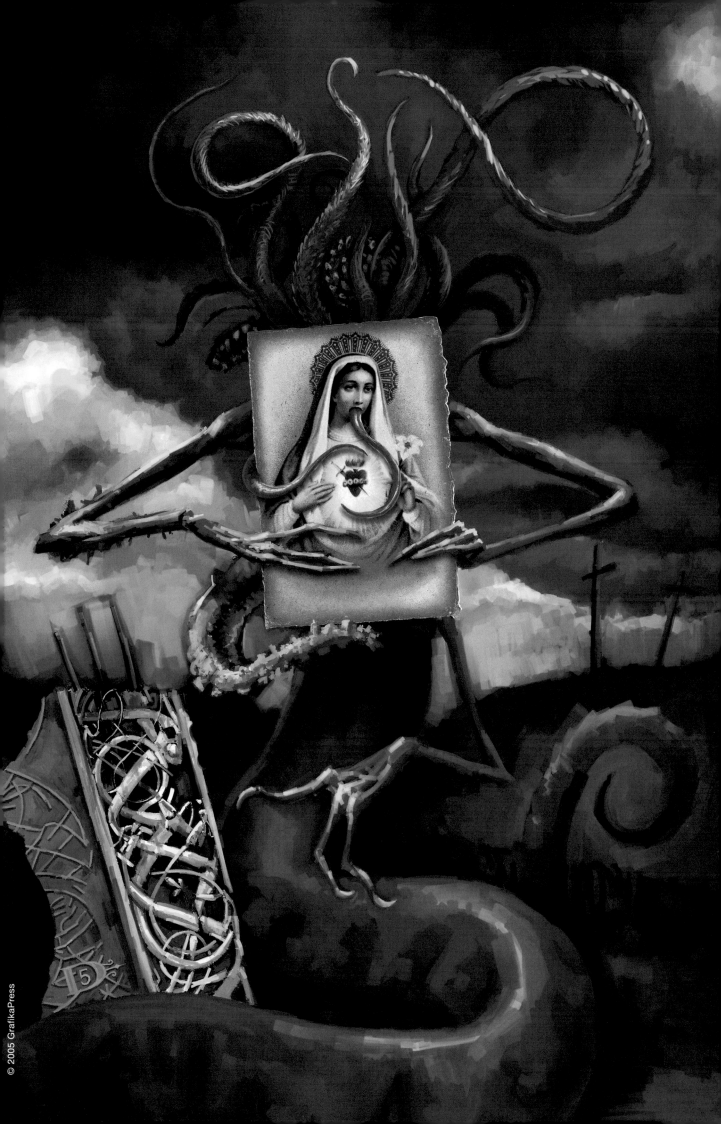

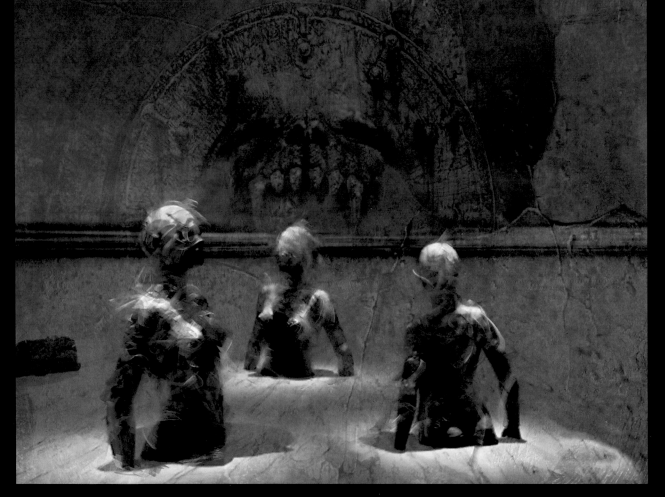

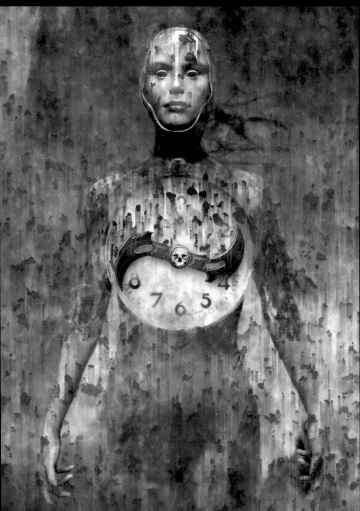

Three Graces
Painter, Poser
Eric Scala, FRANCE
[above]

Glaive
Painter, Poser
Client: Fleuve noir
Eric Scala, FRANCE
[left]

Modern Man
Painter, PhotoPaint
Duncan Long, USA
[right]

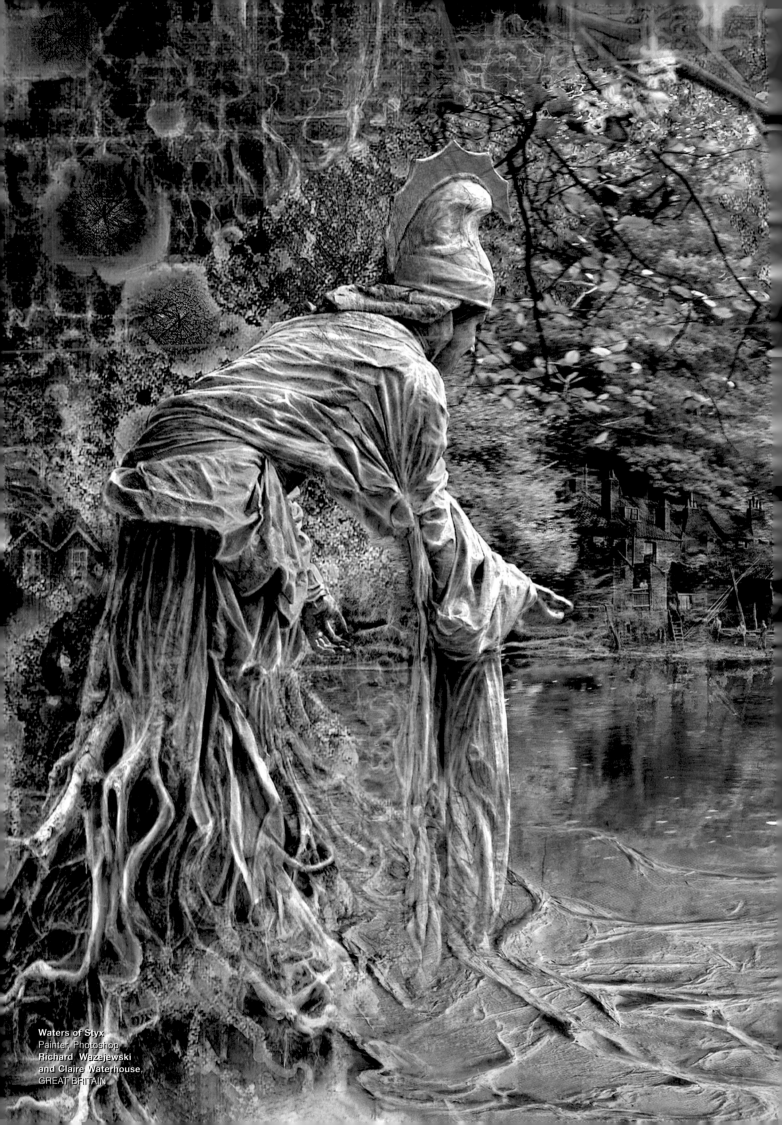

Waters of Styx
Painter, Photoshop
**Richard Wazejewski
and Claire Waterhouse,**
GREAT BRITAIN

Index

SOFTWARE INDEX

Products credited by popular name in this book are listed alphabetically here by company.

Adobe	Illustrator	www.adobe.com
Adobe	Photoshop	www.adobe.com
Ambient Design	ArtRage	www.ambientdesign.com
Corel	Painter	www.corel.com
Corel	PhotoPaint	www.corel.com
DAZ Productions	Bryce	www.daz3d.com
e-frontier	Poser	www.e-frontier.com
Pixologic	ZBrush	www.pixologic.com
